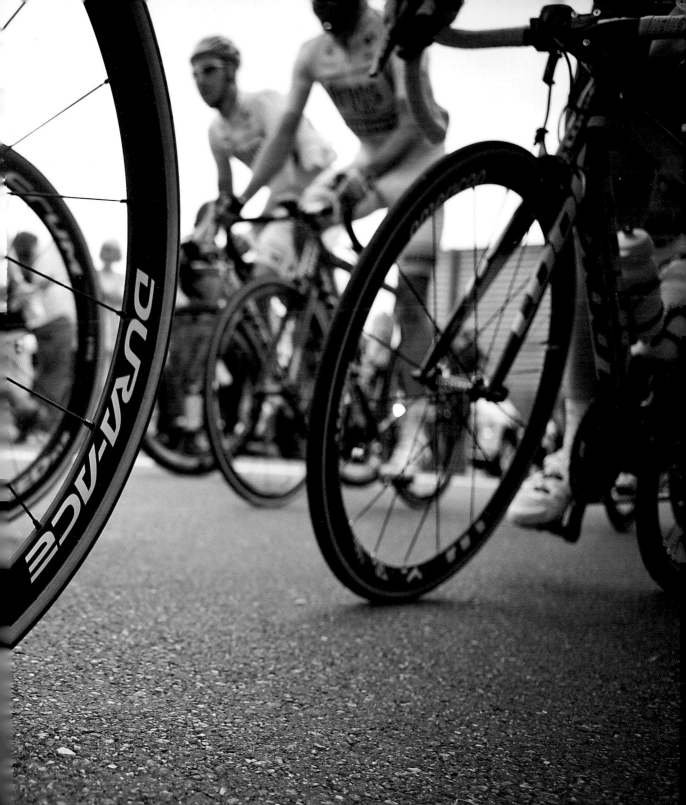

21 DAYS TO GLORY

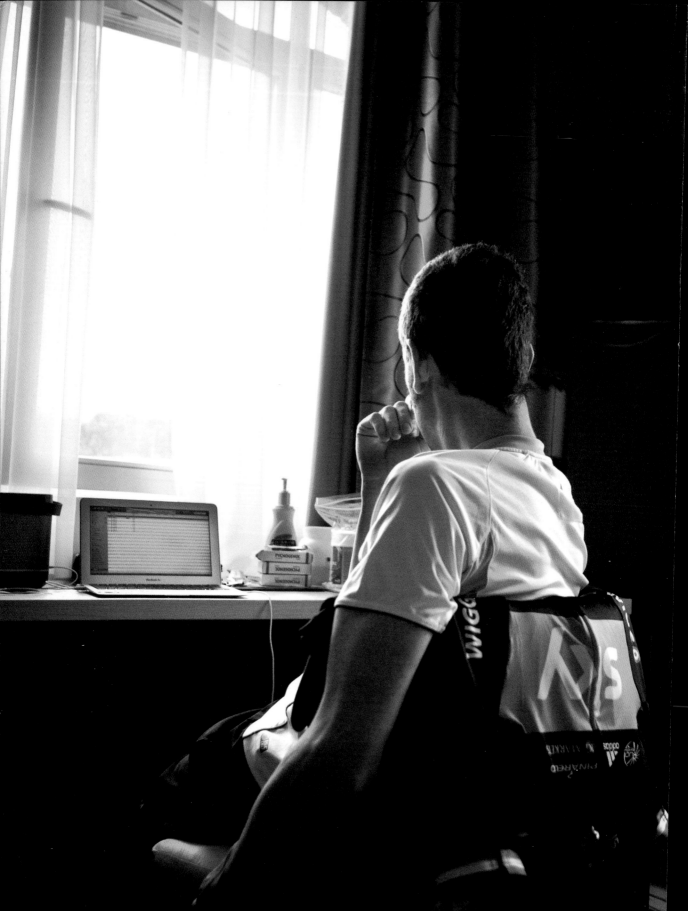

Photographs by
Scott Mitchell
Words by
Sarah Edworthy
Introduction by
Dave Brailsford

Harper
Collins

21 DAYS TO GLORY

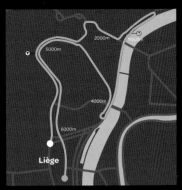

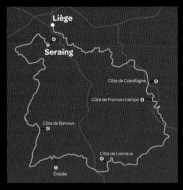

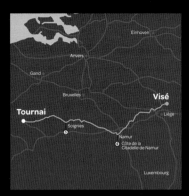

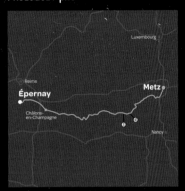

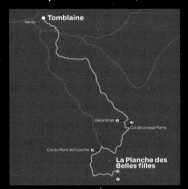

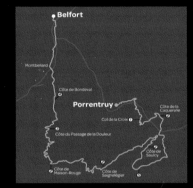

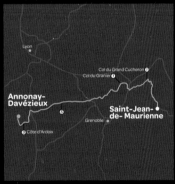

CONTENT

STAGE 3 / p.30

STAGE 4 / p.34

STAGE 5 / p.42

STAGE 9 / p.66

STAGE 10 / p.72

STAGE 11 / p.78

STAGE 15 / p.102

STAGE 16 / p.110

STAGE 17 / p.118

STAGE 18 / p.126

STAGE 19 / p.132

STAGE 20 / p.140

In 2010 we launched Team Sky as a professional road-racing outfit with the aim of a clean British rider winning the Tour de France within five years. The greatest prize in cycling had never been won by a Briton, so it was time to set the record straight. On Sunday 22 July 2012 we achieved this aim, and it was a proud moment. The sight of Mark Cavendish winning on the Champs-Elysées led out by Bradley Wiggins in the yellow jersey in front of phenomenal British support waving Union flags – well, you couldn't script a more perfect way of realising an ambition.

We had set ourselves five years, but the win came together in just three. Our first season, 2010, was a baptism of fire. We had 64 new people, 14 nationalities, a brand-new team operating with a new philosophy, run by people who had never managed a professional road-cycling team before. I'd been Performance Director at British Cycling for 11 years by then and it seemed normal to take the business-as-usual stuff from there and start somewhere else, but I didn't recognise how refined the Tour demands are. It was a difficult year. We were all out of our comfort zones. There's a point where if you want to fundamentally change behaviour, there has to be a threshold where the suffering is bad enough, or the reward great enough, for people to change. We reached it.

Going into 2011, the second season, we had a more structured approach with a clearer idea about the simple things we wanted to focus on. From a performance perspective, we made progress. For Bradley in particular, it was as if the penny dropped. He was experienced, he was mature, he believed in his coaching team and he started to 'get it' in terms of the amount of work he was putting in. We started to see signs of Tour-winning potential. Going into the Tour we had high ambitions, but ultimately he crashed, broke his collar bone and that was that. He bounced back and collectively we went into our second off season as a highly motivated, highly driven team. Bradley had won the Dauphiné, the big race before the Tour de France, and that was a big, big step forward. In the Tour of Spain we finished second and third – our first podium in a Grand Tour. We were moving in the right direction. We had a clear model of how to mount a challenge to win the Tour.

A lot of the riders had been on two-year contracts, so for 2012 we had an opportunity to bring in riders for a specific purpose, which had a huge impact. To pursue our goal of winning the General Classification, we had identified the need for highly talented climbers. We signed Richie Porte, Kanstantsin Siutsou and Christian Knees. With world champion Mark Cavendish and his helper Bernie Eisel, that made five new riders in the Tour team of nine, selected from our squad of 28. We then got these super-talented cyclists to train and race together as much as possible so that when they went into the Tour it was business as usual, rather than a brand new challenge.

As a team we had moved from the conceptual phase into a more tightly refined operation bound by our philosophy. Everyone was aligned, pulling in the same direction. Bradley was in great shape, in great form. For the entire team, the Tour would be 21 days of protecting Bradley's focus – on the road, against illness or injury, against feeling unsettled – to allow him to deliver victory in Paris. But for those 21 days you don't think about the outcome, you don't think about the 'what ifs'; you focus instead on the process, and on delivering that on a minute-by-minute, hour-by-hour, day-to-day basis, because focusing on the process increases the chance of getting the outcome you want …

INTRODUCTION BY DAVE BRAILSFORD

THE STORY

'The greatest prize in cycling had never been won by a Briton. It was time to set the record straight.'

Dave Brailsford

On paper, the tactics for the 2012 Tour campaign looked simple. Survive the first week, take time off our rivals in the second, then defend all the way to Paris. But first you have to roll down the start-house ramp. You have to commit yourself to the ticking of the clock. 'I'm always nervous before a big race, so I wasn't feeling great,' said Edvald Boasson Hagen. 'But I knew that I had trained well, I was well prepared. Everyone has a special feeling before the Tour starts. It's the race you train all year for. There was a lot of expectation from ourselves and from outside the team. It was time to see what would happen.'

For all the talk of teamwork and working selflessly on behalf of the team leader, three of the 21 stages on this 2012 Tour are time trials – when each rider is on his own. As a group, they have absorbed a precise presentation of the 6.4km individual time-trial stage on the screen at the front of the bus. They have studied the detailed information in the race book. They know from personal recces that it's quite 'technical', with changes in direction, in road width, type of surface, grates on the racing line, and so on – and they know it is up to themselves individually to get pumped up, in the zone, prepared to turn themselves inside out to ride to the absolute edge of their capability. As Dave Brailsford says, 'A time trial is called the Race of Truth because you're on your own. No one else is involved. It is a question of how much you can push and hurt yourself over a given time in a given event. These guys

PROLOGUE

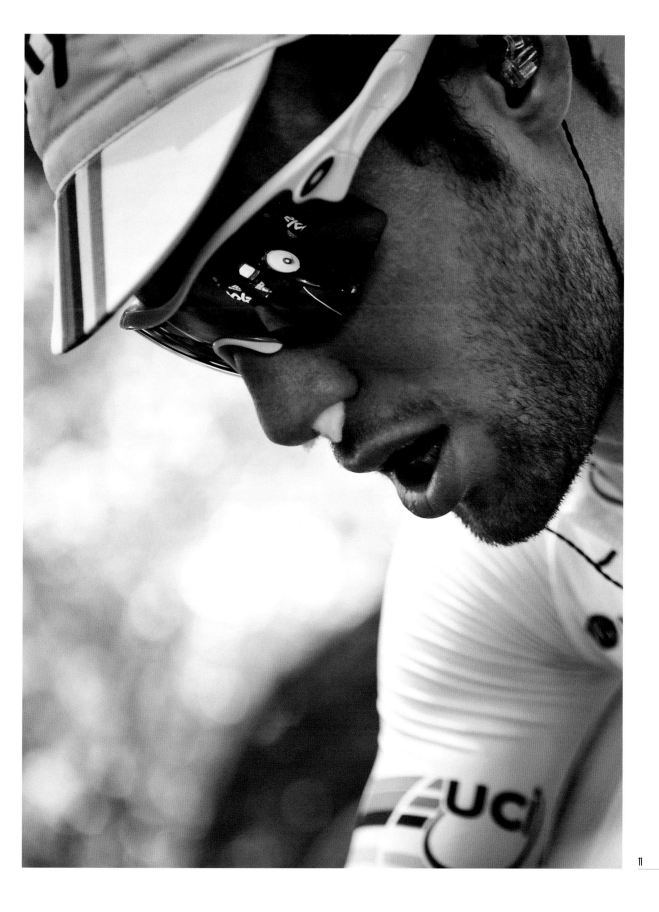

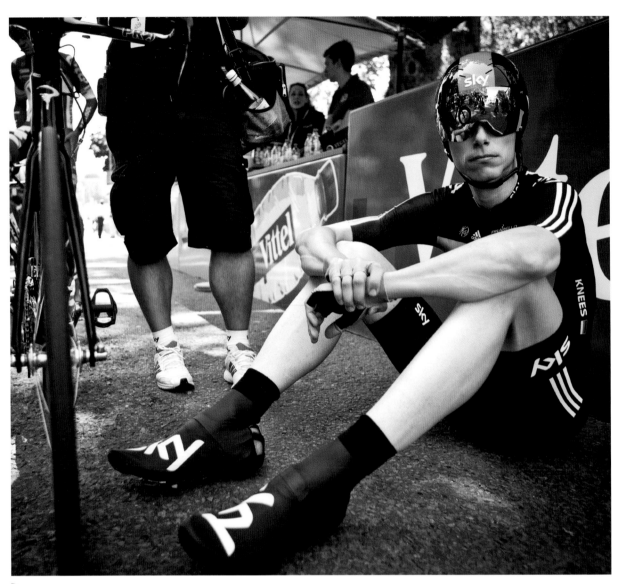

have their own way of preparing for the focus that requires. Bradley is remarkable; in the last hour and a half, he listens to music, he psyches himself up, he knows the process to go through until his heart is pounding, his nerves are going, his body releases adrenalin. These guys figure out that feeling bad is probably good.'

A time-trial day calls on several levels of mental toughness. With 198 riders going at two-minute intervals, there was a lot of hanging around before the day's seven-odd minutes of all-out sprint effort. To reach the optimum

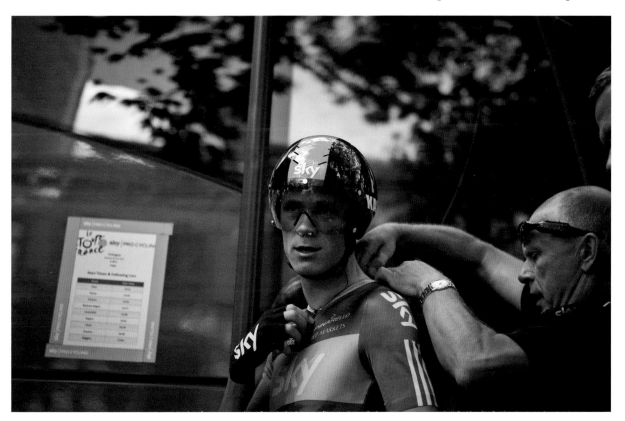

level for physical performance, each rider has a pre-race massage to loosen the body before warming up on turbos to a rate set by Tim Kerrison, head of performance support, and measured by heart-rate monitors. The carers give out cotton wool daubed in a decongestant to clear the airways and ensure efficient breathing to feed oxygen to the muscles. (Chris Froome, in his excitement, left the cotton wool in his nostrils when he went down the ramp and still came 11th. 'If he did that time just breathing through his mouth, how fast can he go breathing through his nose and his mouth?' laughed Brailsford.)

Wiggins has made time trials his domain, but coming into the Tour he was facing unprecedented media attention. How did he feel to be favourite? Had he peaked too soon? Behind his mirrored, specialist time-trial glasses, Wiggins was perfectly composed. 'In the past we had gone to races early in the season and used them

for training, but this year we had gone to races to try and win, to learn how to start leading races and defending a lead, and to familiarise ourselves with all the hassle, the press, the extra stuff that goes with being dominant,' says Brailsford. 'We'd thought, "let's get used to that until it feels normal."'

When Wiggins burst down the ramp in Liège, his aim was to come out on top of the timings – though he had conceded in a team meeting the previous evening that the only man who might edge him out was Fabian Cancellara, the Swiss time-trial specialist known as 'a motorbike in prologues'. Wiggins rolled down in classic form: not pushing too hard at the start, maintaining a consistent pace throughout, ending the day a mere seven seconds off Cancellara with his rival for General Classification honours safely behind him.

'It's a good start,' Wiggins said. 'The main thing was to stay upright, safe and trouble-free. Physically I felt fantastic out there. It's everything we've been training for.'

Bradley Wiggins. Team leader. Age: 32. Nationality: British. Career highlights (as of eve of 2012 Tour de France): Six Olympic medals and 10 world championship medals in track cycling. Road race honours include Critérium du Dauphiné (2011, 2012), Paris-Nice and Tour de Romandie (both 2012).

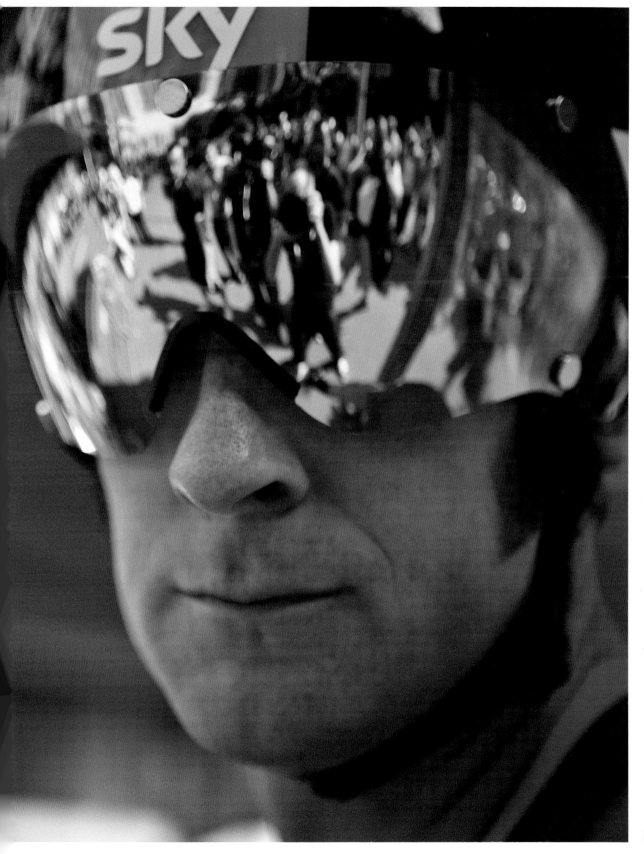

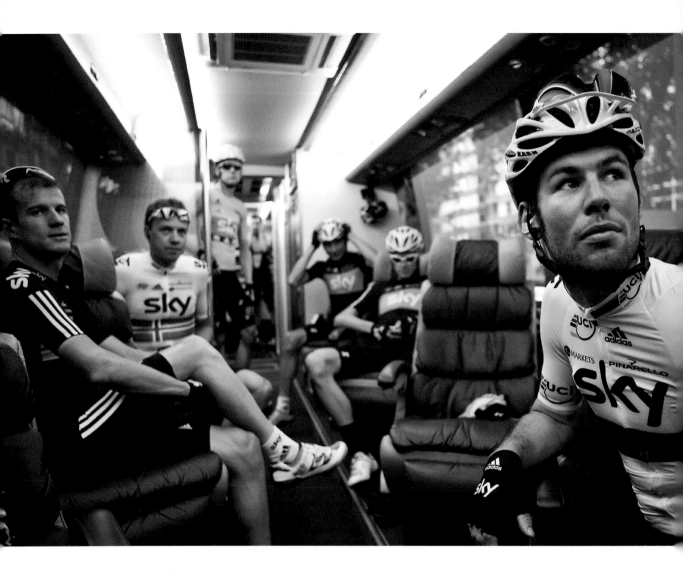

STAGE 1

Energy, nerves, excitement, aggression, danger: the first road stage is always highly charged. The race to Seraing was one of six days – a mad, mad week – to count down before the relative safety of the mountains. To win the Tour de France you need to be a strong time trialler, a robust climber, and you need to perform without errors or suffer bad luck at inopportune moments. On the eve of the 2012 Tour, Team Sky and Bradley Wiggins had ticked those boxes repeatedly, with victories at Paris-Nice, the Tour de Romandie and the Critérium du Dauphiné. They were the dominating force, the favourites.

'Nothing had gone wrong, so it would soon, right?' That was the private fear of Sean Yates, Sky's senior sports director, who prides himself on his intuition. 'That's my forté, judging feelings,' he says. 'In Liège I had a dream that Bradley had a crash. I kept quiet about it, then I told one of the coaches and he said, "Keep that to yourself!" But I had it at the back of my head all the way, the worst nightmare, because it had been building all year. Nothing had gone wrong whatsoever. I had a feeling there was a situation waiting for us somewhere down the road, but I didn't want to spook anyone ...'

On that first morning after the prologue time-trial efforts, Team Sky readied themselves for the 20-day bubble of singular focus and team unity that could end on the Avenue des Champs-Elysées in Paris with the crowning of the first British winner of the most illustrious of cycling's Grand Tours. Compared to the other competing teams, the line-up had an interesting dynamic. 'From the start of the year we had a core group – nine riders, all super duper. Not many teams have that luxury,' Yates said. 'We kept them together, training and racing, so they'd get a good understanding. Our goal was to top the GC, to win the yellow jersey, and everyone had their role.'

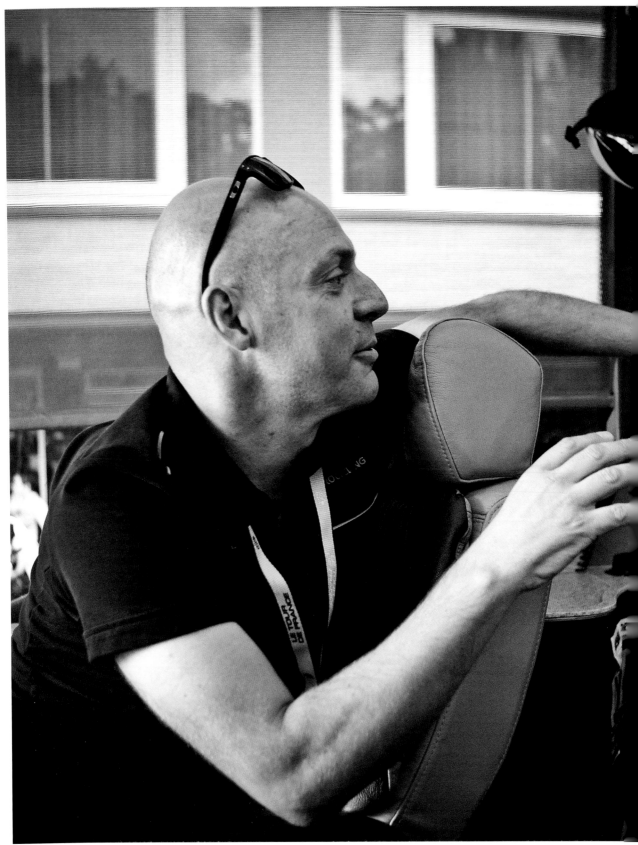

Wiggins, a superb athlete who had worked harder than ever before, was team leader. World champion Mark Cavendish, a big character, was the sprinter. With Cav came Bernie Eisel, his experienced helper. Michael Rogers, hugely respected and calm, would be road captain in the mountains, aided by his Australian compatriot Richie Porte and Kanstantsin Siutsou of Belarus, both heroic climbers. Christian Knees, a big engine and supreme protector, was Bradley's right-hand man. Edvald Boasson Hagen was – according to Yates – 'a massive, massive luxury. He can climb, close down gaps, go on breakaways, he's Mr Perfect', while in-form Chris Froome was Option 2 if Bradley went.

'Cav added a challenge,' admits Yates. 'He was the world champion, and would be included in the team. Traditionally a sprinter needs leadout, so therefore there was an element of compromise. However, we felt we were capable of winning the overall and the stages without a full complement of GC riders to support Bradley, but it was a gamble.'

For Wiggins, the mission was to stay out of trouble and not lose any time until he could make killer blows on his rivals in the time trials. Stage 1 went according to plan, with Wiggins shrugging off a fierce uphill sprint attack from defending champion Cadel Evans. The stage otherwise threw up the usual mix of good and bad: Boasson Hagen finished a buoyant third, but Froome suffered a puncture and crossed the line 1:25 down in 95th place.

19

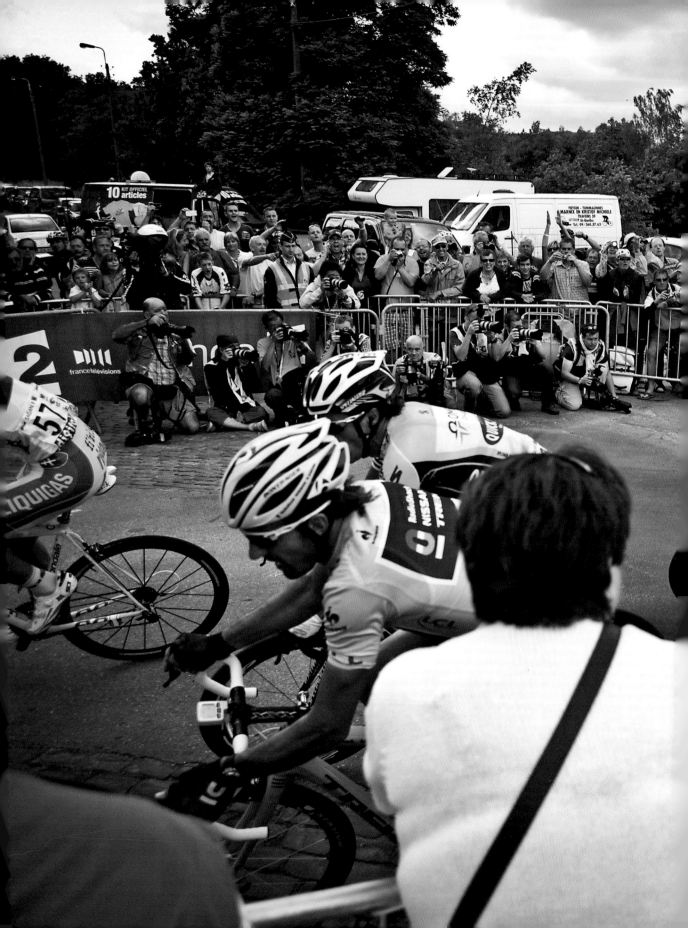

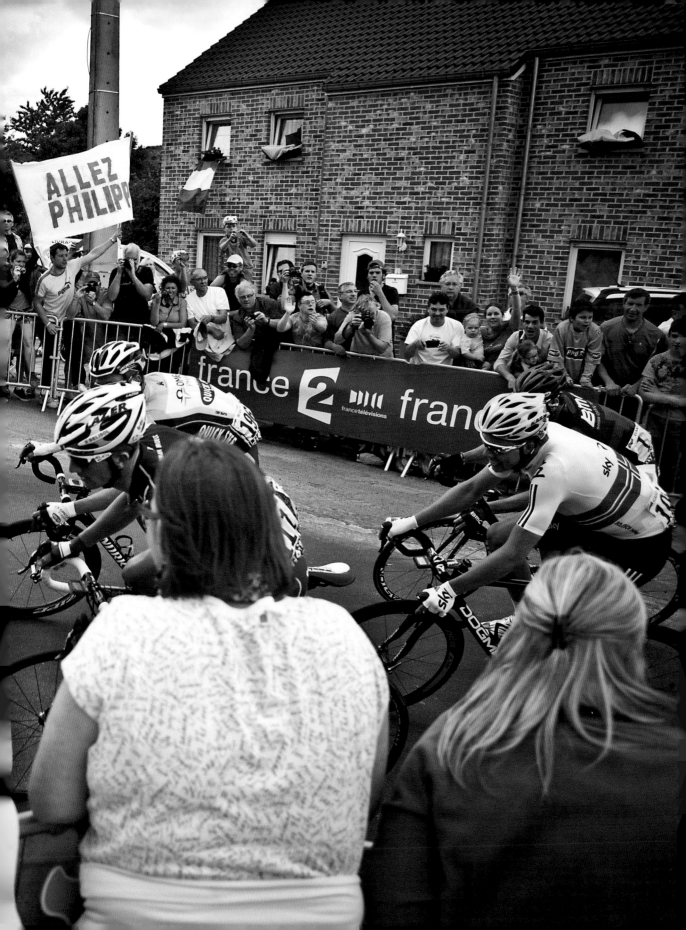

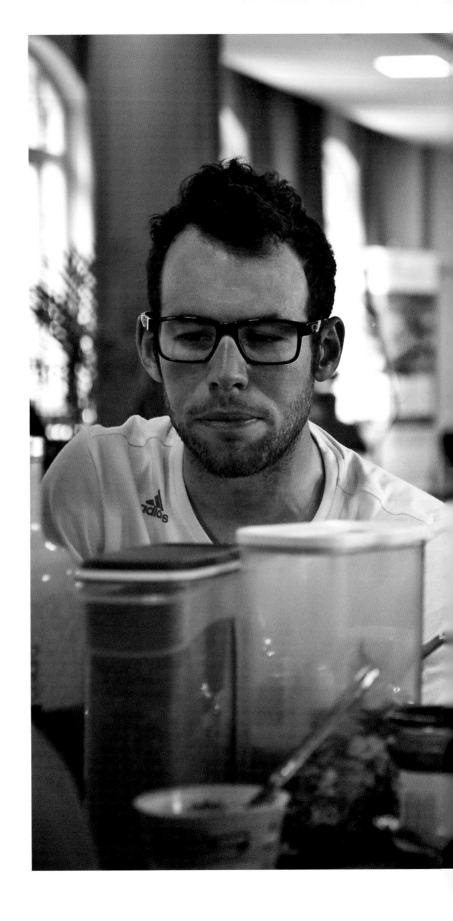

STAGE 2

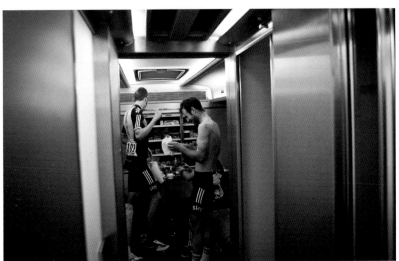

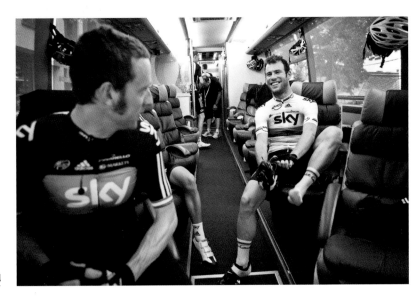

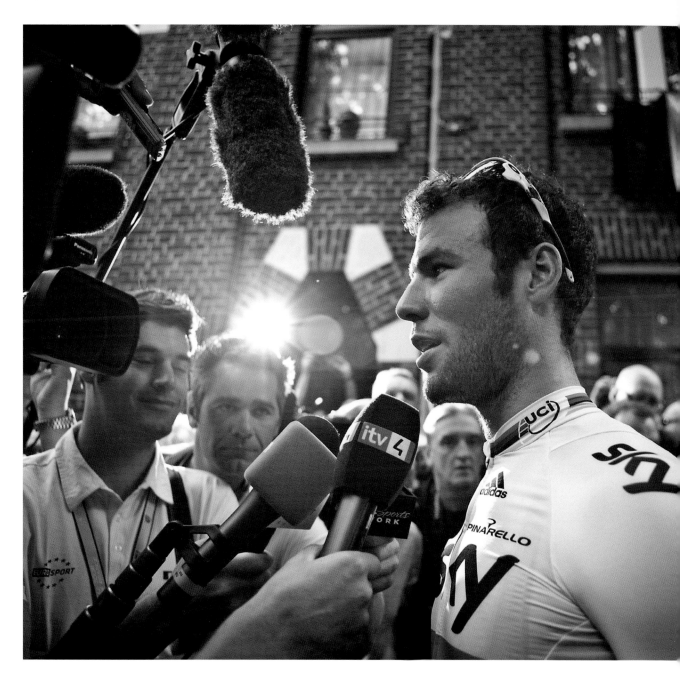

Within the relentless 21-day cycle of effort and recovery, breakfast is a relaxed time. At this point everyone is feeling as fresh as they're going to within a 24-hour timeframe. The food on offer is less strictly nutritional and more about personal preferences, as the riders burn it off within hours. Conversation is random banter, anecdotes from the peloton, thoughts for the day. For Cavendish, the stage to Tournai offered the prospect of a tasty duel between the sprinters, which he particularly savoured in his first Tour wearing the world champion's rainbow bands.

After a quiet start in the hotel the cyclists would then get on with pre-race preparations in the safe haven of the team bus (even allowing for Wiggins's legendary mimickry), before heading out to face the media circus en route to the start. At this stage, Cavendish looked to be in his element. While Wiggins hates the nerve-inducing mass jostle of the first week, and the other riders felt the responsibility of keeping Cavendish safe throughout, Cavendish himself relishes the fight. The first sprint finish came down to an absorbing battle. After being led up by Eisel and Boasson Hagen, Cavendish positioned himself with stunning precision, darting from wheel to wheel before claiming the ideal spot right behind André Greipel and pouncing brilliantly to take his 21st Tour stage success.

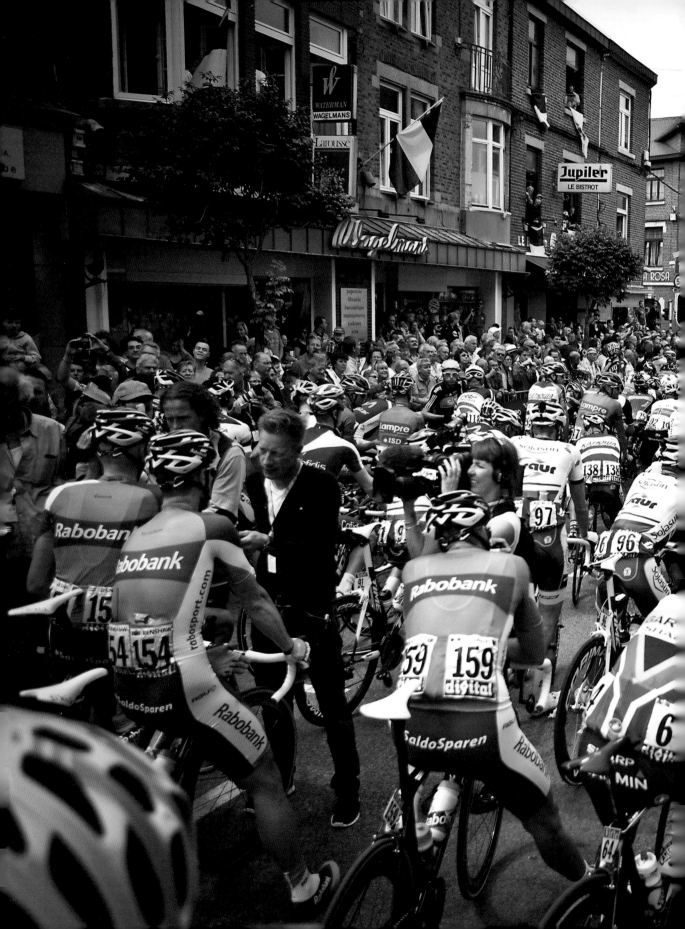

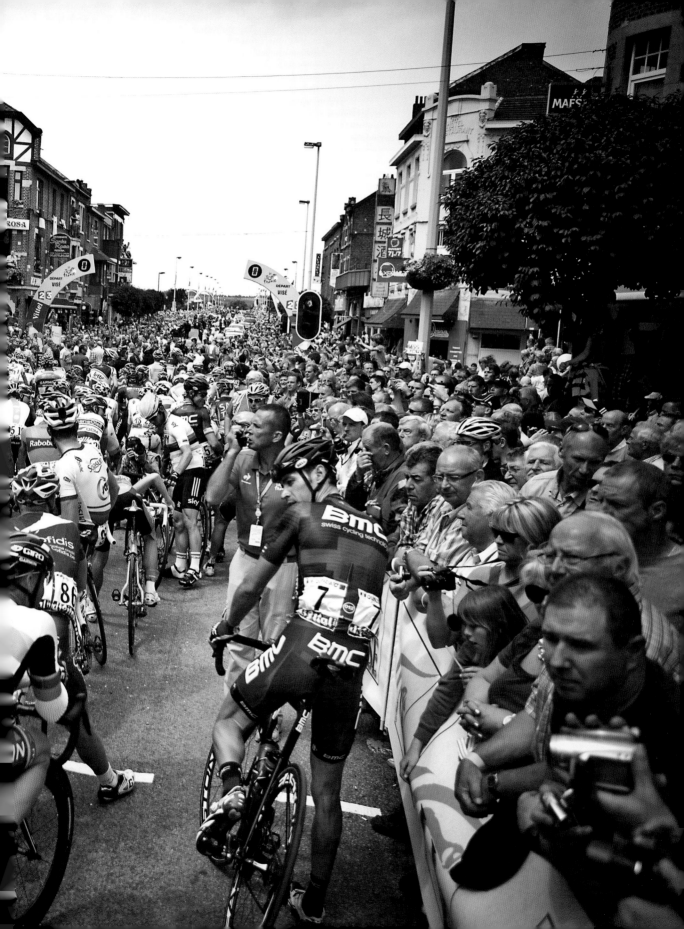

'Eddy and I brought him up and then he jumped away from us from 2km out. He knew he was going to come from behind. He did it perfectly,' marvelled Eisel. 'He took a lot of risks, jumping from wheel to wheel, it cost him some energy. For Eddy and I, his win was amazing because we didn't have much to do!'

Day three of 21 and a Team Sky rider was on the podium, enjoying the winner's presentation, receiving a victory bouquet of yellow flowers from women in yellow dresses ... How many more times would that scene replay over the remaining days of the Tour?

It was a perfect team result, with Cavendish bagging the win, Wiggins retaining second place overall and the team riding well together as a unit. Famously, Cavendish's moods can fill a room, so it was a happy bus that took the team on to the next hotel. 'It's been a good start to the race for the team,' he said. 'Brad stayed out of trouble and hopefully he can continue on towards yellow. We're here to win the yellow jersey. I'm here to do what I did today. I've been more relaxed than ever coming into this Tour de France as the pressure hasn't been there for me to do anything. A win doesn't give me any more confidence as it's never easy to win a Tour de France stage, with a team or on your own.

'Every race since I've won this jersey I've wanted to show why I'm worthy to wear it. I really wanted to do it honour this year, and that means winning wherever I can go. It's very, very special. Every day in training, in racing, maybe once every few minutes I look down, I see the rainbow bands and it gives me a great sense of pride.'

Mark Cavendish. Sprinter. Age: 27. Nationality: British. Career highlights (as of eve of 2012 Tour de France): 2011 Road Race World Champion. Winner of 20 Tour de France stages. First British cyclist to wear the *maillot vert*.

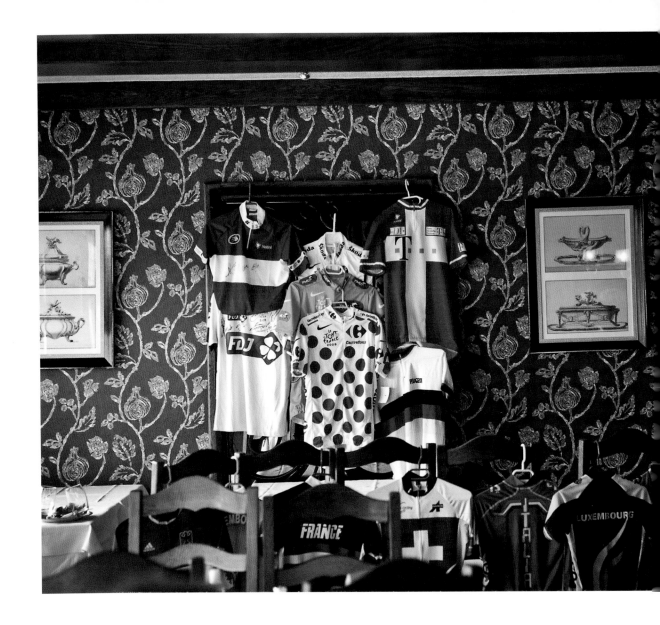

STAGE 3

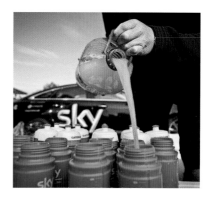

It was always going to be a stressful day. First-week nerves were compounded by the prospect of a tough stage, the first in France, which started across the border in Orchies. It is unusual to feature a stage with five short, steep climbs – which were categorised for the mountains jersey competition – early in the first week and this one, close to the coast, came with the threat of winds and a twisty last 70 kilometres. The team left the hotel in Belgium, with its quirky displays of jersey tributes, and focused on the race to Boulogne-sur-Mer. The riders had studied the notes, heeded the tactics talk, trusted in each other. The carers had prepared bidons and foil-wrapped rice cakes, bite-size sandwiches and cake with fruit jam to fuel them.

Musettes were safely handed over in the feed zone, but just over an hour after the peloton had taken on board their energising snacks came news of the second crash of the day. At 15.10 it was reported Kanstantsin Siutsou was on the ground; by 15.20 the news broke that he was out of the 2012 Tour. 'It sounded bad,' says Richie Porte. 'Sean [Yates] has a very direct manner on the radio. He suddenly came on and said, "Kosta is no longer with you ..."'

Kosta's injury was serious: a fractured left tibia. 'I was in the middle of the peloton on a small narrow climb when I heard Sean on the radio saying it was an important part of the race and telling me to stay in the front with Bradley,' he recalls. 'As I started moving to the front, somebody began to crash. I braked and put out my left leg. Riders and bikes went over it. When I woke up, my body was in one place, my left leg felt like it was in another place. I had no feeling. I remember the shock, trying to get up, people saying "Come on, come on" – and then I was in an ambulance.'

Siutsou's withdrawal – the first in the 2012 Tour – was a blow for the team, both in terms of morale and also with regards to ongoing tactical logistics. The Belarusian had been chosen for the team because he was one of the strongest riders on all terrains, a tireless workhorse on the flat who could go right into the high mountains if required. 'When we accepted the challenge of pursuing multiple objectives at the Tour, we knew that we needed super-strong guys like Kosta who can take on very high workloads, performing at the highest level, day in, day out,' said Tim Kerrison.

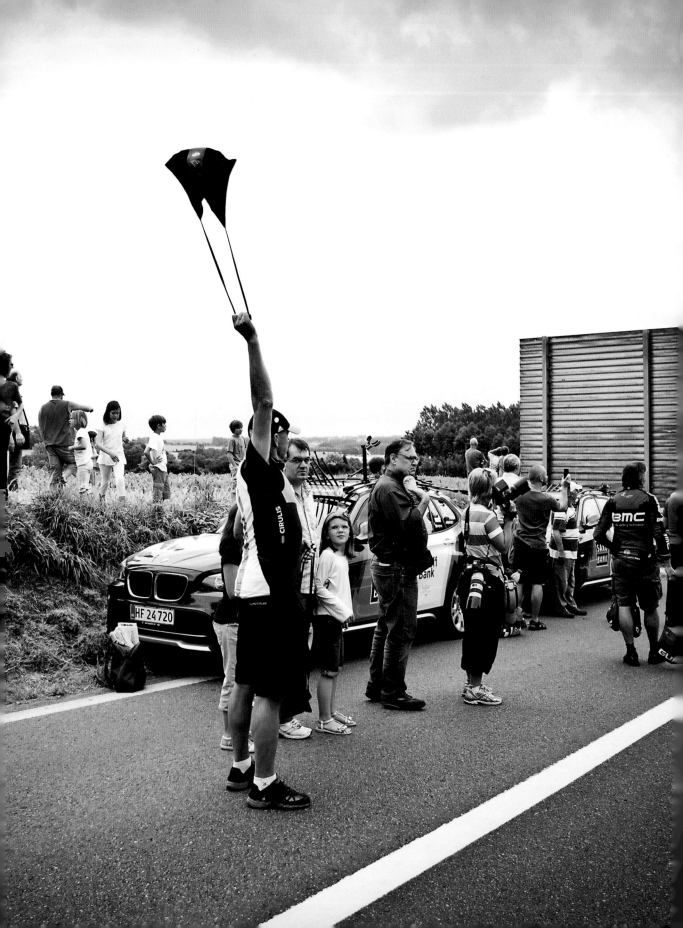

'It really affected us,' says Michael Rogers, who roomed with Siutsou. 'We'd done a whole year together, we're all pretty close, and Kosta was one of our key men throughout our successful season. Stage 3 was a big day, stressful anyway and extra stressful because it was windy, which always creates anxiety. There were crashes left, right and centre. When the news came through, we all went into that world of wondering what we were going to do without him. It's not a good frame of mind. We needed to snap out of it. We were lucky to get through the day.'

Like Wiggins in 2011, it was Kosta's fate to follow the Tour from a hospital bed on television and via the Team Sky website. 'It was painful. The focus for a long time had been Tour, Tour, Tour. I was so happy the night before it started. It was my first Tour, I knew I was ready to do my job for Bradley, particularly at the beginning of the long mountains, and sometimes to work for Mark in the flat. And then one day changed everything for me. But I am thankful. After every stage, the guys sent me messages saying, "You're still with us in the Tour. You're staying together with us." We are a close unit of workers.'

It was not until 2 September – 61 days after his crash – that Kosta got back on his bike. 'I was still unable to put weight on my leg when I walked, but I took my bike on the road and when I turned around, 10km from home, some people saw my Sky kit and started chanting: "Wig-gins, Wig-gins ..."'

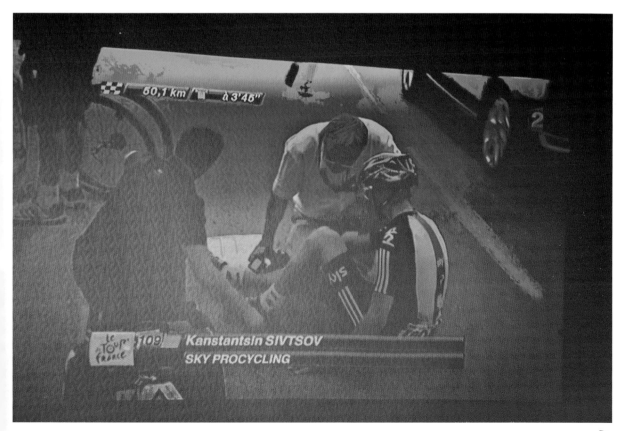

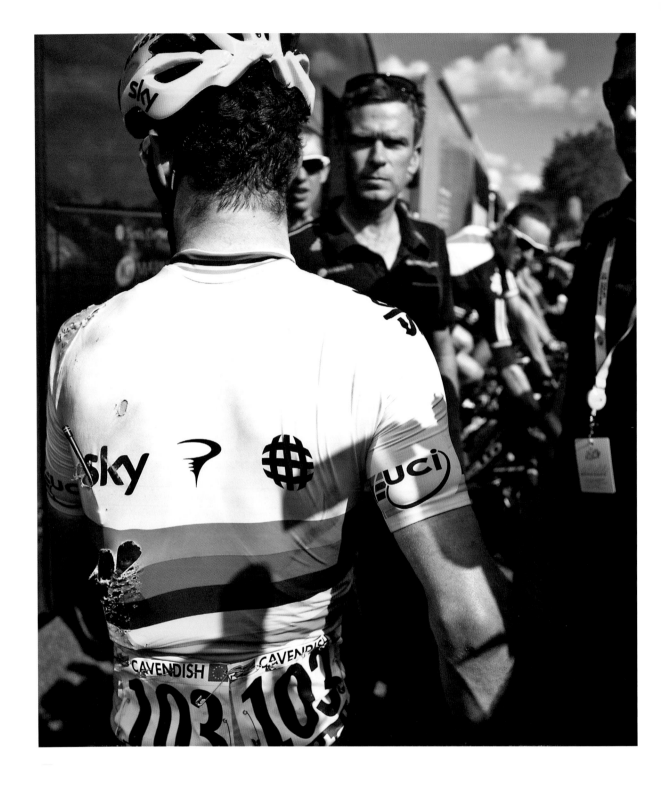

STAGE 4

Day five began with one man down, but Wiggins still safely tucked seven seconds behind Cancellara in the overall standings. The long, flattish road to Rouen had a Cavendish victory written all over it in the morning, but by mid-afternoon the sight of a tarmac-stunned figure in a torn, grubby rainbow jersey told a different tale. Cavendish had been gunning for a 22nd Tour stage victory, but at 2.7 kilometres from the finish he and Eisel were brought down hard in a mass pile-up. Both got back on their bikes and crossed the line, but the world champion was left to rue a missed opportunity, exacerbated by having to watch former team mate André Greipel – who took the honours by a bike length – do the victorious media rounds.

You could see anger and stunned disappointment in Cavendish's body language, while Bernie seemed disorientated. 'They're not happy. There was a fair bit of bad language because it was a chance missed at a win,' reported Yates.

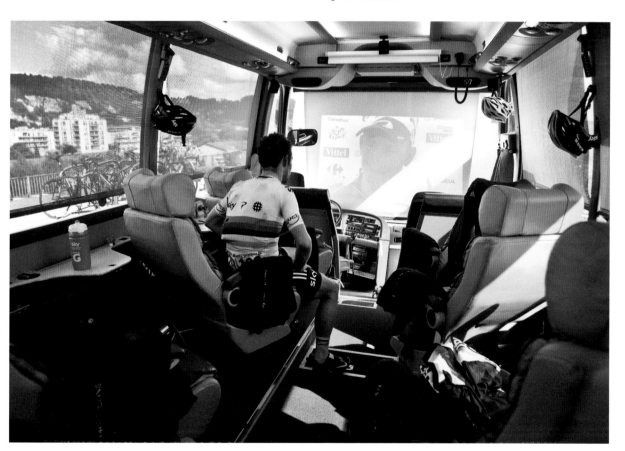

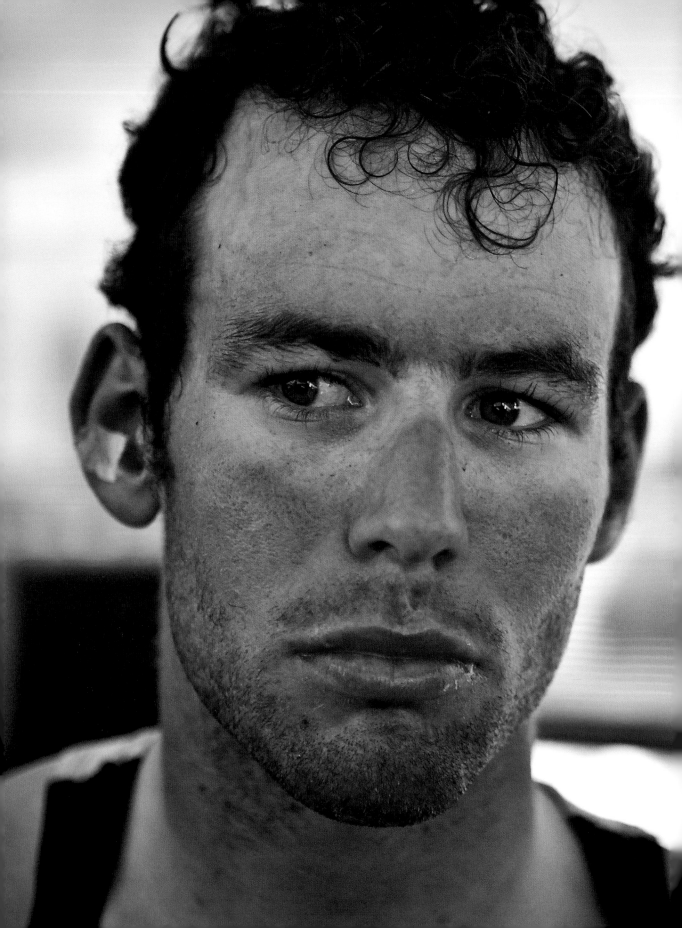

'I definitely remember the crash. I was the first rider down. I hadn't gone down in a bunch sprint for five or six years, and I know why – it really hurts!' Eisel recalled. 'We were going 70km per hour, downhill, I was under Greipel's wheels and we were being swamped from behind and ... no one was to blame. There were just too many sprinters in the same place at the same time. Suddenly I was just a passenger on my bike. I remember hitting the deck and rolling and being hit and kicked from behind, praying, "Please let it stop". Then I felt a warm liquid on my face and realised that was blood. I took my helmet off and thought it couldn't be that bad because I didn't have a headache. Cav was straight there, screaming at me, but everybody was ok. Just skin off...

'We had to take more risks than usual, but we knew that. I was in my usual role for Cav, but it was more complicated in this race because there were two aspects to my job: I was there to support Brad and the boys because our goal was the yellow jersey and I was thinking of where

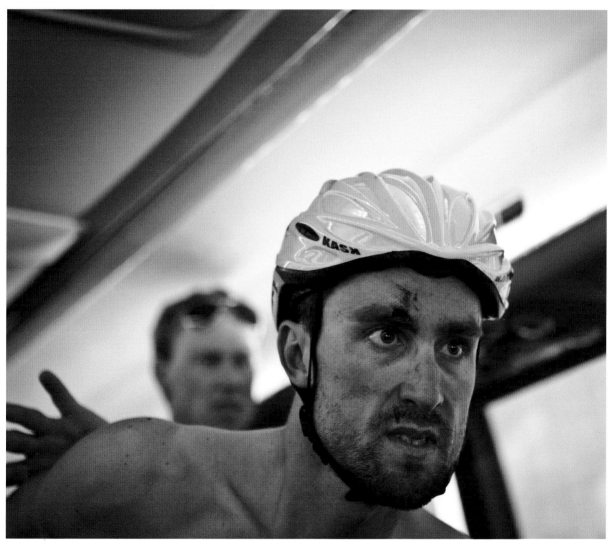

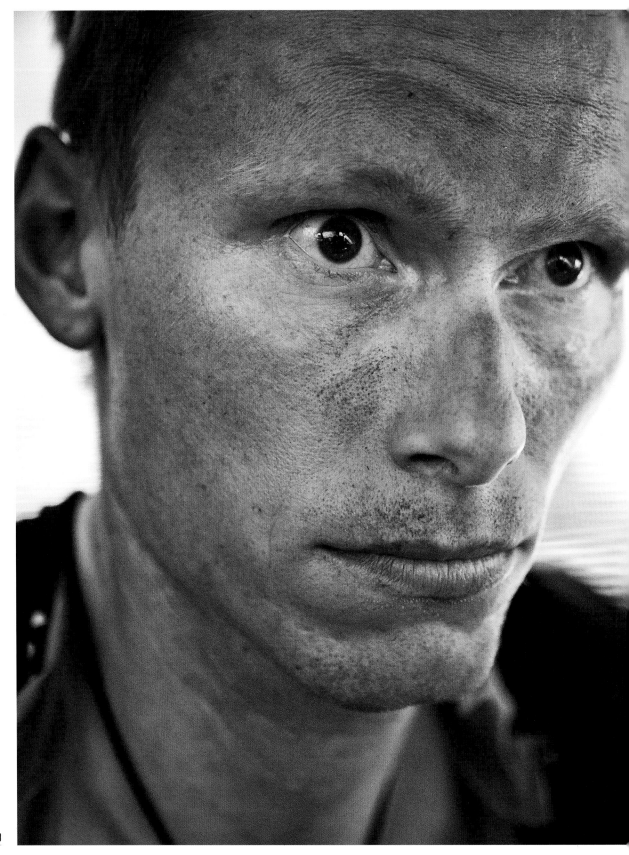

I had to deliver Cav. I'd work at the front, and then go back to Cav, giving him my all in the lead out, keeping him out of trouble. Beforehand I thought I could do more for Cav, but it was really impossible. We were both new to Team Sky in 2012 and when we met up in Liège for the Tour after a successful summer, the expectation was high. For me, the biggest thing I could ever achieve in my sport was to help win the yellow jersey. I remember sitting there, just me and Cav, saying, "Ok, a new world!"'

Christian Knees was probably more relieved than anyone to know his team leader had safely made it to the end of another day without losing time to his GC rivals. At 1.94m tall and 81kg in weight to Wiggins's 1.90m and 69kg, the German is the perfect protective shield. 'When I was a junior, someone said to me after a race, "Behind you, I got the slipstream of a truck!"' joked Knees. 'My role was to stay with Brad, hold him out of trouble and ride in front to protect him from the wind. It's all about saving energy for Brad. I don't care about my energy or where I finish.'

Yates had identified Knees as the ideal right-hand man for Wiggins. 'In order to turn the time trials into killer blows, we needed to help Bradley save as much energy as possible,' he said. 'It was glaringly obvious Knees had to come. I pushed for it from day one. He knows what his job is and he gets on with it. After Kosta was out, he stepped up and had to ride in the easy mountains too. His job was to kill the lesser troops, mind the cause, gauge the feelings, look ahead to anticipate any circumstance that could arise, and he did it in the most efficient manner day in, day out.'

Christian Knees. Wiggins's right-hand man. Age: 31. Nationality: German. Career highlights (as of eve of 2012 Tour de France): German road race champion (2010).

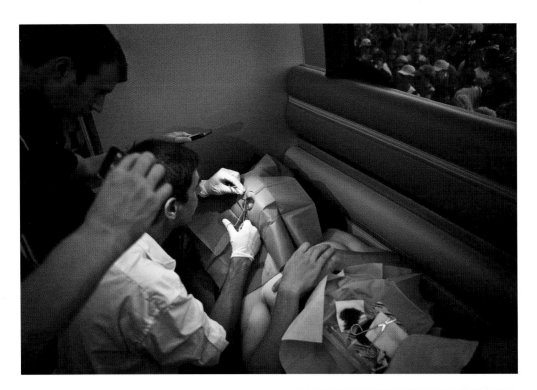

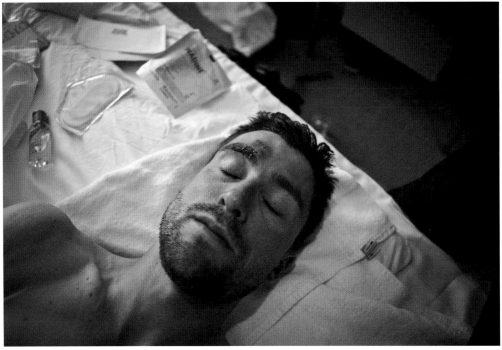

Knees relishes his role: 'I had my chance to go for my own results in the past. I accept that I am a good rider, but not a Top 10 or a Classic winner. As a domestique, I am one of the very best and that is my motivation. It's a team sport and if you have someone in your team like Bradley who is able to win, it makes everything – from training hard to racing – so special.'

For a bruised and battered Cavendish and Eisel, the end-of-day business of showering and changing was painful. Oblivious to the milling fans outside, the 'office' area at the back of the bus became a temporary operating theatre. 'The stitching above the eye was the smallest thing,' says Eisel. 'The shoulder and elbow were worse. I hurt for five or six days. For the first four days I couldn't raise my arm. Every morning you wake up, your muscles are cold, and it hurts so much. I'd look at the bruises on my hip and think ... oh why did I crash? But it's the Tour. You keep going. I've been in cycling for 12 years, I was telling the others, trust me, after three weeks of this intensity, you won't even remember which year you crashed – this year, last year ... Crashing is one thing, but water is the worst. Taking a shower with raw skin ... You really don't want to go in there. The first 30 seconds are agony.'

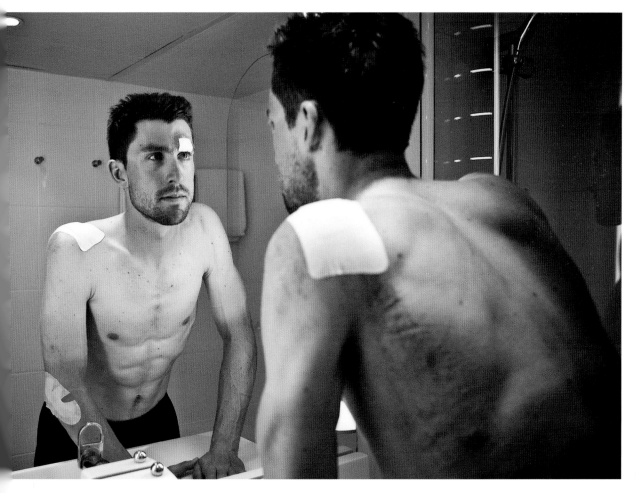

STAGE 5

It was the morning after a late night for the mechanics. After their crashes the day before, the bikes of Cavendish and Eisel both needed to be re-built – a rigorous process which kept the mechanics busy until the small hours. 'The riders are all very easy-going and we have a great relationship with them, but we are aware we have a huge responsibility,' said mechanic Rajen Murugayan. 'When a rider comes back for his bike, it must be 100 per cent ready to go and 100 per cent how he wants it set up.'

The mechanics can have the longest days of anyone in the Team Sky travelling circus. An average day starts at 6am, although it can be a lot earlier if the team have a particularly long transfer from their overnight hotel to the start line. (One stage in the third week involved a 450km journey!) Their first task of the day is to prepare the bikes and put them on the car. Each rider has one race bike and two spares, plus two time-trial bikes. With the full complement of nine riders, that makes 45 bikes. Turbos also have to travel for the riders to warm up or warm down on after the race.

'On a Grand Tour there are four mechanics: two who go to the race – one travels in each race car with the sports directors in case of any incident – and two who go straight on to the next hotel to set up ready for when the riders come back,' explains Murugayan. 'The team has 14 vehicles so we help drive and find a good parking area at the hotels. We take more than 40 suitcases from the truck into the hotel and distribute the bags to the right rooms. Then we fix up water and electricity, which we need to wash the bikes and cars. Our mechanics truck is like a Formula One team's mobile workshop, everything in order, ready for us to work quickly. We follow the race on the TV in the truck so we can estimate the time the transfer will take back from the finish to the hotel – an average of 60 to 90 minutes.'

After a tough stage which started in Rouen – once the capital of a Gaulish tribe known as the 'Velocasse' – the mechanics were hoping the riders would not return with any *vélos cassés*, or broken bikes. In fact Team Sky had moved up inside the final 30 kilometres to take control of the bunch for the first time in the race and were well placed to avoid the late crash which dashed the hopes of many of the sprint contenders. The bikes came back dusty and grimy, but still in one piece. Ditto the riders. Another day down, another day closer to the mountains.

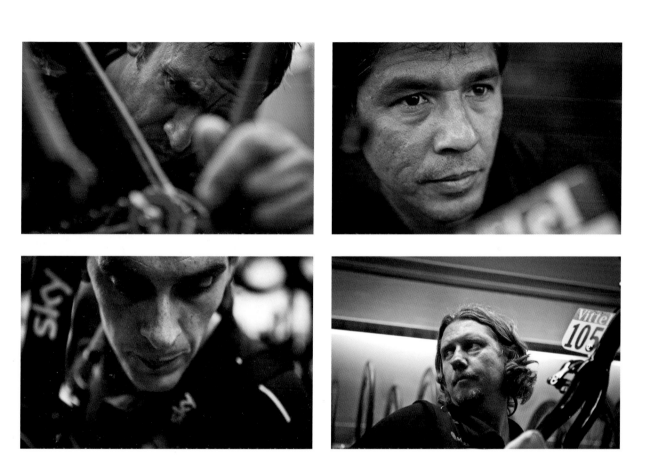

Team Sky mechanics (clockwise from top left): David Fernandez, Rajen Murugayan, Gary Glem and Diego Costa.

At last, it was the final day before the race hit the hills where Team Sky planned to 'put the hurt on the rivals and open up the gas on the climbs'. In theory it was the last charge of the sprinters for a week or so, but, to Cavendish's chagrin, the management did not want to risk the yellow jersey. His instinct urged him to duel with Greipel, Goss and co, but a puncture put him out of the picture. Froome, Eisel, Knees and Rogers were all towards the front protecting Wiggins, while Porte crashed three times and Boasson Hagen was caught up in one of the day's string of crashes. No one could stop and take him up. The team, privately mindful that it was at about this stage last year that Wiggins crashed out, wanted to tick this day off and safely reach the end of a crazy, fraught week. It represented a psychological milestone.

'I usually win an average of five stages on a Tour de France, but I had to take a back seat,' a rueful Cavendish said later. 'The yellow jersey is the most iconic symbol in sport. That was the team's goal, and it had to take precedence. It was difficult for me because I'm not just any rider, I wanted to do the rainbow jersey proud. Our sport is unusual in that you get to represent a jersey for a year. It's a big, big honour, and I wanted to do it proud every single time I wore it.'

STAGE 6

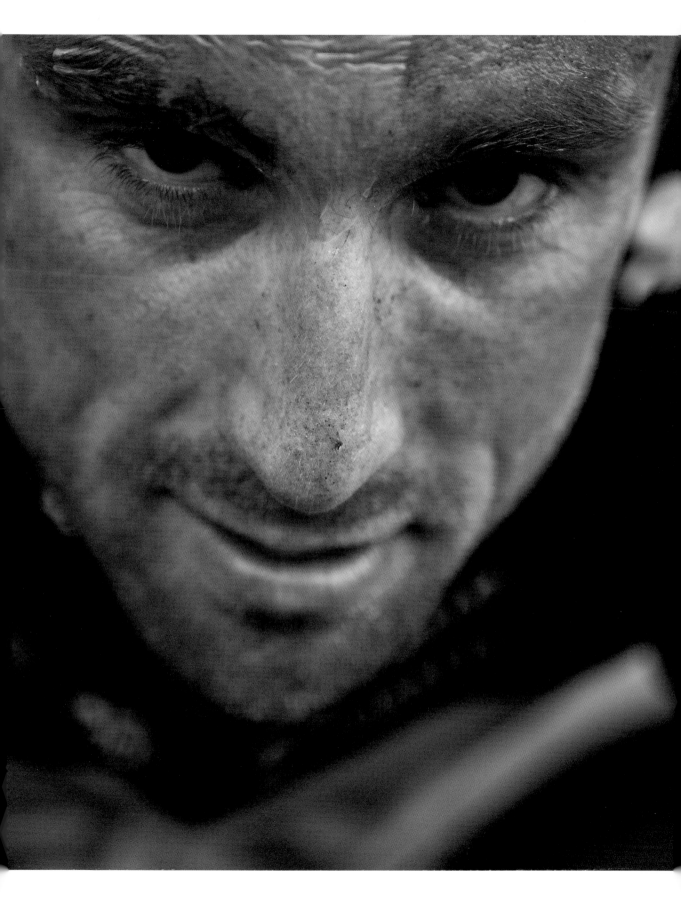

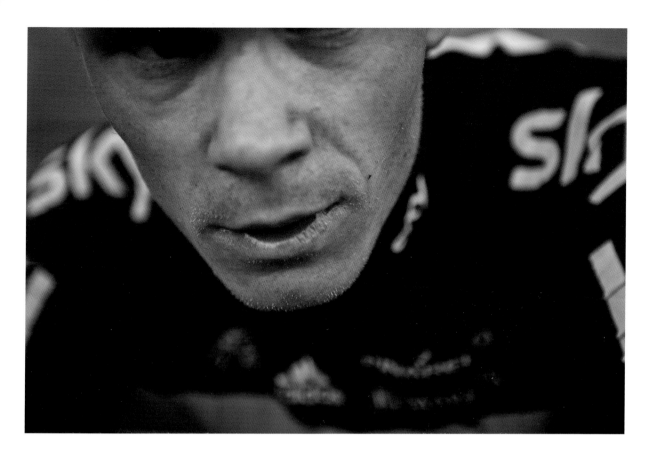

When the 2012 Tour course was published in October 2011, Brailsford and Yates saw it played nicely into Wiggins's strengths. 'The courses tend either to have a lot of hard climbs or a mix of hard climbs with a significant number of time-trial kilometres like this year's. On paper, if we were to create a course that would best suit Bradley, this would pretty much be it,' conceded Brailsford.

'Bradley hates the first week,' said Yates. 'It is not a matter of being nervous in the flatlands, more about wanting to get this week out of the way, to get into the mountains and start showing what we could do.' Eisel – who Cavendish prizes as a 'really clever bike rider' – was a great asset in the first week's mission of looking after Wiggins. Primarily Cavendish's helper, he had proved to be a valuable team motivator in the 'kill-or-be-killed' jostle of the flatlands. 'This year was the first time I'd worked with him,' said Yates. 'He's a strong, experienced rider, but it wasn't a given that he would be taken because of his form. As it turned out he rose to the occasion, rallying the troops and working hard for the team. Bradley spoke up at team meetings saying how great it was to have Bernie there.'

Safely protected by his team mates, Wiggins escaped the drama of a horrendous crash. 'In a split second everything changed and all hell was let loose. Five minutes before that crash happened, Brad came right up to the front with Christian and it was one of the best moves he's made so far,' said a relieved Brailsford.

Chris Froome. Future Grand Tour contender. Age: 27. Nationality: Kenyan-born British. Career highlights (as of eve of 2012 Tour de France): 2nd overall and a stage winner in 2011 Vuelta a España; 3rd overall in Tour of Beijing.

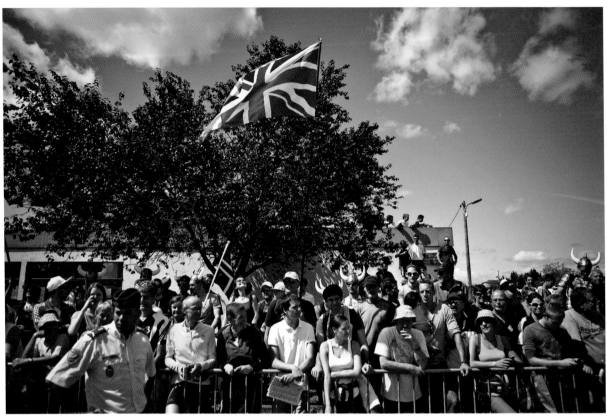

Into the mountains. The appeal of man and bike taking each other on over Nature's steepest challenges always brings out the crowds. The riders set off down a tunnel of thronging spectators who lined the pavements of Tomblaine ten deep, climbed onto walls and vehicles and leant over balconies and upper window ledges. The peloton worked up the climbs with a blur of flags in their peripheral vision – Union flags (who would have thought that a few years ago?), Norwegian and Australian flags, the odd Viking helmet or silly wig, and all manner of yellow shirts. Fans cheered, pointed cameras and mobiles, and clutched *L'Equipe* or binoculars. It is a big event when the Tour comes to your neck of the woods.

This was the stage Team Sky were most nervous about; they had dominated stages like it in smaller races in the run up to the Tour, but this was the real testing ground to see if the team really could perform on the biggest stage. Stage 7 was set to finish on the summit of a 'new' mountain – La Planche des Belles Filles. Sean Yates had recce'd it earlier, as he had all the stages he thought might pose problems. The riders had studied the profiles, talked through tactics and responses to potential scenarios, and clarified their roles. All that was left to do was turn a pedal.

Saturday 7 July had been earmarked as an important day. With Cancellara, the time-trial specialist, leading by just seven seconds, the yellow jersey was up for grabs. This is where the Team Sky plan had to be executed to

STAGE 7

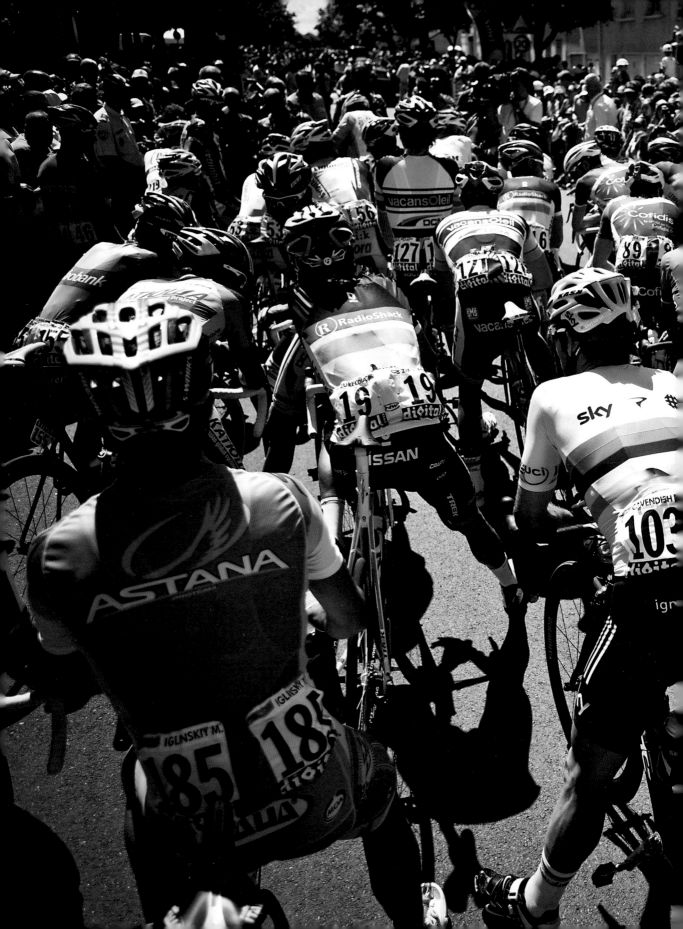

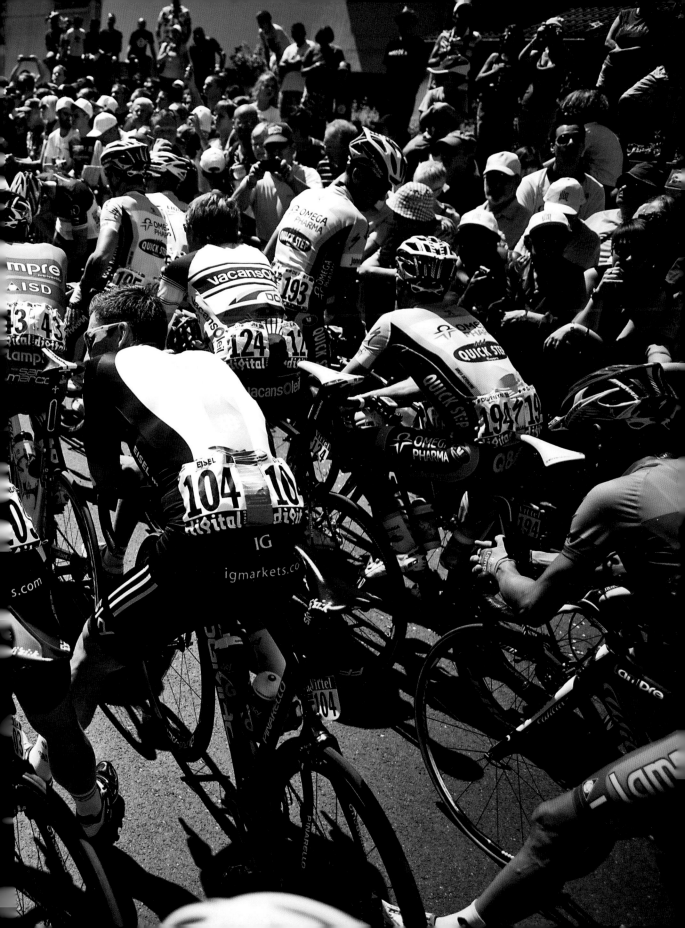

First day in the mountains, last day in the yellow jersey: Fabian Cancellara, the Swiss time-trial specialist, loses the lead in the overall standings to Bradley Wiggins.

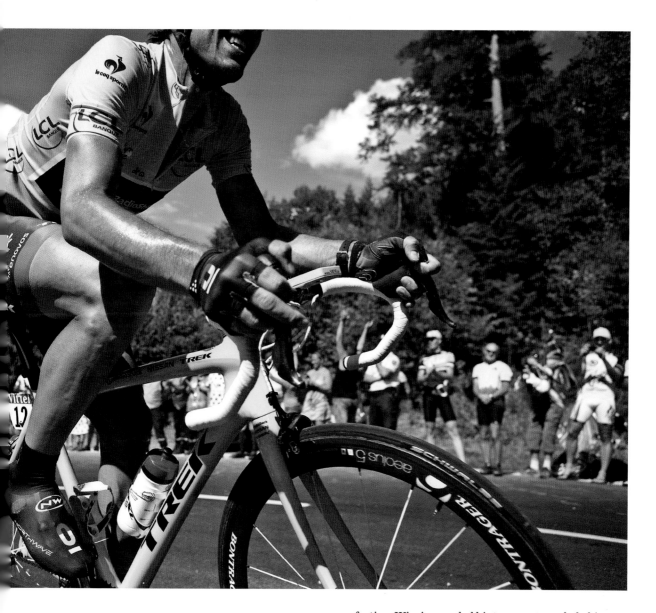

perfection. Wiggins needed his team mates to help him hit the climbs in the best position. Coming into the foot of the 5.9km climb, Boasson Hagen took up the pacesetting at the front of the peloton with Rogers, Porte, Froome and Wiggins right behind him. The pace was fierce, and the 8.5 per cent average gradient soon helped to split the bunch in two. By the time it was Porte's turn to pull at the front, the leading group had been reduced to just eight ... and then five. Defending champion Cadel Evans, star descender Vincenzo Nibali and Rein Taaramäe were the only ones with legs left to stay with Froome and Wiggins. When Evans accelerated with one kilometre to go, he couldn't shake Froome, Wiggins and Nibali, and Froome darted for the line to take his first Tour stage win.

'The finish at Belle Filles was one of the highlights of the three weeks for me,' said Porte. 'Everyone saw Sky was there. We meant business. The whole team played a part.

It was the first day in the mountains and we all knew then we could win the race. It was a special day, pure satisfaction,' added Eisel. 'I was riding with Christian Knees and we brought the big guys to the bottom of the climb. I'd done my job, delivered the guys, and took it easy up the climb. When I got back to the bus, the guys said, "Froomey won and Bradley's in yellow!" We watch the end of each stage on the TV on the bus on the way to the hotel, and I saw the other guys flying up the climb. It was incredible. Cadel attacked and Froomey chased and outsprinted him. There was a magical shot as Froomey comes over the steep climb alone and behind him is just blue sky ... beautiful.'

It was the first time Team Sky had led the Tour de France. They had three riders in the top 10 of the GC: Wiggins, Froome in ninth, Rogers in 10th. 'It is an incredible feeling to have done what we've done,' said Wiggins. 'It sounds corny but this is something I've dreamt of since I was a child – sat on the home trainer in Kilburn watching my hero Miguel Indurain do it. Those dreams have now come true and I'm sat here at the top of the mountain in yellow. It's phenomenal. I'm chuffed for Froomey, because he had some bad fortune last week, but now he's got his stage and he's going to be an integral part of me winning this race. I've survived a very, very manic first week and I'm just very pleased to be in yellow.'

The milestone moment was felt throughout the team. Back at the hotel, the mechanics waited to greet the man whose bikes they prepare with a congratulatory hug. And then, after the performance he'd been training for all year, it was the normal routine for Wiggins: massage, dinner, then back to his hotel room to reflect on that yellow jersey that lay folded, ready to wear the next day.

'It's a dream come true. I'm chuffed to bits. It wasn't the plan to go for the stage but I'd seen the finish before and I thought "I've got the legs" and I gave it a small nudge.'

Chris Froome after his first Tour stage win.

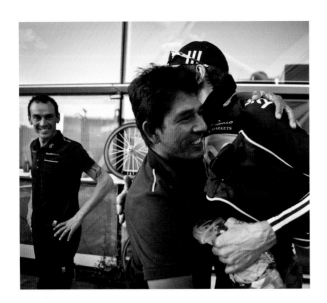

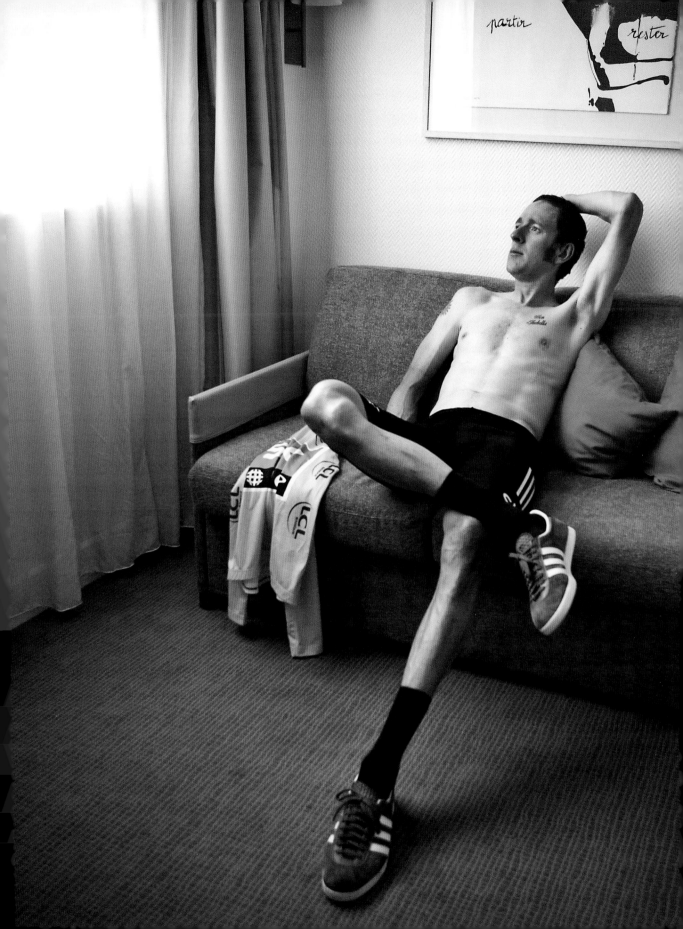

'It's a fantastic position to be in after the first week and two tough days down. Now we have the time-trial and then a rest day, so it's certainly some of the toughest stages ticked off.'

Bradley Wiggins

STAGE 8

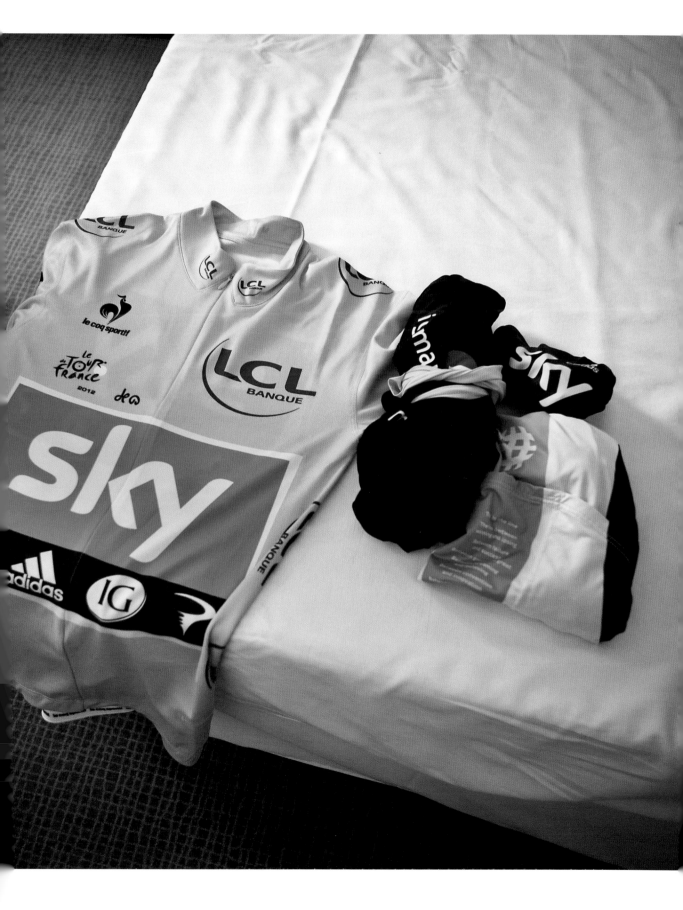

To wake up and see the yellow jersey at the foot of your bed sounds like Christmas – but not to a Team Sky rider immersed in the Brailsford mantra: 'You don't think about the outcome. You don't think "what if I win?", "what if I lose?". You focus on the process, and deliver that focus on an hour-by-hour, day-by-day basis. You try to remove the emotional thinking and go into logical mode.'

Yes, it was day one for Wiggins in the yellow jersey, but there were still 13 more days to go. The hard work to defend the coveted jersey was about to begin. 'From then on, everyone in the team was a helper – Bernie, Christian, even Cav would go back for water bottles on warm days or raincapes when it was wet,' noted sport director Servais Knaven.

For Wiggins, it meant more pre-race attention, chaperones to take him to the start line, podium presentations and post-race media duties, which in turn meant not travelling back on the team bus but returning in the car with Knaven and a carer. Becoming the 'star' can be isolating. His public demeanour may have looked pensive with the responsibility, but inside the haven of the team bus he was the same Brad, the remorseless mimic. 'He was often hilarious, our comic relief every day,' said Porte. After all, he was used to this business of leading stages.

As Brailsford says: 'Bradley's matured. When he's in the zone, he becomes very focused. He's tried different things over the years. He's pieced it all together. He understands what it takes to deliver. When he is in that focused state, he can seem aloof, but he isn't. He's ... remarkable.'

The order in which the Team Sky train would work was this: Knees and Eisel pulled at the front on the flat, then Boasson Hagen put in his turn, followed by Porte, Rogers, Froome and Wiggins as they progressed towards the final ascent. In the mountain stages, Sky very often still had four or five riders, when other teams were down to only one or two. Clearly all the team members were in superlative condition.

'The way we work is to analyse the demands of the event and work back from there,' explains Tim Kerrison. 'And events vary greatly between different races and also from year to year, so next year's Tour will have different demands to this year's. We analyse the performance capabilities of our riders, and then tailor the training programmes around prioritising the development of the areas where the riders are in most need of improvement. This is a year-round process which will start in the early season training in November, December, January – including the team camps in Mallorca in December and

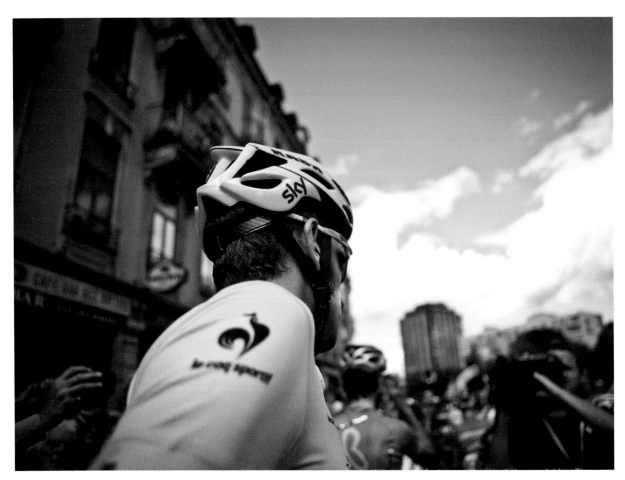

January – but will continue throughout the season. With the Tour group we tried to structure the racing season to have bigger in-season training blocks between races, and it was in the training camps that we held during these blocks that a lot of the really intense, specific training was done. For Brad, one of the many areas we worked on was developing his explosive power.

'This year our two lead riders were the strongest two time triallers (Brad was first and Chris came second in both long time trials), and they were the strongest two climbers. In terms of physical condition, this requires the ability to maintain a high power output for a sustained period for time trialling, and a high power-to-weight output for a sustained period for climbing. So the primary aim of our training was to increase the guys' ability to maintain a very high power output for up to an hour, whilst maintaining a low body weight and lean body composition. Aside from Brad and Chris, the rest of the team were also in great condition such that they were able to provide support long into every stage.'

The first day in yellow was tough, but at the end of it it was job done. 'The boys were incredible again today and really marshalled the race,' said Wiggins. 'They set us up to be able to go with the others on that last climb.'

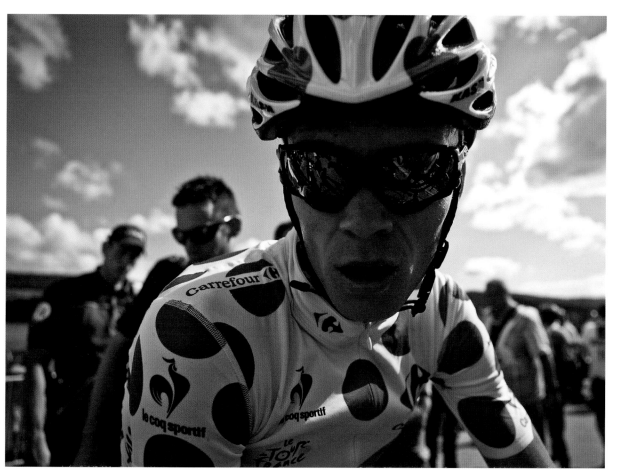

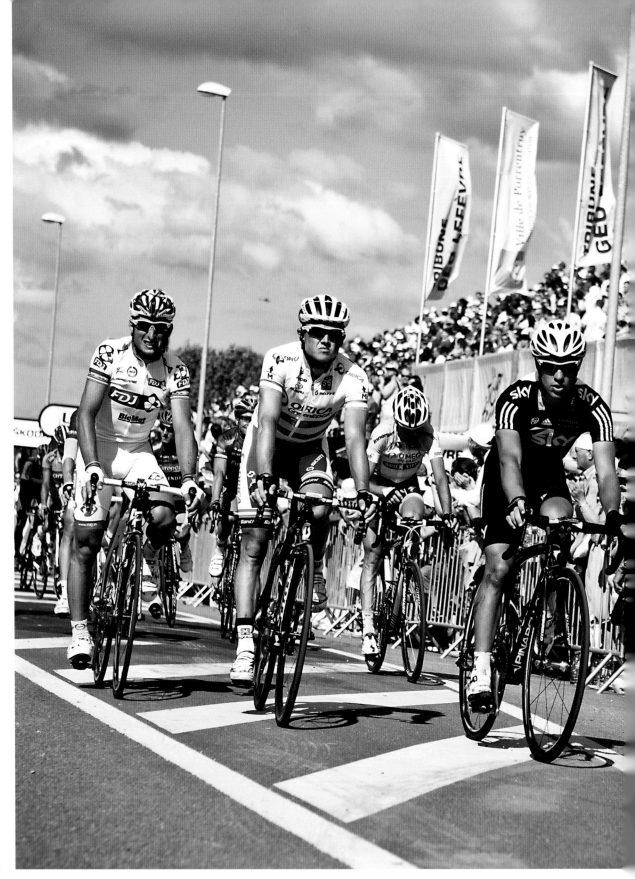

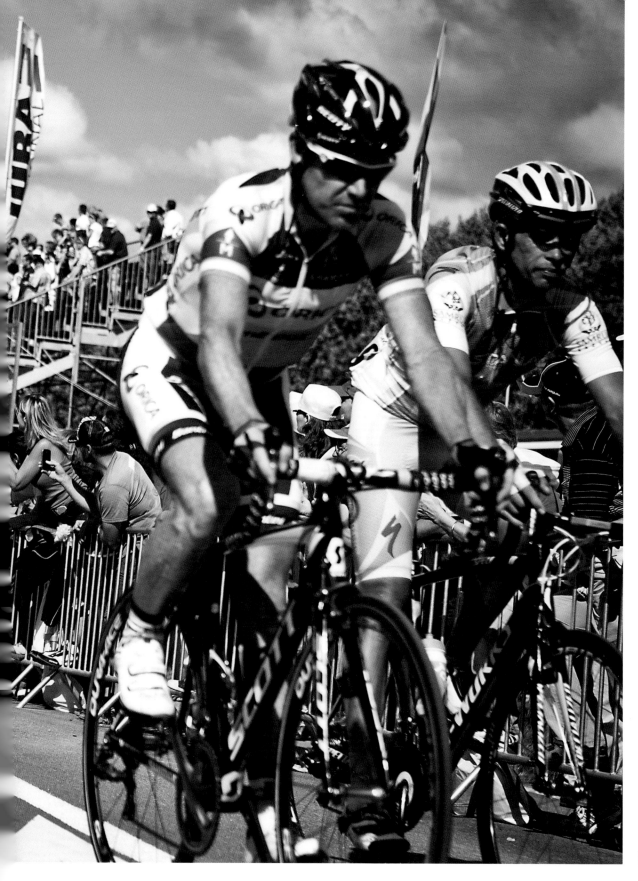

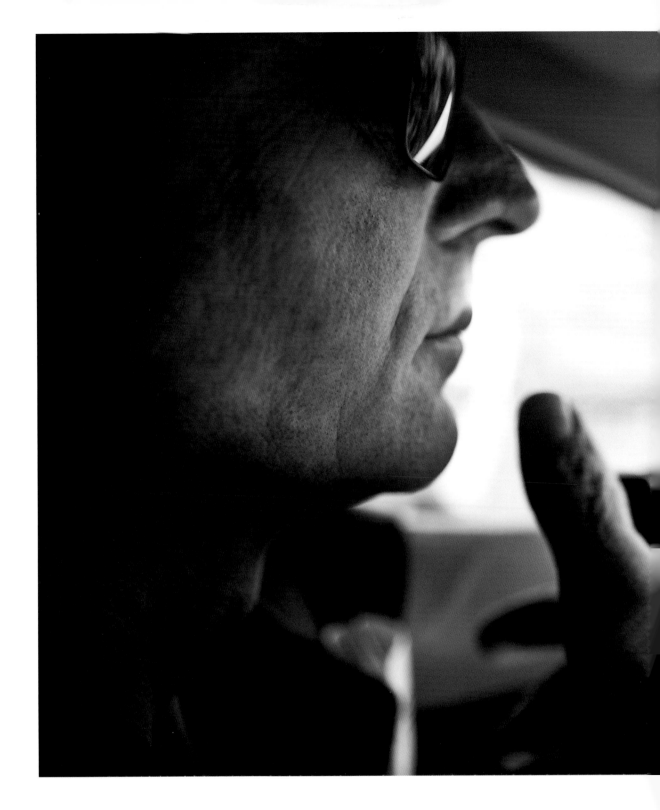

STAGE 9

In his role as head sports director, Sean Yates is familiar as the figure in the race car, on the radio, talking tactics. 'My job is to look after the team on the road, most obviously the riders and how they ride the race, but also the masseurs, mechanics, bus drivers, physios, doctors and so on, making sure the team is operating harmoniously. I'm like a foreman on a work site, making sure everyone is towing the line, not cutting corners, all working towards the same goal – to be the best of our ability. I function through intuition. I don't always say a lot but my head is always working, assessing the mental and physical feelings of the riders, seeing the big picture.'

In the overall game plan, the first long time trial – 38 kilometres from Arc-et-Senans to Besançon – was where Wiggins was planning his first killer blow. The team were working hard to save him as much energy as possible so that he could blast his GC rivals on the twisty riverside route. Resplendent in his yellow skinsuit, he went out to do what he does best: he knew he would suffer, he knew it would hurt, but he focused and executed brilliantly. It's not easy to maintain a consistent pace; as Froome acknowledged, 'It is good to know you are on track for a good time, but you have to be careful you don't overcook it. It's a fine line to gauge that effort.'

Wiggins and Froome stormed to a Team Sky 1-2 as the team notched up its third stage victory – and Wiggins claimed his first Tour de France stage victory. It was another emphatic display. It had never been done before in British cycling, but the team viewed it as a repeat of what they've been doing all season: taking it day by day, treating the Tour just as they would any other race.

'This is what we've trained for. Sean was saying to me on the radio in the last 10km – "think of all those hours, all those sacrifices you've made" – and this is what that was all for and that really motivated me,' Wiggins said. 'All the hard work during the winter, missing my children's birthdays, being on training camps and things. This is what it's all for – these moments. I didn't set out for the stage win, it was a battle for the GC, but to get the stage win is a bonus. And that's fantastic as well.

'We're nine days into the Tour now and there were two tough stages before today. Everyone was tired last night and you never know how you're going to recover. Time-trialling's what I do best, though. I get into my zone, know exactly the routine I have to go through during the stage and I felt great today. The minute I turned the first pedal stroke on the warm-up I felt fantastic so I knew I was on a good one.'

For Yates, his protégé's time-trialling prowess would be one of his Tour highlights. 'I live my dreams through Bradley's legs. We think alike. I understand him. I can relate to him really, really well. I may be in the car, but I can imagine just what he's feeling, what he needs. That feeling is growing all the time into a unique bond. I'm not the most open of guys, and neither is Bradley. I know he doesn't want to mess around with his kit, his bike, whatever. If your goal is to get the best out of yourself on a bike, everything else detracts from that. You have to be uncompromising. Love it or be tormented by it, or something in between. You have to know what you want, have it straight in your head.

'A few years ago I was frustrated by the way he was going about his business. He has always been a fantastic athlete but he was not delivering to the best of his ability, but it all came together. Tim Kerrison helped him realise what he wanted and what he needed to do in order to achieve that. And Bradley became calm in himself.'

Bernie Eisel. Cavendish's experienced wingman. Age: 31. Nationality: Austrian. Career highlights (as of eve of 2012 Tour de France): 12 Grand Tour appearances and a host of stage wins.

Richie Porte. Talented climber and time-trialler. Age: 27. Nationality: Australian. Career highlights (as of eve of 2012 Tour de France): Race leader for stages 11–13 and winner of young riders' classification in 2010 Giro d'Italia.

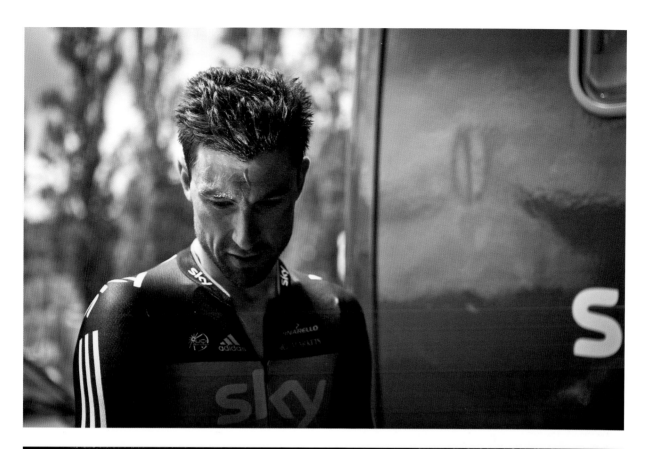

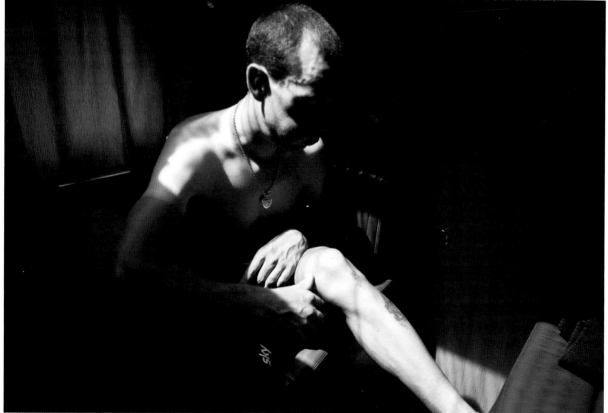

'Time-trialling is what I do best. I know exactly the routine that I need to do. I felt great from the first pedal stroke and I knew I was in for a good one.'
Bradley Wiggins

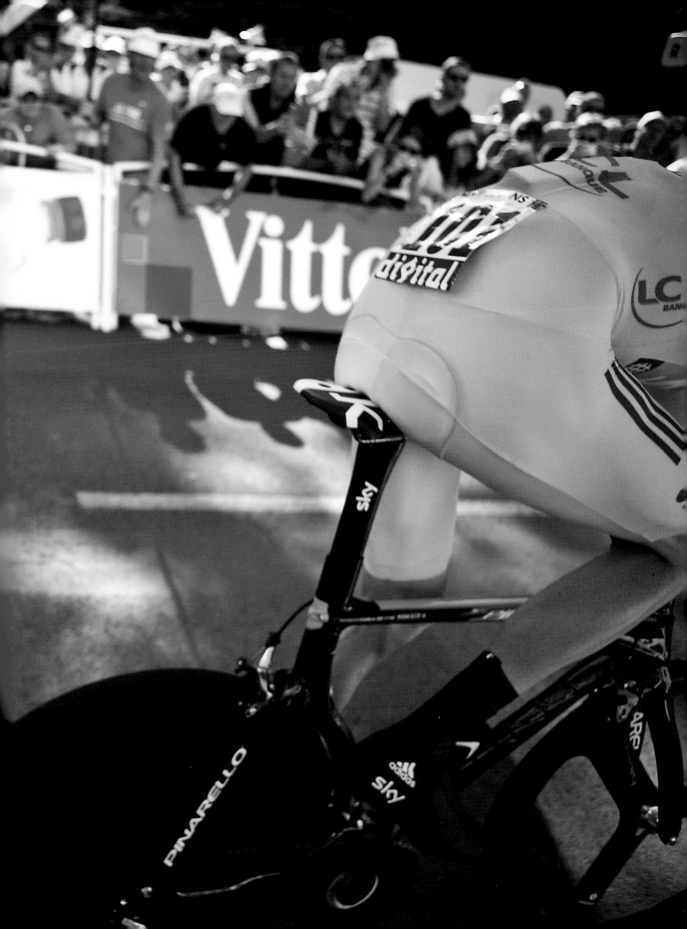

STAGE 10

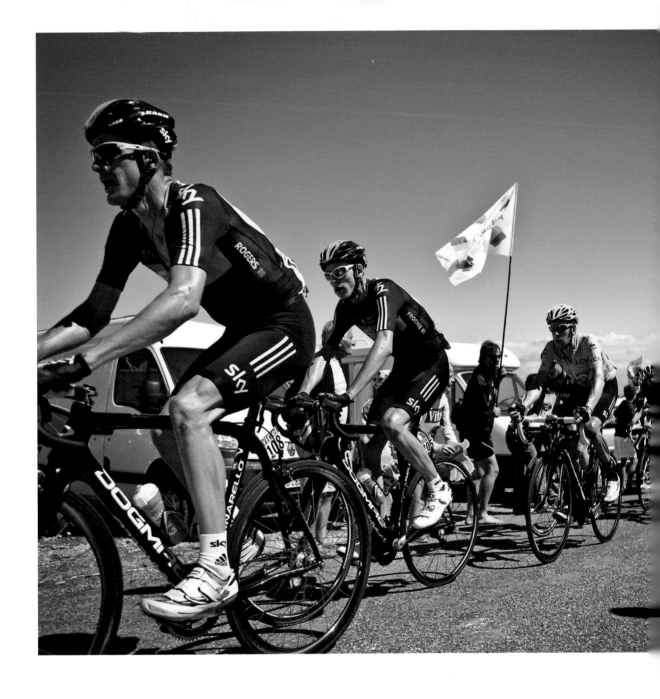

Michael Rogers. Road captain. Age: 32. Nationality: Australian. Career highlights (as of eve of 2012 Tour de France): Nine Grand Tour appearances and three times World Time-Trial Champion.

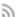

The Tour moved into the high mountains for the first time, with the daunting *hors catégorie* Col du Grand Colombier standing as a test to everyone's response after a rest day. After two tough days in the mountains and a time trial, the rest day between stages 9 and 10 was a welcome recovery window. 'The key is to try to keep the mind relaxed but the body working,' says rider-turned-press officer Dario Cioni. 'A rest day means you are in a hotel for two consecutive nights. Nice! You don't have to pack and travel. Riders can wake up whenever they want, as long as they're ready to go training at about 11 for a couple of hours. They don't want it to be super gentle. Riders aim to put in a few stretches of effort up a climb to keep the body turning ... then they

might have a longer massage and catch up with the team physio.'

Team Sky were quickly back into race mode. 'It is intense, you can't relax,' says Porte. 'There are 200 guys who want that jersey Brad's got and they are prepared to put their life on the line to get it.' His fellow Australian, Michael Rogers, was effectively the road captain, the man who Wiggins would follow without question in the mountains. 'I am one of the more experienced riders, having had 12 years or so at pro level, so Sean and Servais leave it up to me to make decisions quickly. I talk to Bradley, gauge his feelings, assess the situation. We go into races with Plan A and B, but there are so many variables, sometimes you need to respond instinctively. I think tactically how to deploy our riders' strengths, who to use and when. I might ask Christian, a big guy, strong on the flat, to ride at the front, or tell Richie, smaller, a good mountain climber, that it's time for him to set the tempo.

'For us, the first week was about survival and emerging unscathed; the second week was about showing our stuff in the mountains and moving into the lead. We would literally tick days off. Collectively we'd had a very successful 2012 season, determined by Bradley's amazing wins, so we came in with high morale. We felt we could come to the Tour and perform better than the others in the peloton. We were looking forward to getting out there and showing the world what we could do. What made the difference? Our teamwork. Everyone bought into their roles. When you have a good leader like Bradley, and you see the work you do contributes to his role, and he can attain results because of your work, everyone buys in.

'The psychological turning point came on the top of the legendary Col de Joux-Plane in the penultimate stage of the Critérium du Dauphiné at the start of June – the last race before the Tour, which Bradley won and I came second. The Joux-Plane is one of the steepest climbs in the Alps, and one of the hardest in the history of the sport – 11.4 km long at an average gradient of 8.4 per cent, although much of the climb hovers around the 10 per cent mark. We put in a strong performance over this mountain. When we saw there were four of us – Bradley, Froomey, Richie and myself – together at the top of the ascent, we knew we had pushed up another level and that gave us a lot of confidence to bring into the Tour.'

So when Nibali attacked on the descent of Grand Colombier, Team Sky did not panic. They simply rode hard on the next climb and got him back. No problem.

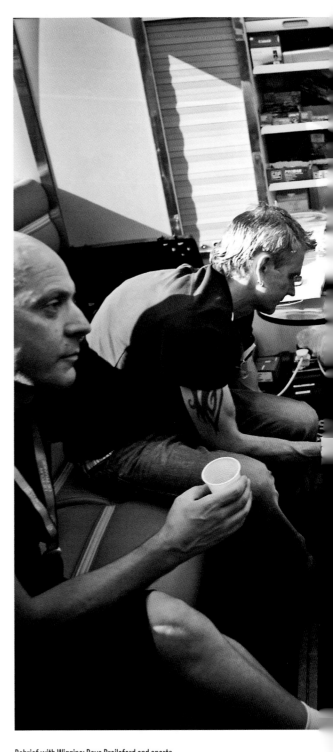

Debrief with Wiggins: Dave Brailsford and sports directors Sean Yates and Servais Knaven listen as the Team Sky leader airs his post-stage views in the meeting room at the back of the bus.

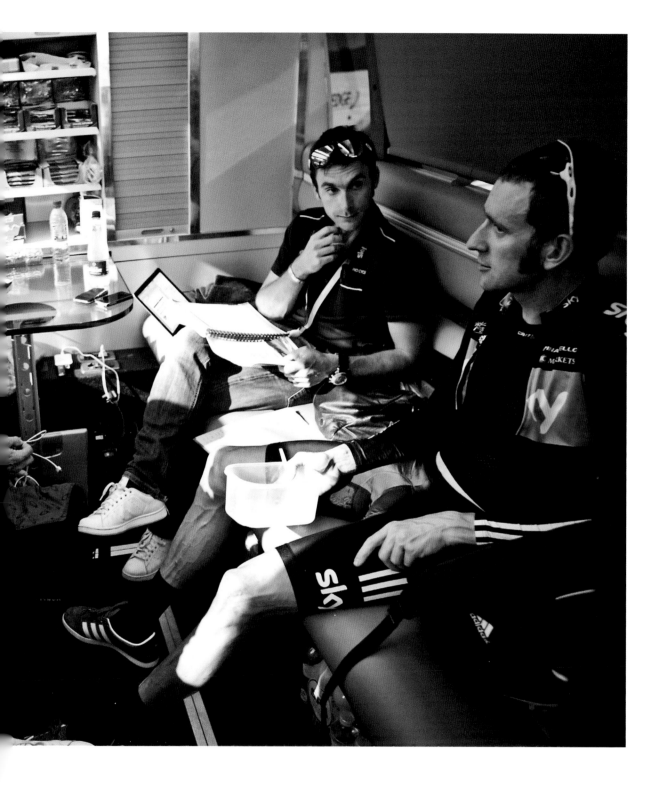

STAGE 11

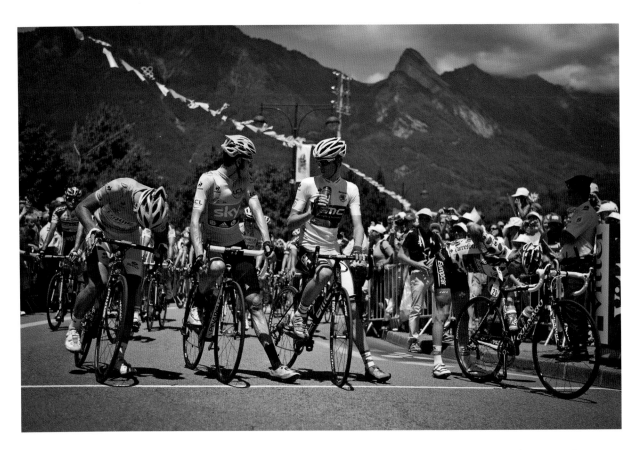

On paper, it was short on kilometres; on legs, it was tough. The first stage in the Alps featured two *hors catégorie* climbs and ended with an 18km category one ascent, but this is what the squad had been training for, and with massive turns from Rogers, Porte and Froome, they duly repelled attacks from Evans and Nibali – taking a surprising chunk of time off the defending champion – and ended the dramatic day's action with Wiggins and Froome first and second in the overall standings.

The mountains are exhausting for everyone, but the satisfaction gleaned from each day playing through the lower gears is enormous. Cavendish took a back seat and entered the spirit in domestique mode. 'It was nice to do my bit for the team, collecting bottles and raincapes,' he recalled. 'I was just around to make the time cut and it's tougher when you're not riding your hardest to win, just to survive. It's a difficult mindset to get into, but I was fine.'

After Kosta's departure, Eisel and Knees – workers on the flat – had to take turns pulling at the front during the early mountain stages and relished the extra challenge. 'I was enjoying the mountain stages more than ever before because Cav was going well and also because it was very special to be riding at the front, leading a peloton with the yellow jersey,' said Eisel. 'When I look back, I see I was able to give more because we had the yellow jersey. Riding to defend it is energising, motivating. It's always a good feeling when you're leading your team at the front, but

when it's the Tour de France, it's amazing. Every day you suffer, and suffer again, but for the honour of defending the yellow, you know why you're putting yourself through it.'

Knees, too, found himself flying higher than before: 'I had to work more in the mountains than originally planned but I surprised myself when I realised how good I was, thanks to our training in Tenerife. When I was getting to the top of the biggest summits, there were 40 guys behind me really suffering.' As Porte said, 'If one guy goes out, as Kosta did, you learn new things about each other. There's always one guy who steps up. You shouldn't single anyone out from guys of our calibre, but Christian was incredible, the equal of five guys himself.'

For Boasson Hagen, who in any other outfit might be team leader, job satisfaction was high. 'In 2011, I won two stages, but this year I knew what I had to do – help Bradley win. I understood my job and I had fun. There were some great stand-out moments for me, but especially when I was pulling hard in the mountains and I heard Sean say on the radio that people were getting dropped ... I'm proud we did so well in the mountains. I'm proud to have done a good job.'

The bus took the exhausted riders back to the hotel, but the vigilance about performance remained. As usual, there was video analysis of the finish so riders and sport directors could see what had happened. From the jumble of radio talk and personal recollections, you hear the

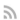
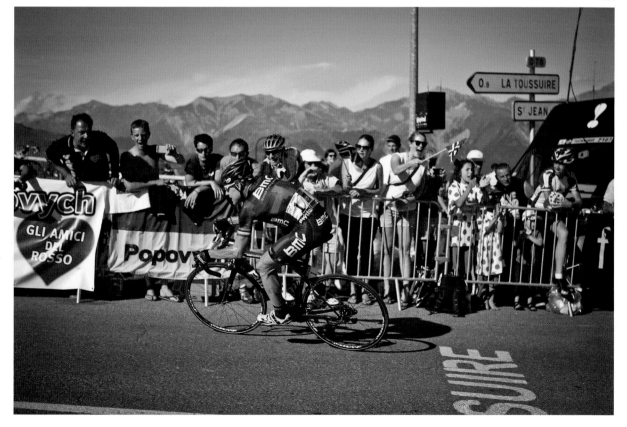

gist of how a race unfolded in the last kilometres, but it's
hard to pinpoint where a good job was done, or a mistake
made. In the mountains, with everyone working all day
for Wiggins, it was an important boost for each rider to see
where they helped and how he was able to finish off the job.

 The result of the stage to La Toussuire was fantastic,
but one person feeling slightly uncomfortable in the
bus de-brief was Froome. As Option 2, he was now very
comfortably in second, benefitting from the work being
put in to assist Wiggins up the mountains. 'We were
playing safe. We wanted to win the Tour and Froome was
a great asset,' said Yates. 'The pulling he did at the front
was minimal so he enjoyed an easy ride. But there was a
glitch. We had a plan for Stage 11. He thought he'd done
what was asked of him, and then was free to go ... but Brad
was unprotected and in trouble. I had to call Froomey
back over the radio. There's nothing malicious about him,
he had just gone off plan. I was pissed off. It put us in a
situation where we had to answer the press, clarify the
mission to the team ... but, as a whole, the day was up
there with some of the best performances I've witnessed
in cycling.'

Another long, long day, with the team operating in their bubble, executing their race plan, ticking off the days. On an average day riders get a wake-up call three hours before the start, unless a longer transfer from hotel to start town necessitates an earlier departure. The timeframe allows an hour to wake, shower, check in with the doctor and eat breakfast. Most conversations revolve around how everyone is feeling. 'Every morning, even though it's chatty and informal, it's all about recovery, feeling fresh, a good night or bad,' says press officer Dario Cioni.

Breakfast and bus travel are the only times all the riders are together, so it is an opportunity for both banter and jokes as well as making plans and exchanging ideas for the day ahead. With bags packed and sent on ahead to the next hotel, the riders and sports directors board the bus. Each rider has his own designated seat, helmet hook, pocket for sunglasses, different weight jerseys, shoes, wi-fi connections. 'My spot is at the very back on the right-hand side. If I don't get it, I don't feel right!' says Boasson Hagen, while Porte adds, 'The bus is our refuge. It's like a second home, a place to chill out. Step outside and you're in the circus.'

The bus is also a workplace where team meetings are held. Precise information about each stage comes courtesy of the race book, an on-screen presentation, videos of previous finishes and Google Earth. Very often race coach Rod Ellingworth has gone a day ahead of the team, got up at dawn and filmed the finish so the riders can see how the barriers are set up in the road, how wide the road is, how tight the turn. According to Cioni, 'The pre-race information we give to the riders is on a level above everyone else. It's part of the Sky philosophy of looking to make tiny gains in every area.'

The riders then have half an hour free to change into their race jerseys, check their clothes kit for the day (lightweight or normal, rainbag for extra clothing), stock up on food and energy gels and opt for sunscreen or, if it's cold, apply oil and warming cream to legs. They try to go together to sign on, with their bikes and an escort, wading through the melee of fans, spectators, photographers and autograph hunters. At kilometre zero, outside the stage gathering point, the race gets underway with a rolling start.

At the finish, the riders are greeted by carers handing out bottles of pineapple juice mixed with water, who also give directions to where the team bus is parked, or inform a rider if he's been randomly selected to go to doping control. 'When Brad was in yellow, he had to attend the presentation ceremony so I'd meet him with a carer and take him to the ASO podium area where he could clean up and change into fresh team kit,' says Cioni. 'After his press conferences, I would drive him back to the hotel in my car which had supplies of food and drink for him.'

On the bus, the riders first have their specially formulated recovery drink, then water, water, water. Half an hour before the estimated finish time, the bus driver switches on a rice cooker. The riders are encouraged to eat

STAGE 12

'The pre-race information we give to the riders is on a level above everyone else,' says press officer Dario Cioni. 'It's part of the Sky philosophy of looking to make tiny gains in every area.'

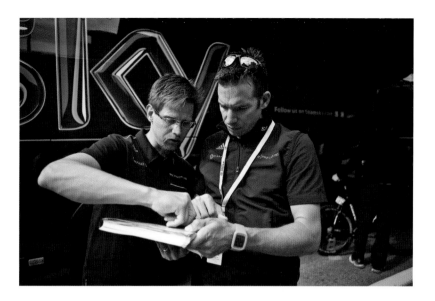

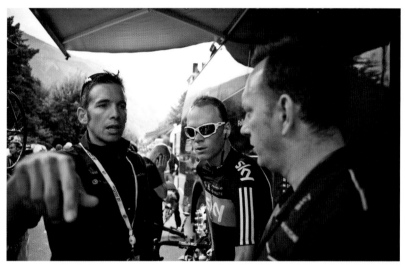

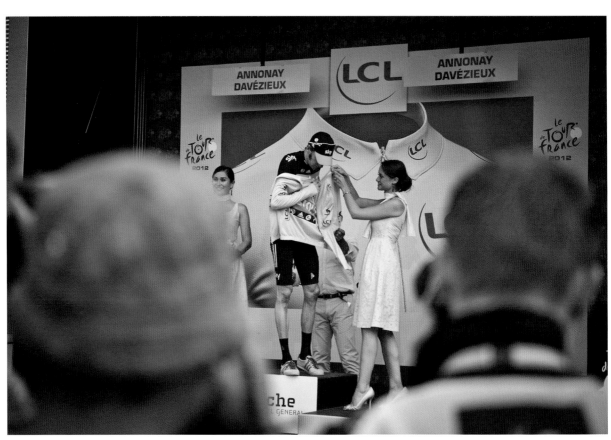

rice with tuna, olive oil and honey. 'Those first moments after the race are important, the body is greedy for carbs and this mixture helps prop up glycogen stores for the next day,' explains Cioni. Unless the hotel is close by, the riders shower and change before the bus attempts to leave the car park. Four members of the team will have travelled straight from hotel to hotel to unpack bags, get room lists ready, deliver suitcases to rooms, fit beds to bespoke mattress packs (individually made for each rider to ensure a good night's sleep). Apart from Wiggins, who rooms alone, the riders chose to pair up: Cavendish with Eisel, Froome with Porte, Knees with Boasson Hagen, Rogers with Siutsou.

Then it's dinner, massage, physio, bed and a call home. 'Mostly Cav and I don't talk at all,' says Eisel. 'I'm on Skype, he's on Skype. There are four people in the room!'

STAGE 13

On Bastille Day, the French riders were out to put on a show while Team Sky quietly got on with the business of keeping Wiggins out of trouble, covering all attacks and executing the plan discussed in the morning meeting which would indulge in some intra-team payback. The idea was to take up the running on the last drag with two kilometres to go and come into the final corner on the front. 'Wiggins found himself in that position with Edvald on his wheel and that was a bit of payback to give him the opportunity for the stage win,' commented Brailsford, after Boasson Hagen had sprinted to third.

'It was nice to see. We didn't win the stage but the important thing was to set Eddy up and give him the opportunity. It was a nice gesture and probably a little bit of thanks for all the work Eddy has been doing in the mountains all week.' The Norwegian appreciated the move: 'It was a special moment to see the yellow jersey doing a lead out for me ... even if I didn't quite make the line. It showed how thankful he was and how much we have achieved together.'

A glance at the final results made the day seem uneventful, but with the wind and a series of roundabouts to negotiate at the finish, the stage required absolute vigilance. Knees, Wiggins's designated right-hand man for the flatlands, was as protective as ever. 'In the first week, I was not thinking too far ahead. I was concentrating on bringing Brad through the first six or seven days.

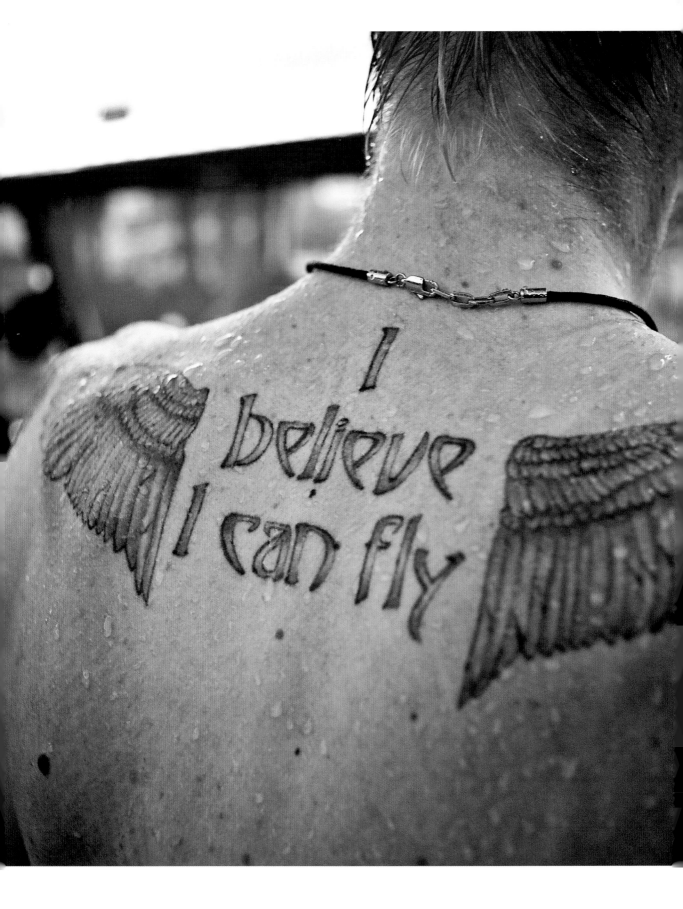

He crashed last year and all I could think was that I didn't want to see him lying on the ground. When we reached the mountains, it was good to see what he could do.' The spread-wing tattoo inked across Knees's shoulders proclaims 'I believe I can fly', and the team in full-on unified motion did seem like a cross between a host of guardian angels and a small flock of eagle-eyed escorts, hovering with intent to kill off any rivals' hopes of catching Wiggins.

And so another day was crossed off. A glance at Wiggins's personal space on the bus was getting like *Groundhog Day*: yet another cuddly lion, yellow jersey, copy of *L'Equipe* with Sky making the headlines, more empty bidons. Physically, he remained in great condition. 'He is a superb athlete who can absorb the workload and reap the benefit. He has a fantastic constitution,' says Yates, while Brailsford claims he has the perfect physique for a Tour de France winner. 'He's a tall guy, and long levers are significant from a biomechanic point of view. A power-to-weight ratio is important, so, because he's tall, his weight needs to be as limited as possible. Bradley's lost an enormous amount of weight but retained his power. He's in perfect shape and that is difficult to achieve.'

Maintenance of condition is the day-to-day business of the carers. During the race hours, their job is to prepare the riders' gear (helmets, clothing, shoes and spares of each), supply fresh bidons galore (3,000 bottles are drunk

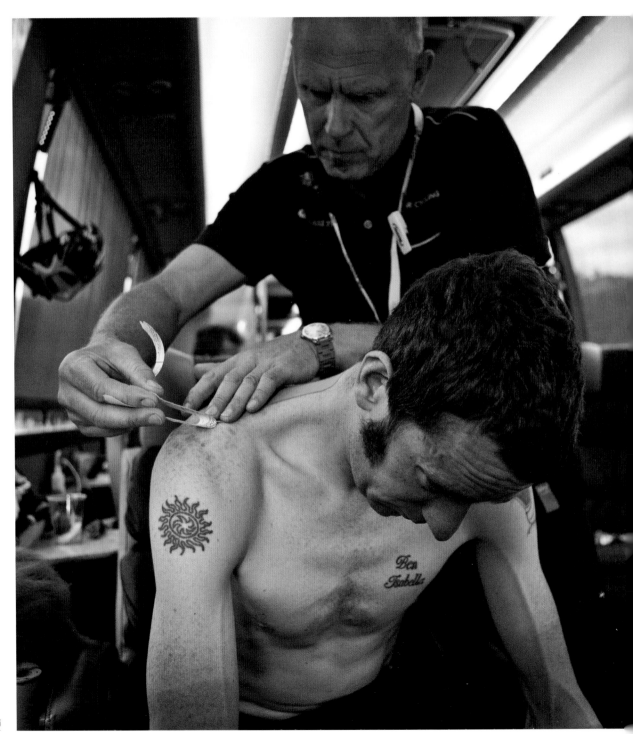

during the three weeks), prepare the food for the musettes in collaboration with team chef Søren Kristiansen, oversee the pre-race warm-up and post-race massage. They operate with an armoury of healing hands, compression tights, cotton wool with decongestant and blue kinesiology tape to apply to shoulders, legs and feet to speed-heal or support muscles and connective tissue.

'There is a team of us divided between the race and the hotel who are focused on making sure the riders are as comfortable as possible. As well as food, drink and physio, we provide the best hygiene and cleanliness,' explains Mario Pafundi. 'It's about looking for marginal gains everywhere. I clean hotel rooms, remove dust and dirt, check under beds and furniture. When it's hot, we put in air conditioning or a dehumidifier. We transport anallergic bed sheets and thermogel mattresses for each rider. We work hard to create the best atmosphere for the full complement of staff. If riders sense other people around them are tired, it is contaminating.'

The route from Limoux to Foix was highlighted by *Tour 2012* magazine as one of the key stages that would have an impact on the race. 'More unknowns, more compelling viewing. Something will happen on the Mur de Péguère, but nobody knows what,' it trumpeted. 'We're in the Pyrenees, and the day's star turn is a huge climb that is called "the Wall". It's never been in the Tour de France before. It's really remote. The way up and the way down are both difficult, and it's not far from the stage finish. It's a day full of don't-miss stuff.'

Never mind the race fans following on television, online or on handheld devices, for the riders the 'don't-miss stuff' turned out to be impossible-to-avoid tacks on the road. Sabotage. Not entirely unheard of in Tour history – in 1950, the French government had to apologise when drunk spectators blocked the road in the Pyrenees and forced an Italian team to withdraw – but not at all acceptable for the yellow jersey group whose tyres were decimated at the top of the final climb. Jean-François Pescheux, competitions director of Tour organisers Amaury Sports Organisation, expressed his horror: 'We don't know who it was. No one saw anything. We've found some of the tacks. They're the kind of tacks you use in mattresses or carpets. They were obviously thrown by a spectator. There were around 50 riders together in the front peloton at the top and about 30 of them ended up with punctures. Some of them had three or four nails in their tyres. We couldn't neutralise it straightaway because we didn't know what had happened. Fortunately Team Sky neutralised the race.'

The incident was unfortunate, but it didn't faze Wiggins and co. This three-week race was all about protecting Wiggins on various levels – safeguarding him from rivals' attacks in the heat of competitive action, guarding against injury or illness, helping him keep settled and focused. Two weeks had now been successfully ticked off, but day 15 proved the virtue of the Team Sky minute-by-minute mantra of wariness. 'For the whole three

STAGE 14

weeks, we were in the driving seat, but we couldn't make any mistakes,' said Brailsford. 'Any second, any minute, any hour, it could all go wrong – as it did last year when Bradley crashed and broke his collar bone. We never relaxed, we never got complacent. We never let ourselves think "It's going to take something really extraordinary to go wrong now", because extraordinary things do happen. We were vigilant to the end.'

On the day on which he became the first Briton to wear the yellow jersey for a seventh time, Wiggins asserted his authority as race leader and earned himself the reputation of 'Le Gentleman'. Cadel Evans, the defending champion, was one of the worst affected by the sabotage – the Australian had to wait for two minutes for a spare rear wheel, then suffered two more punctures on the way down the final climb. Wiggins called for the peloton to slow their effort to allow Evans to bridge the gap. 'No one wants to see something like that have an impact on the race,' he said afterwards. 'As a group the thing to do was to wait, the stage win was over. The climb was over. There was nothing left to contest. I wouldn't want to benefit from something like that. I thought the best thing to do was to wait.'

Pinarello, who supply Team Sky's bikes, had provided special-edition yellow frames as soon as Wiggins took the lead, but the yellow jersey man himself was cautious about turning comprehensively yellow, opting for touches on the frame and a yellow saddle. His team were pleased to

no longer be wearing the yellow helmets (awarded to the outfit topping the team classification in a 2012 initiative from the organisers). As Servais Knaven said, 'Other teams thought we were being arrogant when we wore them on the first stage. We hadn't got the yellow jersey – why the helmet? They didn't know the new custom. At the beginning I wasn't happy either. You do everything to make the team livery perfect and coordinate clothing, bikes and helmets, and then we had to wear the yellow helmet!' Boasson Hagen agreed: 'They just didn't look good. Yellow didn't match with anything, except the yellow jersey, which we didn't get until the beginning of the second week.'

For the mechanics who accompanied the sports directors in the race cars, it had been a frenetic afternoon of wheel changes and tyre assessments, but the introduction of yellow onto Wiggins's bike gave extra meaning to their long night of washing, cleaning and preparing 27 machines. The team was edging towards its goal. They could see the reward of the painstaking, meticulous work in soaping frames, checking every bolt, tyre and wheel, changing gearings. 'For us, the Tour means four weeks away from our wives and families, so the team becomes our family,' said Rajen Murugayan. 'The best part of the day is after the race, when you ask the riders how the race went, how the bike felt. We share all the emotions of their day.'

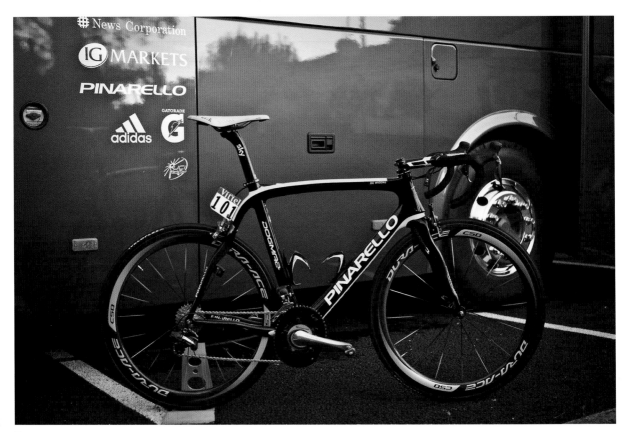

STAGE 15

'You're in a bubble for four weeks, immune to the rest of the world. It's all-consuming,' says Sean Yates of team life on a Grand Tour. To get through the Tour on the right side of sanity, you need to stay inside the special atmosphere of your bubble. As Christian Knees suggests, it can be disorientating to leave: 'Once, on a rest day, I went to a supermarket to pick up something and it felt very strange, a different world.' The one man who is particularly vulnerable to that protective bubble being pricked by external distractions is the yellow jersey holder. Everyone wants a bit of him.

From the hotel lobby to the sign-in and start line, the world seemed full of people desperate to glimpse the iconic jersey. There are fans to acknowledge, autographs and Lycra to sign, journalists and photographers to satisfy. After the race, it is straight to the podium area with Dario and a carer for a clean-up and fresh team kit – accessorised with distinctive black compression tights and blue suede trainers – ready for the podium. Another presentation, bouquet, congratulatory kiss, cuddly lion, clean yellow jersey. More press conferences, then a trip back to the hotel in the race car, eating and rehydrating on the journey, thinking ahead to a quickfire dinner, massage and bed.

For Wiggins, it was the ninth day in the iconic top. Did the simple act of putting it on each morning feel a weight of responsibility? Or was it like a second skin on

an athlete who had dreamt of this achievement since childhood, who was already three times an Olympic gold medallist? Scott Mitchell's photographs show Wiggins relaxed, concentrated, resigned (in a positive sense) to the yellow-jersey-wearer's routine, true to his own idiosyncratic style. From morning wake-up call to the day's end, Wiggins was a man on his mission.

'The Tour, as the biggest race in the world, is so stressful for everyone, from the riders to the staff, and hours-wise the riders have the easiest jobs. Some of the staff are up at 5am and don't get to bed until 2am,' said Michael Rogers from his 12 years' experience. He admired the way his leader handled the intensity of expectancy that underpinned the relentless day-to-day schedules and ever-burgeoning media interest. By Stage 15, the name of Bradley Wiggins had moved from deep inside the sports pages to the front pages of sports supplements, and was soon to hit national news headlines. 'For any rider, in any team, the amount of press attention and pressure makes it hard to just concentrate on riding the bike.' Rogers continued, 'There might be pressure from the fact that some team budgets for the following year will be set according to performance. Some riders might have their contracts in the back of their minds. The press want your attention. Photographers push and push to capture the top shot. It is incredibly stressful. We might get back to a new hotel at 10pm for dinner, massage and sleep. Towns are so

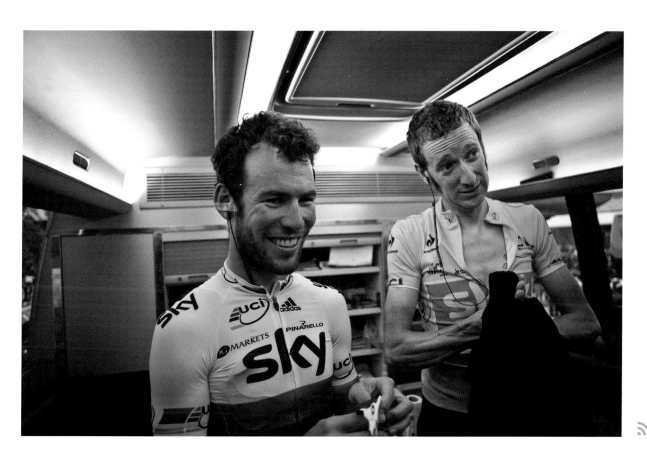

happy to host the Tour, they put on big town parties, with loud music, and we riders can't sleep! Some people thrive on that sort of pressure and the attention that comes with it, but I don't think Bradley enjoys it. Outside the hotel or bus, you see him smile but you know it's for the cameras. He's counting down the days. All the riders will say that, by the third week, you can't wait to get the bloody thing over with.'

Wiggins may not have enjoyed the sideshow, but he didn't let it unsettle him. It simply meant he was on track to secure his ambition. His attitude owes much to Brailsford's determination for the 2012 team to build up experience as race leaders, as defenders of a lead, as performers familiarised with all the hassle that goes with being under a global spotlight. Wiggins was used to the demands, inured to the routine. It felt normal. His team mates, ever vigilant to his feelings, watched the way he paced himself. 'Once we'd survived some crucial moments and taken yellow, I could see the relief of the stress that had built up in the mad first week leave his body,' recalled Eisel. 'It's always more relaxed in the bunch once you hit the mountains. We knew from then on that we would get more space and more respect from other teams. There'd be no more crazy stuff in the peloton.'

'We all had great respect for Brad,' said Porte. 'He had to deal with all the pressure as well as ride the kilometres. He had the media asking all sorts of questions. He had to

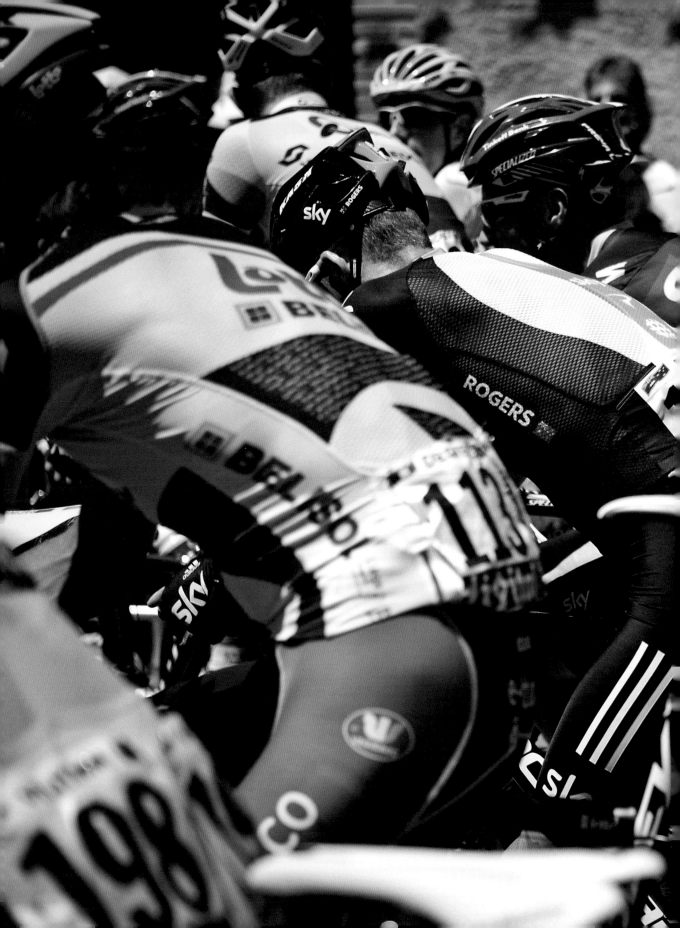

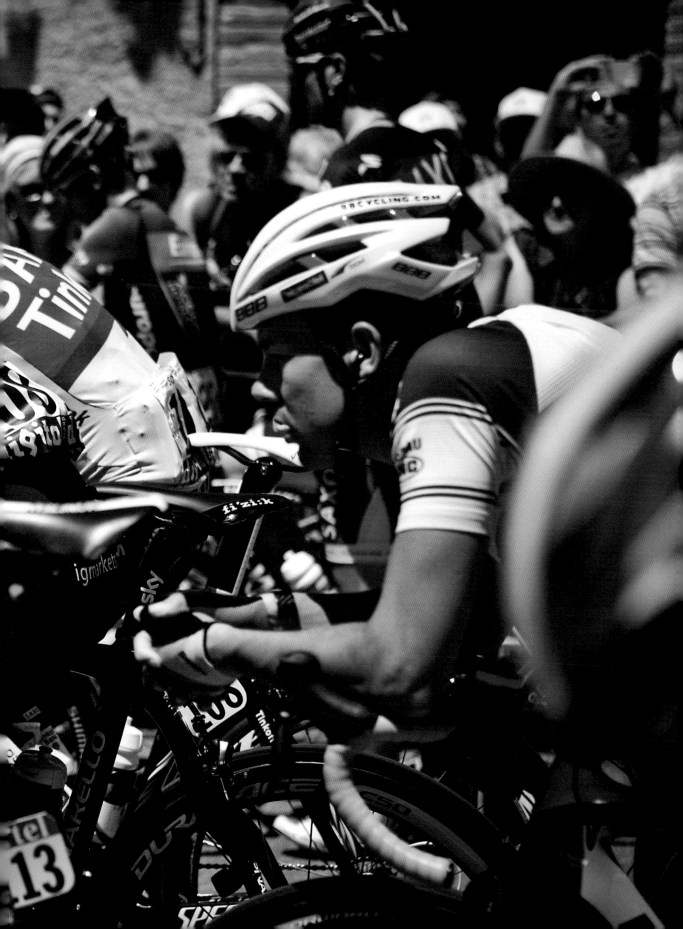

pop all of that. He had so many commitments but he was the same Brad, often hilarious.' The bus was his haven, where he wasn't a 'name' leading cycling's greatest race. He was Brad, the guy who people around him had known for years. 'Bradley and I have grown up together,' said Cavendish. 'Together we've been at the forefront of the rise of GB cycling. He's like my big brother. We'd die for each other, but like brothers we can also get jealous of each other and bicker. Which we do. But I'm always incredibly proud of him.'

Everyone took inspiration in rubbing with the yellow jersey. 'As you get more and more tired, your body can't recover fully. People react in different ways,' explained Eisel. 'Some talk more. Some stop talking. Some get grumpy. You see people's true personalities, but it's much easier to bear when your team has yellow. You know why you're doing it.'

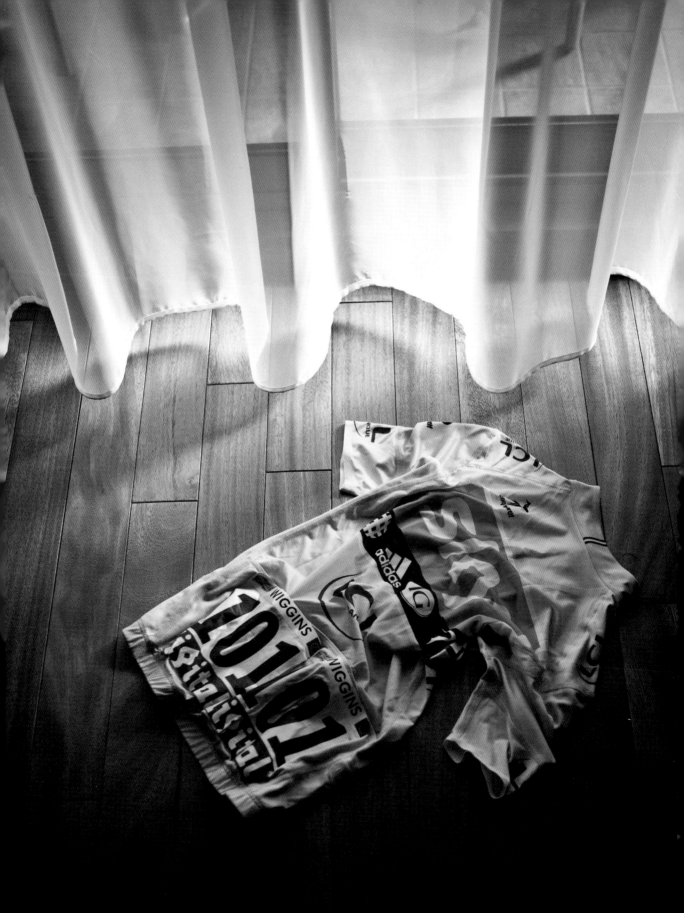

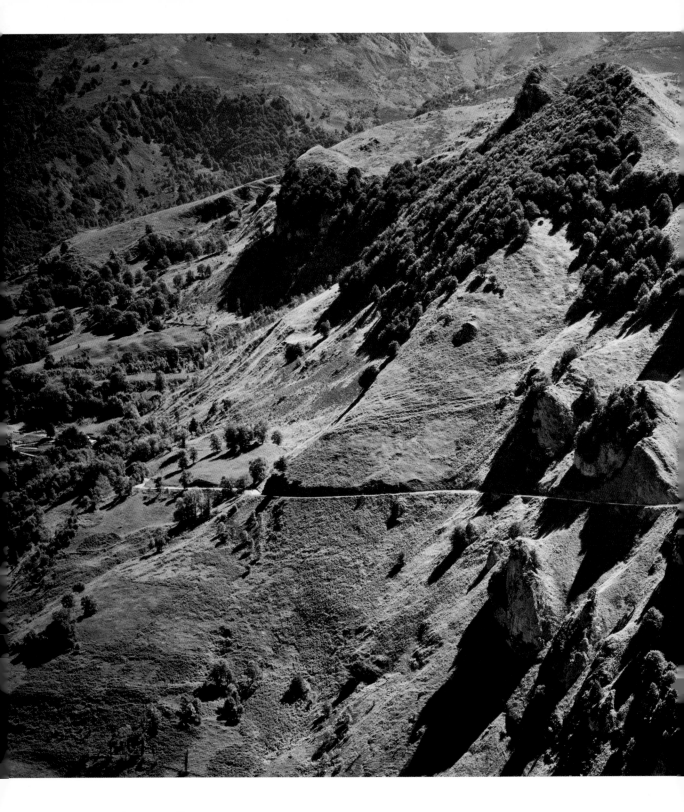

STAGE 16

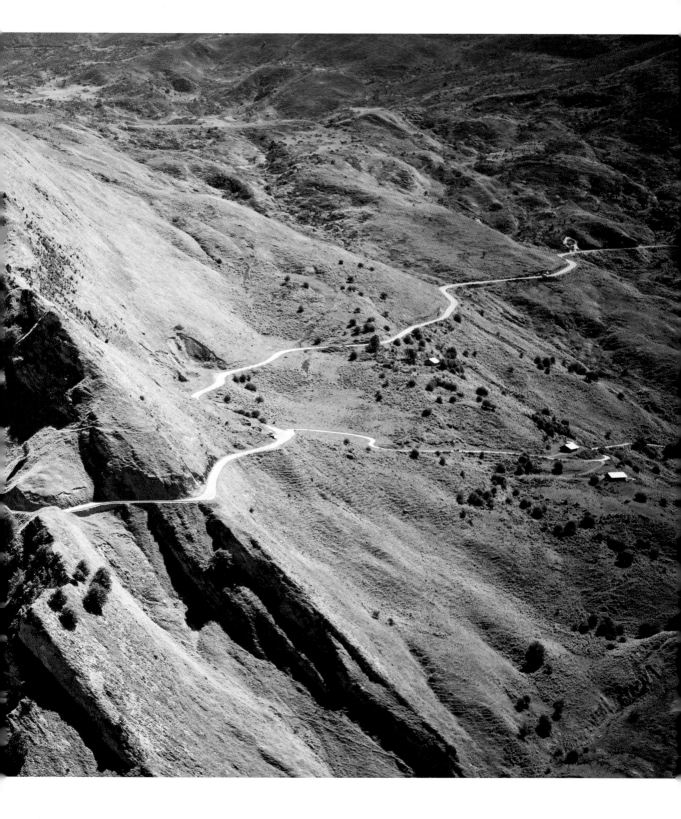

The big one. On this day the riders faced probably the most daunting stage of the Tour, with 4,686 metres of tough climbing in the High Pyrenees under a baking sun. The route followed a classic line of climbs that have been used by the Tour, from east to west or from west to east, several times since 1910. Four big mountains stood to play a potentially decisive role in deciding the overall winner: two *hors catégorie* climbs in the ferociously steep Col d'Aubisque and the mighty Col du Tourmalet – the most climbed mountain in the history of the Tour – followed by the Col d'Aspin with its steep, technical descent and the scary, jagged peak of Col de Peyresourde.

The bleak mountainscape, beautiful against the blue sky, had become for the day a well-populated place of pilgrimage for fans who came to line the narrow twisting roads to support the riders on their Herculean day's task. In contrast to the families who picnic in ditches in the more bucolic stretches of the flatlands, these were diehard followers who themselves had cycled up to a good vantage point or encamped days earlier in caravans, having claimed a location with a sweeping perspective. Day trippers lined roads and ridges in scenes reminiscent of a Western, where the cowboys look up to see they are surrounded by Indians who have suddenly popped up in battle formation along the top of a hillside.

The battle here was Team Sky against Cadel Evans, but more potently Vincenzo Nibali. The pace was

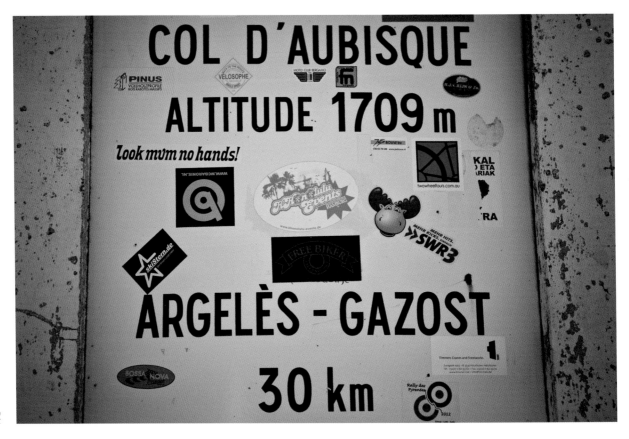

blistering and Evans dropped almost five minutes to the yellow jersey after being distanced on the final two climbs. Nibali had bided his time, but on the approach to Peyresourde suddenly accelerated, only to be efficiently stamped out by Wiggins and Froome working as a duo. The Italian attacked one more time, but Wiggins swiftly negated the threat. 'The team were brilliant from the off and we knew what we had to do. It was just a case of doing what we've been doing since the start of this race, which is riding together as a team,' he said. 'It was another tough one, and obviously there weren't many bodies left at the end. It's good to get that one out of the way.

'This is what we've trained for and that scenario is what we've prepared for. We've trained for the demands of this race and for the demands of what this race consists of in the third week. I think that's what makes us the best riders in this race. All year it's been about this, and training in this kind of heat and for these climbs. The fitness and recovery has been a team effort. The backroom staff's work – with the hydration when the stages finish, and all those little things – adds up over the three weeks.'

Those little things largely come under the remit of Tim Kerrison, who has three areas of responsibility on the Tour. As head of performance support he manages the team – comprising medical, physio, nutrition, sport science, performance analysis and so on – and coordinates the delivery of support services in training and at races.

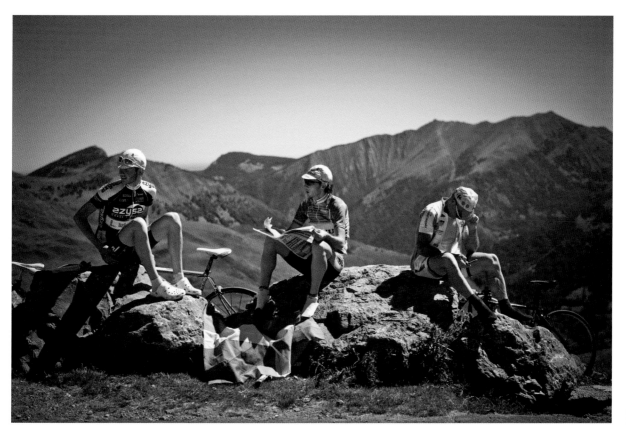

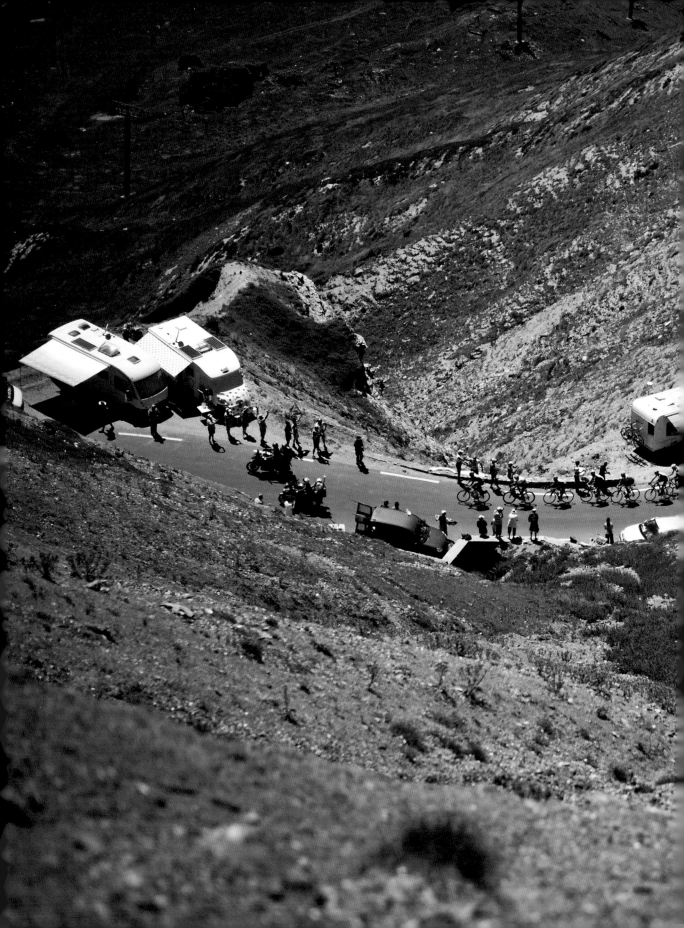

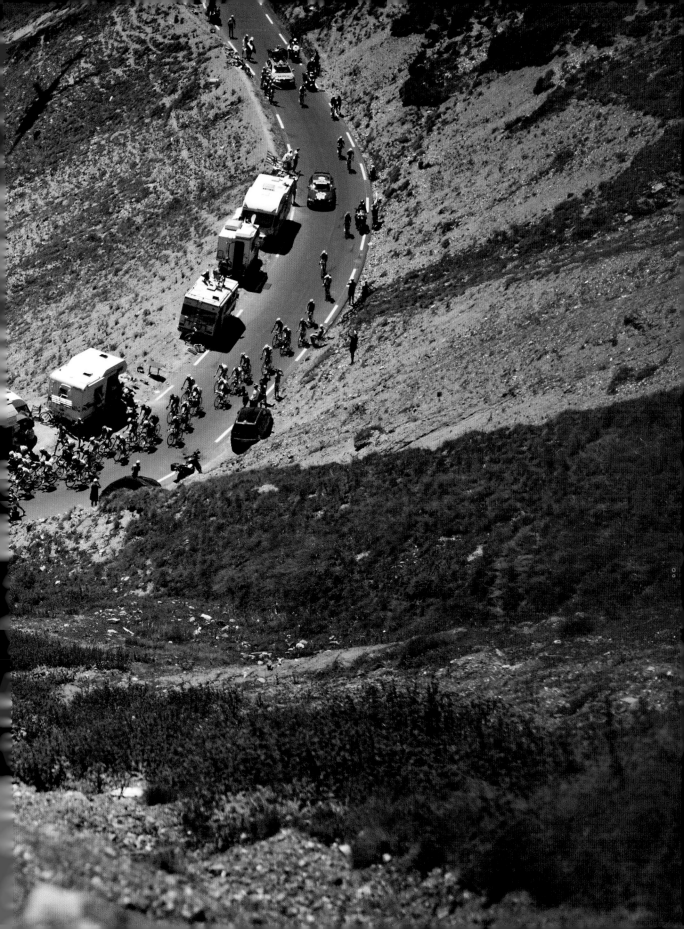

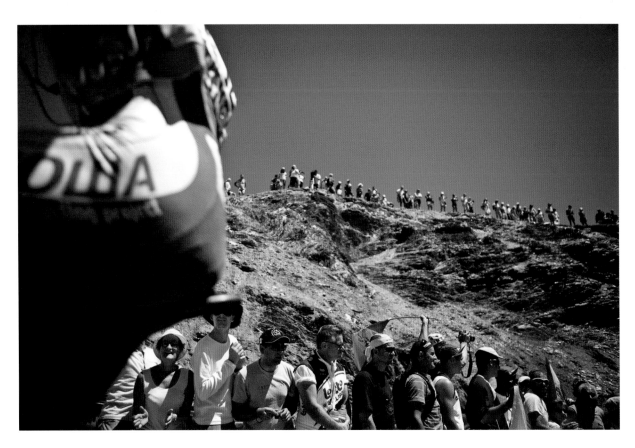

As a member of the coaching team, he works with the other coaches – Rod Ellingworth, Bobby Julich and Kurt Asle Aversen – to prepare the riders for competition. And as a member of the management team – working with Dave Brailsford, Carsten Jeppesen, Rod Ellingworth and Fran Millar – he helps manage the team's operations.

In the big picture, Kerrison coordinates the preparation of the Tour de France squad throughout the 2012 season cycle. 'This involved bringing the core group of riders together for a series of races and training camps throughout the year,' he explains. 'Through this process, the riders refined their riding style as a team during the races, then went into intense training camps in between the races to further develop their physical capabilities, targeting areas where individual riders' abilities fell short of the anticipated demands of the upcoming races.'

At the race, his presence serves several purposes. 'First, to oversee the support services provided to the riders, including nutrition, hydration, heat management, recovery and data analysis,' he continues. 'Second, to work with the sport directors to align race strategy with the physical capabilities or limitations of the riders. Third, to continue to learn about the demands of the event to feed back into our preparations for future tours.' Also known as 'the numbers man', Kerrison measures the riders' individual performances using the SRM system, which records speed, distance, cadence, power, heart rate,

and altitude. 'The data is used heavily in the coaching process to analyse the demands of the events and assess riders' performances in training and racing. The system also provides the riders with real-time feedback during racing and training, which the riders use to better pace themselves through efforts.'

This was the first of a double-header in the Pyrenees. Although the next stage didn't look as demanding – it would be shorter, significantly – there would be a lot of tired bodies out there. As Wiggins said, 'It's a case of people recovering and a case of who recovers best at this stage. The one thing I keep saying is that no one has it easy out there. We're all in the same boat. We all have to do the same course. And tomorrow is another day.'

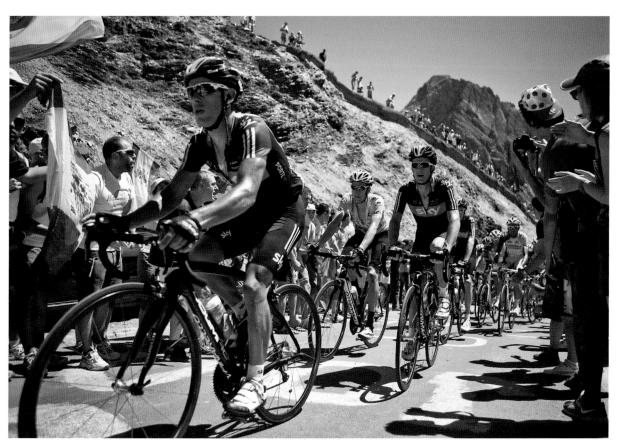

Moving inexorably towards the sharp end of the Tour, 19 July was the last day in the mountains. Starting under menacing skies and miserable drizzle, the riders knew what they had to do. It was business as usual – everyone helping maintain position, with even the rainbow jersey doing stints going back for bottles and raincapes. At the start of the day Wiggins had expected someone to attack, and to attack hard. As riders began to drop back through fatigue, he was feeling better and better – until he and Froome were left as a duo to stretch their overall advantage ahead of Vincenzo Nibali.

'The minute we went over Peyresourde I knew that was it,' Wiggins said. 'I knew Nibali was in trouble and a few of the other guys. I had a little chat with Froomey on the descent and told him to go for the win if he felt strong. At that point, the first time in this whole Tour since I'd led the race, I thought, "Maybe I've just won the Tour". And that's when it starts getting hard, because you lose concentration and start thinking a lot of things. Froomey was egging me on for more but I knew that [the riders behind] were all gone. It was an incredible feeling. It really was.'

The way the riders had anticipated the day's action and responded accordingly was thanks in no small part to Sean Yates and Servais Knaven. As Yates said, 'The sports directors have to carry the can. We make sure we're comfortable with what's up ahead, but it is always a balance between analysing a stage and boring the pants off a rider with the details and them riding it blind.'

The sports directors deal with all the logistics involving the 30-plus members of Team Sky. 'We oversee day-by-day race tactics and strategy decisions as well as organise the travel, hotels and media opportunities,' says Knaven. 'Some days it's straightforward, some days there's a lot of trouble-shooting, but they're always long days. We take a close look at the course every day – assessing the width of the roads, where the climbs start

STAGE 17

'Everyone in the team makes sacrifices for the yellow jersey, that's cycling. It's our work. I'm 27 and I hope to win the Tour one day. If you had said to me a month before the Tour that with three days to go I would be second, I wouldn't have believed you. I'm very happy.'

Chris Froome

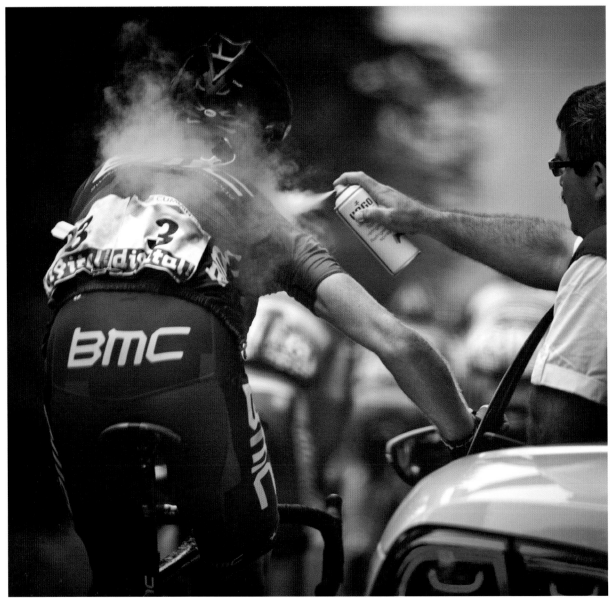

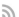

and gather technical detail. Sean concentrates on strategy and the course; I look after planning, logistics and team management. Sometimes it's like a puzzle, sometimes it's repetitive.

'On a typical day, the backroom team get up four hours before a race start. I talk to the mechanics and masseurs. Sean and I go through our last preparations for the day's stage and discuss tactics. We might find the riders at breakfast and see how they're feeling, and talk to the doctor if any have been sick or had a bad night. Then I pack my suitcase and put it on the truck ready to be transported to the next hotel. We set off about two and a half hours before the race start, aiming to be there 75 minutes before the riders set off. The sports directors travel on the bus with the riders, the mechanics drive our race cars.

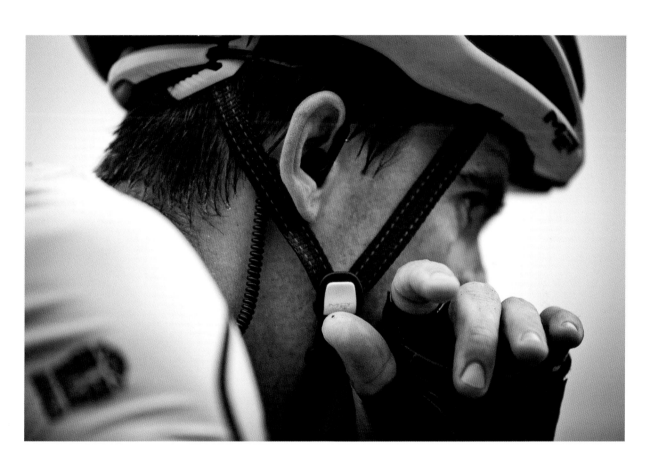

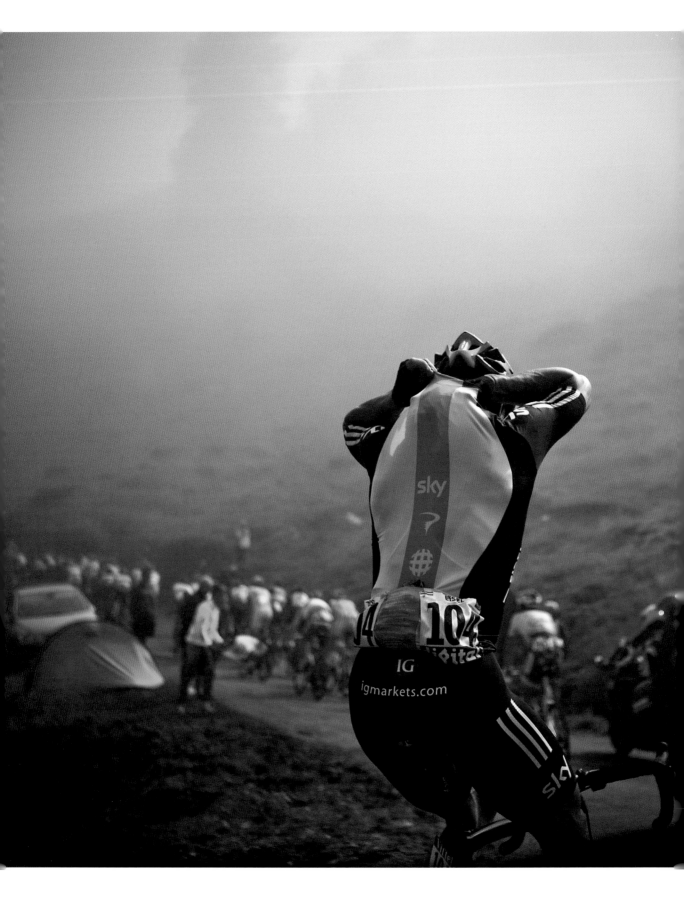

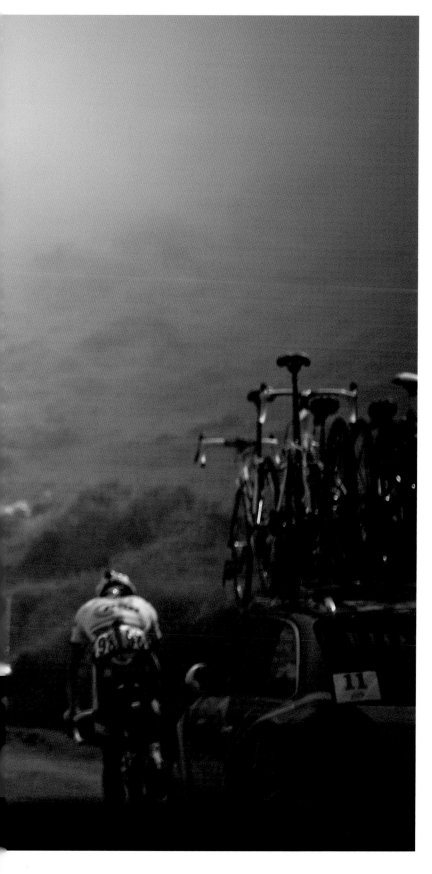

Bernie Eisel dropped back for raincapes for the team.

On the bus we have a meeting to talk about the stage tactics and everyone's roles. While the riders put on their kit, Sean and I prepare the cars with maps, notes, and check the radios. About 20 minutes before the start, we leave in our respective cars – Sean behind Bradley and me ready to follow the first rider to be dropped.

'During the race, we follow the action through the windscreen and on our in-car television screens, talking with the riders over the radio. You joke a little, of course, but it's pretty serious trying to win the Tour de France so the radio chat is mainly relaying information to the riders about who's in the breakaway and shall we let them go?

'Sean and I have to work to keep our radio contact, which can be lost if I am too far behind. I will be asking Sean for his position, and getting updates on weather

so well. He's worked out which teams have come with what goal and we second-guess their moves.

'After the race, the riders and sports directors travel by bus to the next hotel. That journey can be 30 minutes or two hours so we use it to work. We have one-on-one chats with each rider. They shower, eat, watch the stage on TV. There's internet on the bus, so I try and finish the next day's schedule. When I arrive at the hotel, I get copies made and distribute it while Sean talks to the mechanics about the bikes and gearing requirements for the next day. On a good day, I might have half an hour to call home before dinner at 9.30, then bed. It is an intense routine. Sometimes Sean, Tim and I go out early in the morning on our bikes for an hour or so to clear our heads. It depends on what has to be done. We managed it four or five times!'

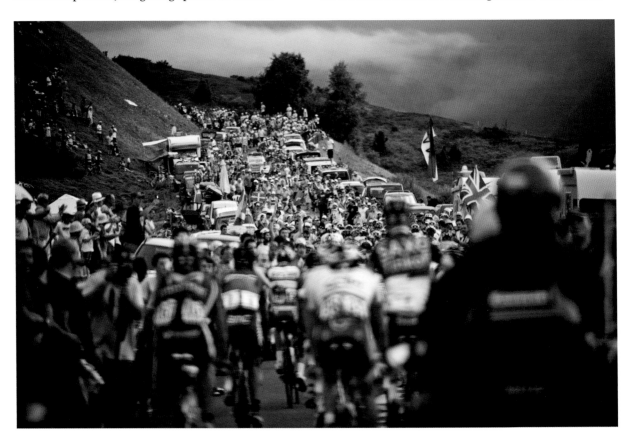

conditions, wind directions and so on. We talk mostly to Rogers and Eisel. The riders can talk rider to rider, but Bradley, Knees, Eddy, Porte and Froomey are all quiet on the radio.

'The relationship between sports directors and riders is very close. The job we do for them is a huge responsibility. We have to trust the road books and find the inevitable mistakes in there. We have to be 100 per cent sure when we say something and, in the time trials, when you tell the guys they must speed up here, you have to be absolutely sure you are accurate. Sean reads the peloton

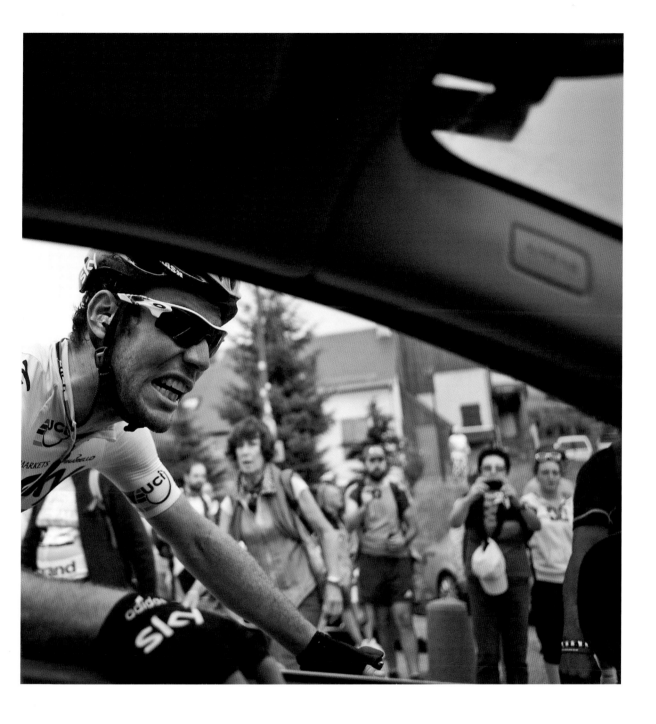

Out of the mountains and on to the long, flat approach to Brive-la-Gaillarde, but there was no chance of trying to save energy for the next time trial. 'It was full gas and full on, one of the hardest days on the Tour for us,' said Bernie Eisel. 'The plan was to let a small group go and set up a sprint for Cav, but the yellow jersey was being attacked. Even teams who didn't have sprinters decided to ride hard. It was impossible to control. We let a big group go with Eddy in there. We'd even had Bradley up there for us …'

Cavendish takes up the story: 'Sean Yates said in the morning, "let's take it easy", but there were no more mountains to take a break for, so I said I wanted to go for it. And Brad backed me up. Froomey and Mick committed straight in too. So the team rode for me. I was so happy, those lads who I've been riding with these last three weeks helped me out. Brad did a monster pull, then Edvald. Normally I'd go for the sprint from 200 to 300 metres, but I had to go from 700 metres. I used slingshots to get past people, impressive movements. I just knew I'd get it. After that dry spell, I was really hungry for a sprint victory.'

It was the fourth triumph in the race for Team Sky, who now had more honours than any other team. It was also the 22nd Tour success in Cavendish's career and prompted Wiggins, sportingly, to acknowledge some reciprocal help and pride in participation. 'Mark proved today who the fastest man in the world is without any doubt. You saw how far he went, 600m from the finish, and left them for dead. It was fantastic to be part of. It's been a great three weeks and I've always wanted to be able to do that for him. It's the first time I've led him out for a Tour stage. It was great.'

But tough … 'The hardest moment was coming back to the bus and some guy shoves some Lycra towards you to sign with the words "Easy day!"' said Eisel with a wry smile. 'What the fuck? I'm on my hands and knees.'

An important player in the riders' 24-hour recovery cycle is Søren Kristiansen, chef for Team Sky throughout the Tour, who is motivated by his desire to show that food needs to be restorative psychologically as well as physically. On paper, his role is to restore and build the athletes in association with Team Sky's nutritionist, Nigel Mitchell, but he uses food and its feel-good potential – both in taste, nutritional sustenance and presentation – to keep the riders smiling while they're eating purely healthy food. Food is fuel, but it can also maintain morale.

'Søren is fantastic,' enthuses Christian Knees, whose Twitter feed is laden with pictures of appealing plates. 'Good food is a detail that adds to your motivation and mood, because he gives you something different every night. You don't know what to expect, you've never seen it before. I know from the past how bad food, or just plain pasta and chicken day after day, makes you feel tired just to look at. Søren looks at the demands of each stage and knows what kind of food we need, but he makes it more special than that.'

STAGE 18

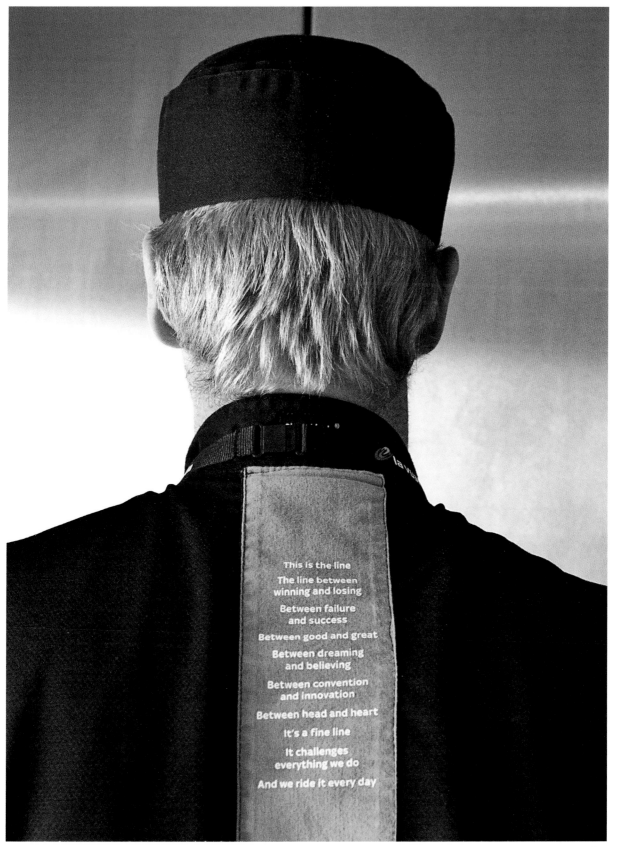

This is the line
The line between
winning and losing

Between failure
and success

Between good and great

Between dreaming
and believing

Between convention
and innovation

Between head and heart

It's a fine line

It challenges
everything we do

And we ride it every day

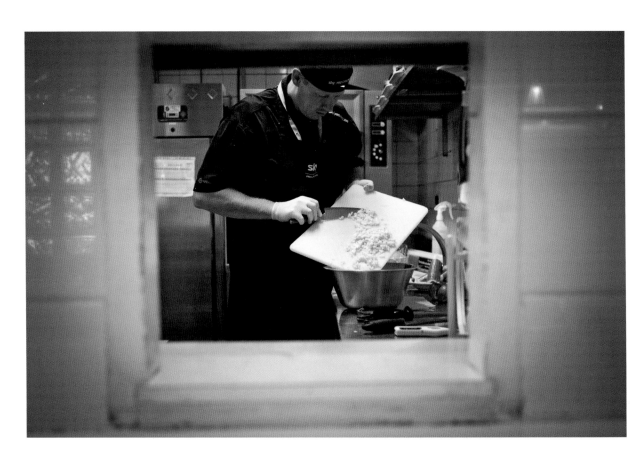

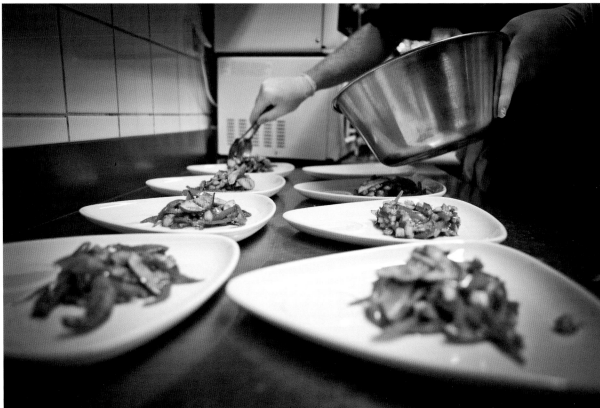

On rest days, Søren might put on a barbecue night. The night after the last time trial it was a (healthy) hamburger. Tour cyclists need at least 6,000 calories a day, three times as much as a normal person, and consuming the quantity of food that contains that amount of calorific energy can be difficult. After massive exertion, you don't feel like eating much. Equally, munching your way through a huge pile on a plate gets boring. Søren knows the riders well, so he can modify each plate depending on their individual tastes and what they need at that point in the Tour. The team was the same all season; they would have eaten 100 dinners together cooked by Søren, but no two of them will have been the same.

Søren describes his style as 'old-fashioned food made in a new way'. He is influenced by classic Nordic food and likes to work with vegetables that are not hard for the body to digest, but release energy slowly in the body. He is an advocate of a lot of raw food. Beetroots are a favourite, and they crop up in fresh beetroot, carrot and cucumber juice. Pumpkin risotto, barley and quinoa also feature frequently. Each meal is planned not only nutritionally, but to match each Tour stage. 'On the mornings of hard mountain days we don't make porridge because it's too heavy on the stomach, but we'll have some during the flat stages in the first week,' he says. The mountains require extra nutritional input, but with more readily digestible protein. 'In the first week, I have more opportunities to give the riders red meat. In the second and third weeks we go into the mountains and I'll cook more chicken and turkey as it's easier to digest. There is always a lot of fish on the menu.'

On the night after a Team Sky stage victory, it has become tradition to have a small toast. 'Time goes so fast on the Tour. It is a really intense experience. At the end of one day, you have to think about the next day, you have to stay focused all the time. There is not time to celebrate a stage victory, but we will always have a glass of wine or champagne with dinner before we go back to our rooms,' says Boasson Hagen.

'Mark has waited a long time and been patient and he has got his reward. He has had to put away his goals and make sacrifices on the Tour so far, and that is hard for a world champion. We all wanted to repay him somehow.'
Bradley Wiggins

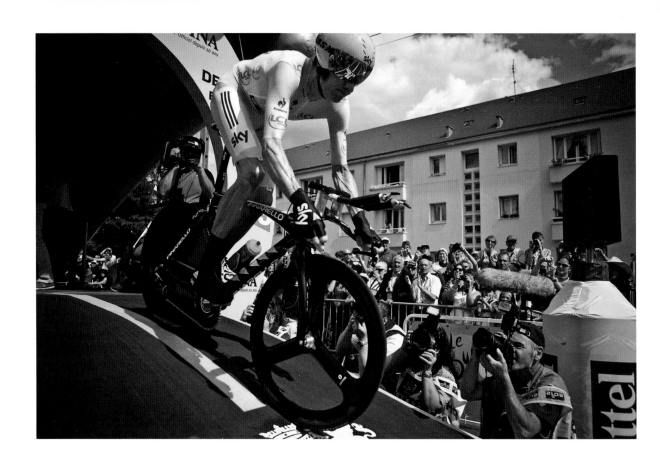

STAGE 19

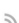

The 53.5 kilometre time-trial between Bonneval and Chartres had been earmarked as a banker for Wiggins if things had not gone to plan in the mountains. Pre-race previews had set up this penultimate stage as a potential clash between two adversaries: Wiggins versus Cadel Evans. Purists might have wanted to see a showdown of nerves and firepower between the defending champion and the season's top performer, but Team Sky were happy to see their leader still in the yellow jersey and with a comfortable two-minute-and-five-second advantage over the second-placed rider – their very own team member Chris Froome. The ambition behind setting up Team Sky in 2010 was to see the first Briton win the Tour de France. Three years down the line, could it really be a British 1-2?

To those not immersed in the world of cycling, all the talk about seven or eight men 'helping' Wiggins and 'protecting' him en route to Paris made him sound oddly vulnerable, which of course he was not. He was the most decorated British Olympic cyclist, with a haul of six Olympic medals that was the equal of Sir Steve Redgrave. Road cycling is a team sport, and the one thing Brailsford was keen to project was the unity and teamwork involved in Team Sky's successes: 'The guys work tirelessly for each other. They get on really well and they all back each other no matter what the situation is.' For 19 days, it had been all about ensuring Wiggins had the space to do his stuff. And now, on 21 July 2012, he was poised to underline his

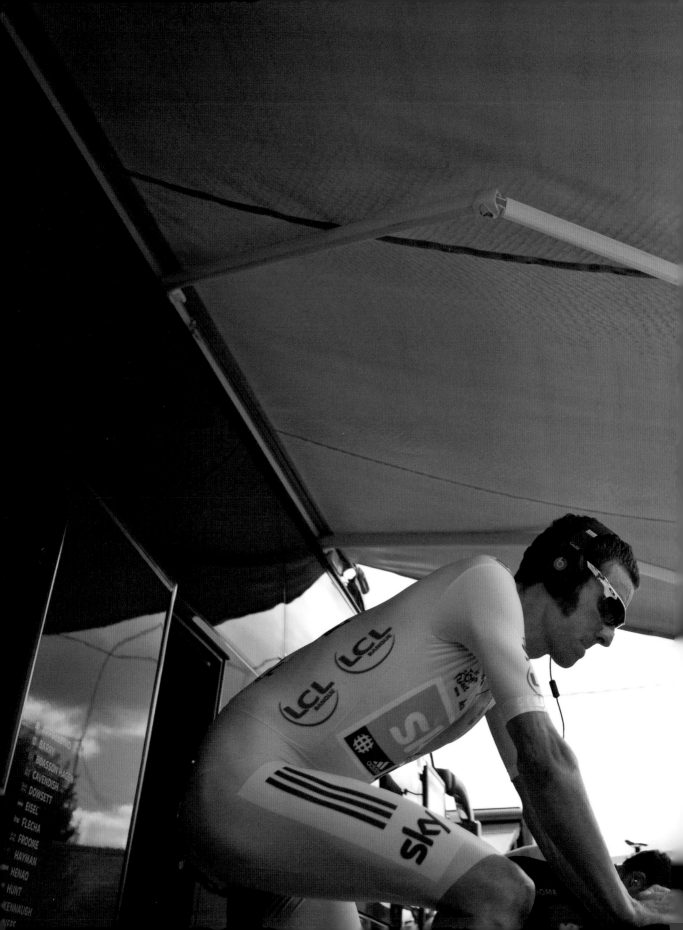

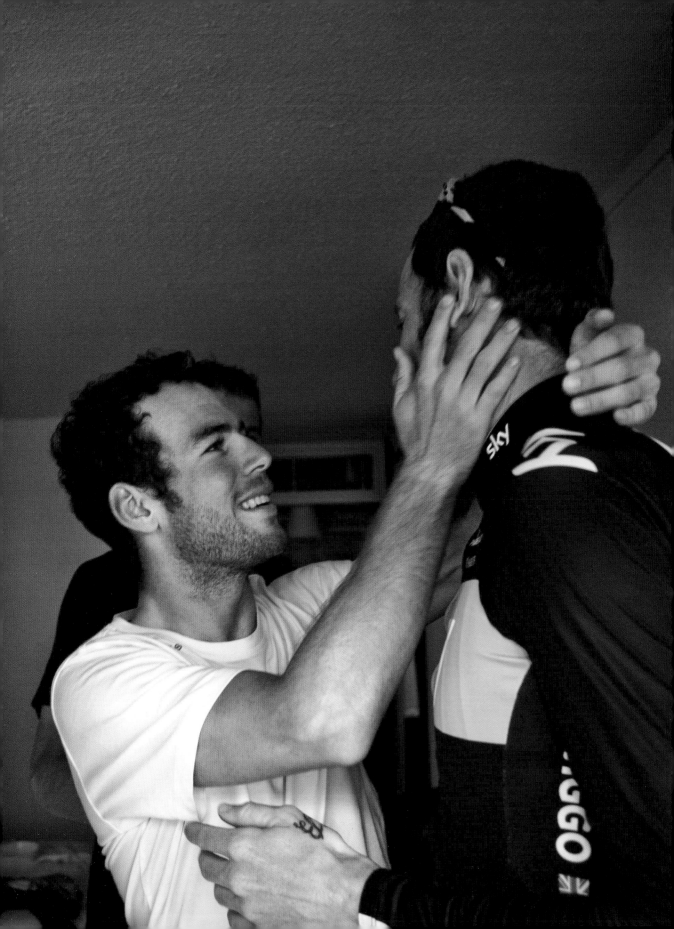

superiority. Nowhere does Wiggins show his talent better than in a Race of Truth.

After warming up for the biggest moment in his life, in the glare of the world, Wiggins was last to go down the start ramp. Froome had just posted a stunning time. Pumped up, concentrated, determined, Wiggins put in a sublime display, stopping the clock in one hour, four minutes and 13 seconds. It was fully one minute and 16 seconds faster than Froome, who took second. It meant Wiggins would go into the champagne-swilling promenade of the largely processional stage in Paris with a huge advantage – three minutes and 21 seconds over Froome and six minutes and 19 seconds over Nibali.

'It's what I wanted to do – I wanted to go out with a bang,' said Wiggins, with what could only at this stage be understatement. 'It's a long way, 53km, but it's what I do best. I came out in March and looked at this course with Sean. I felt fantastic out there. From the first pedal stroke in the warm-up I normally know whether I'm on it or not. I knew today the minute I rolled off that ramp that I was on a good one. It's the Tour. It doesn't get much bigger than this. What a way to finish. I wouldn't say it was a lap of honour, because it hurt, but I just wanted to finish the job off in style.

'There was a lot of emotion in the last 10k. Everything was going through my mind. All the years of getting to this point, my family, disappointments, crashing out of the Tour last year, watching Cadel in this very position a year ago in Grenoble. I always imagined what that would feel like and now I know. I was thinking about my wife and children, my grandfather, my nan, my mother. That was just spurring me on with every pedal stroke. It sounds cheesy, but you work your whole life to get to this point – it's the defining moment in your life. From the minute I got into cycling as a kid it's all summed up for me today.'

His team mates mentally rode every second with him, even after their own efforts. 'One of the highlights of the Tour for me was sitting in the car with Eddy and a soigneur getting updates on Bradley's progress on my phone,' recalls Richie Porte. 'We saw Chris's time, then Brad's. Halfway through he was a minute quicker. That was mind-boggling. We knew they were good, but ...' Eisel watched him cross the line, rise up from his saddle and punch the air – 'and I could see all the pressure and tension leave his body. He'd done it.' Cavendish, too, buoyed by his victory the day before and anticipating another on the final sprint

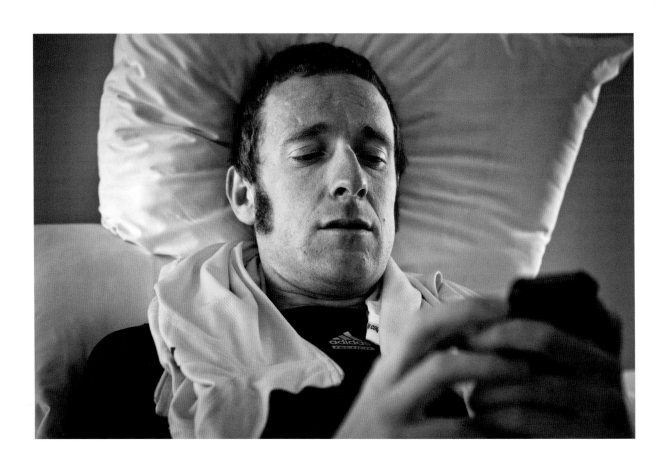

around the Champs-Elysées, was thrilled. 'The yellow jersey is one of the most iconic symbols in sport and it's been the proudest moment of my career to go through this Tour with Bradley. As I've said, we've grown up together. I'm incredibly proud of him.'

Nor was Siutsou forgotten. 'We really wanted him to come to Paris,' said Rogers. 'We realised that with a broken leg it would be hard for him to catch a flight alone, so we were trying to book him transport. We really wanted him to be there. He was one of the key men throughout our whole successful year and he'd only had two days of the Tour. The celebrations in Paris were about the 2012 season, not just the Tour de France.'

And at last Dave Brailsford allowed himself to emerge from logical mode. The days had been ticked off. The glory beckoned. 'It was an amazing result and it's been an amazing Tour for us. I don't think it came as any surprise as long as the guys stayed on their bikes today that they were going to come first and second. It went to plan.

'Bradley's had an amazing race. What a way to demonstrate he is the best rider in the race by finishing with a time trial like that. I'm incredibly proud of both him and Chris, as well as every single person in the team. It's never been done before by a British rider, or by a British team – it's a very special day.'

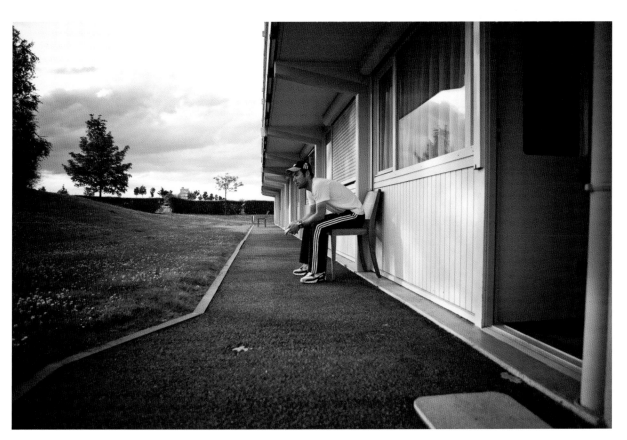

STAGE 20

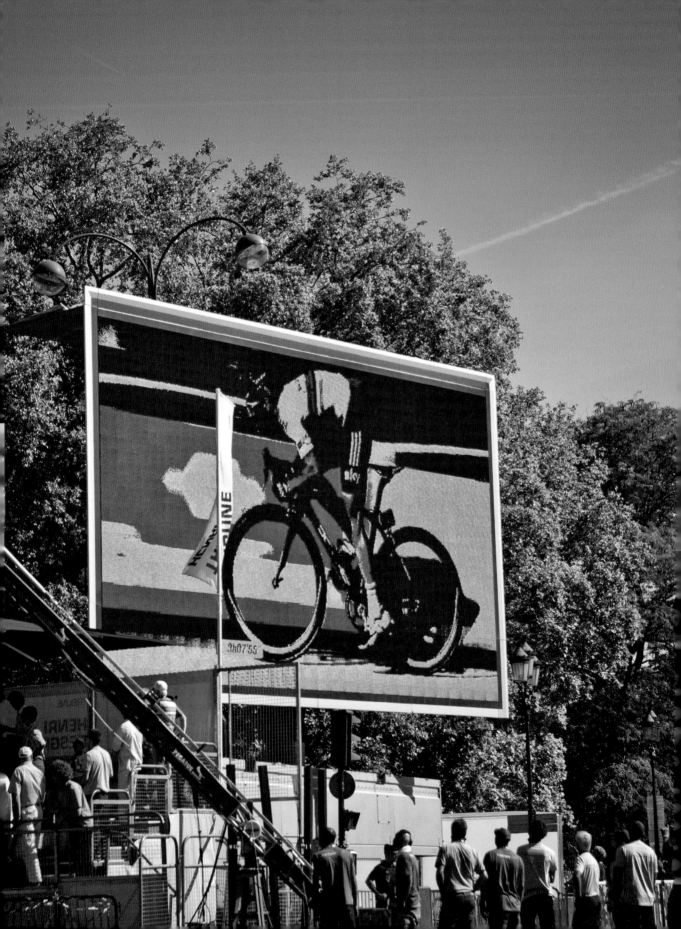

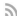

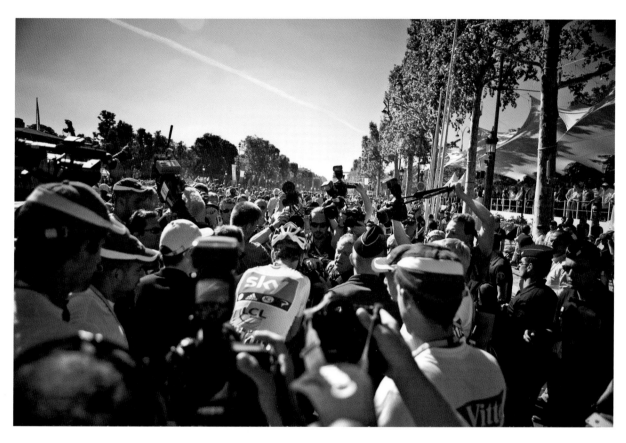

And so to the Avenue des Champs-Elysées, awash with 'Allez Wiggo' banners and Union flags. It was, said Wiggins, 'goose-pimple time' amid congratulatory hugs, an exhilarating afternoon in glorious sunshine to fulfil those dreams he had savoured as a bike-mad mod pedalling around a Kilburn council estate. But after an intense 20 days, it's hard to come out of the bubble when you're still with your team, still on your bike, still feeling great. And there were still some tactics to execute. Wiggins, not only the first Briton to win but also the first Olympic gold medallist from the track to win the Tour de France, was going to lead out the first British World Champion in 46 years to sprint to his own record victory. The yellow jersey would set up a sprint for the rainbow jersey.

'I watched Bradley cross the line the day before and thought "great", because he would be there to support Cav too!' said Bernie Eisel. 'We could rely on him. The Champs-Elysées is like Cav's living room, but the day started with me thinking, ok, just keep riding, because at

the end Bradley will be supporting too.' Christian Knees was not so sanguine. Wiggins's ever-diligent protector did not start to accept the victory until he'd seen his team leader safely cross the line on the Paris cobbles. 'Even there I was working, I came out to the front and Brad pushed me in front downhill ... I was thinking "Keep your fucking hand on the handlebar!" It was brilliant to be riding there with him on the back wheel, a real honour to be first on the Champs-Elysées. It was a very happy moment for me.'

No rider had ever won three times consecutively on the Champs-Elysées, but in 2011 Mark Cavendish snatched that record. Could he possibly achieve a fourth? Could he add another magical record to Team Sky's day of glory? The answer was yes. 'The Champs-Elysées is special for every rider, because you reach those cobbles and you know you've got to the finish of the Tour de France. To win there, though, is the Holy Grail for every sprinter,' he said. 'It's not easy. The distance from the far corner is too far ...

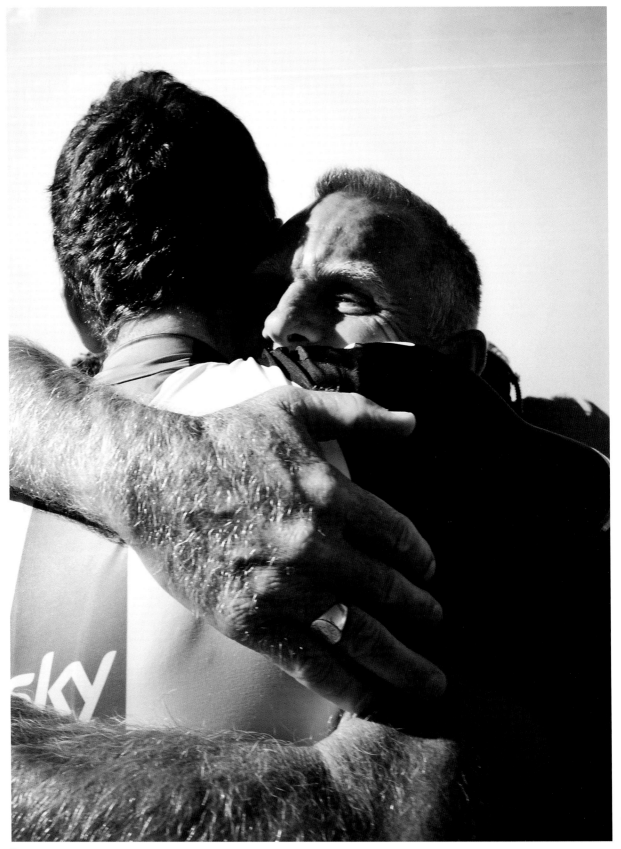

you have to time it right … you have to be instinctive. It's tricky because it's man-to-man stuff. We wanted to go out with a bang. The break went away, Brad led me out in the yellow jersey, then Edvald went so fast around that corner … On other sprints you don't want to go 100 per cent, you've still got a Tour to get through, but on the Champs-Elysées there's nothing to hold back for. It was super.'

The scene was extraordinary, too much to take in. A one-two for Wiggins, Froome, Team Sky and Britain on the podium. A record victory for Cavendish, making him, in terms of all-time stage wins, the best sprinter in the history of the Tour. A city full of Union flags, buzzing with patriotic fervour. A nation back home invigorated by another British cycling show of world-class domination.

'It's difficult to know what to feel,' said Wiggins in a state of shock. 'The thing that's struck me most is just what my win means to other people around me, like the Team Sky photographer breaking down in my room and my mechanic being in tears. You just think, "Fucking hell, everyone else around me is living it too."'

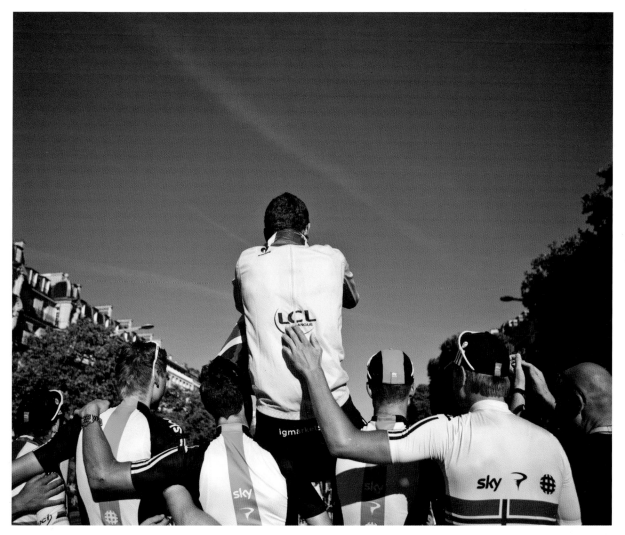

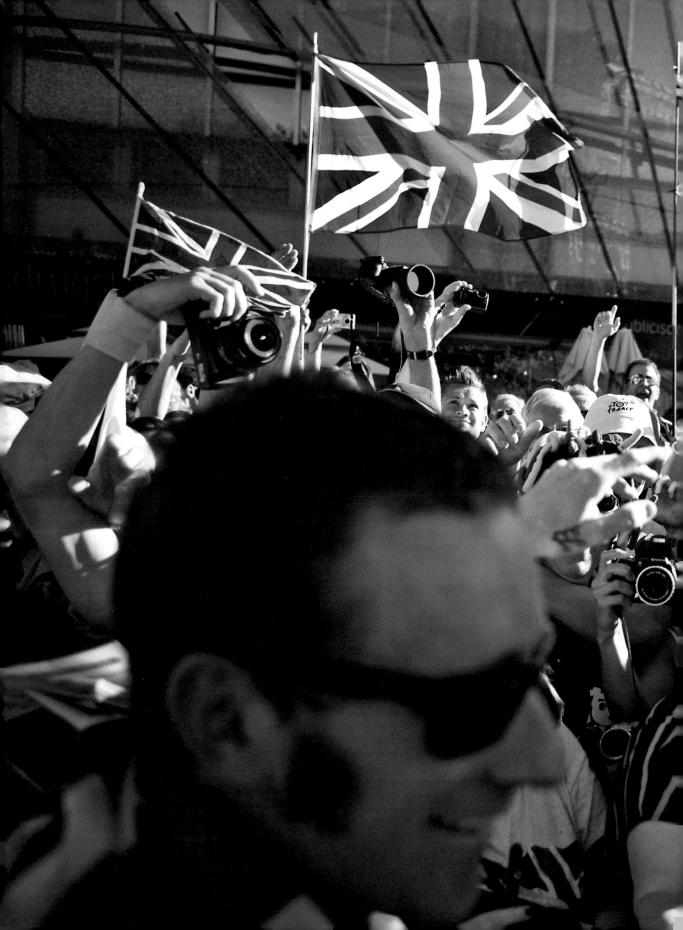

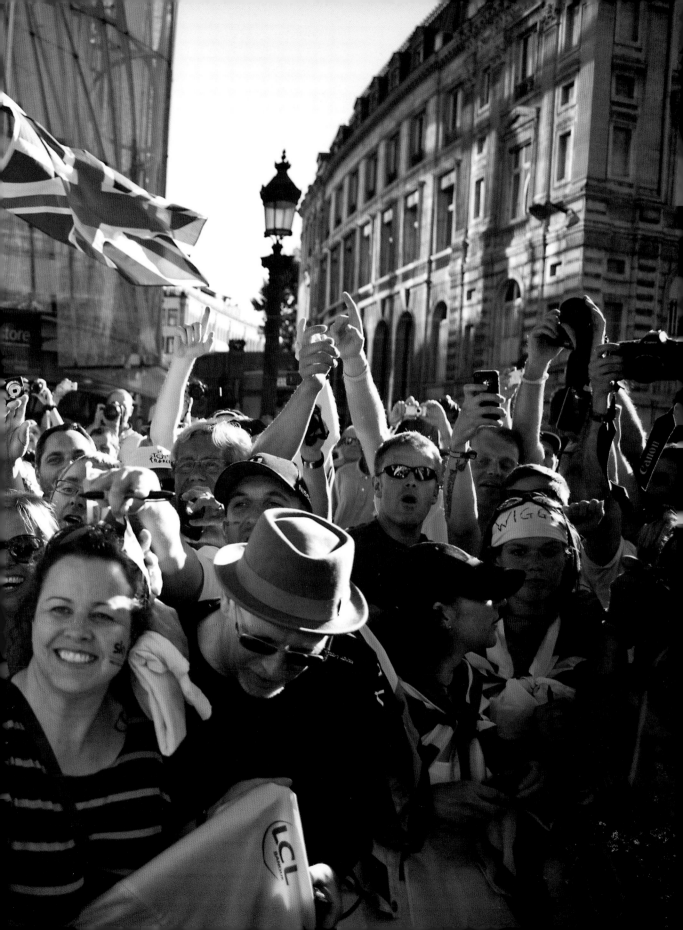

THE DETAIL

'For those 21 days you don't think about the outcome. You don't think about "what if I win" or "what if I lose".
You focus on the process, and on delivering that process on a minute-by-minute, hour-by-hour, day-to-day basis.'

Dave Brailsford

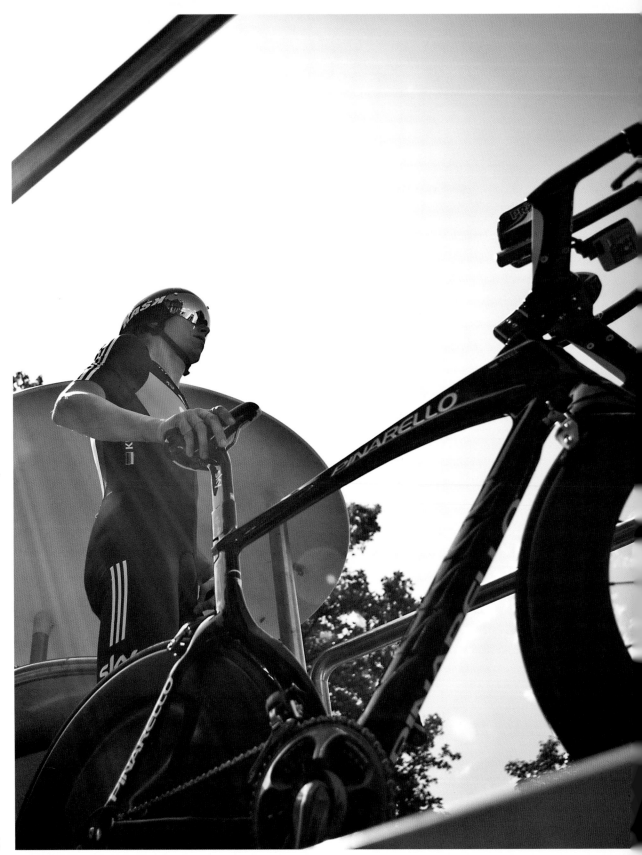

ROUTE/ The 2012 Tour riders burst from the start-house ramp at 2pm, in two-minute intervals, to sprint from one side of the Parc d'Avroy in Liège and finish on the opposite side over 6.4km through the city centre.

THE CHALLENGE/ A short, tough, quick-fire test would provide the start order for Stage 1. The route required plenty of acceleration and braking, favouring racers with a wily reading of lines through corners and good bike-handling skills to maintain speed. The short distance – 6.4km out of the Tour's 3,500km – meant it was imperative for the title contenders to claim as big a time advantage as possible to prevent a nerve-fraying first road-stage phase.

HOW IT UNFOLDED/ Andriy Grivko, the four-time Ukrainian time-trial champion, was fourth down the ramp and established the early standard, posting a time of 7 minutes 28 seconds. Midway through the procession of 198 racers, Sylvain Chavanel of France laid down a stunning time of 7 minutes 20 seconds, which looked unbeatable until Bradley Wiggins crossed the line. Wiggins was six seconds down at the intermediate split, but responded by powering through the second half to shave less than half a second from Chavanel's time.

However, Fabian Cancellara – the Swiss time-trial specialist described as 'a motorbike in prologues' – raced home in 7 minutes 13 seconds to take his fifth opening-day win, equalling Bernard Hinault's record of starting the first stage in the yellow jersey for a fifth time. Cancellara beat Wiggins by seven seconds. Chavanel was third.

How did Wiggins's main GC rivals fare? Cadel Evans, the defending champion, finished 10 seconds off in 13th place. Ryder Hesjedal, the 2012 Giro d'Italia winner, and Vincenzo Nibali failed to threaten. World time-trial champion Tony Martin suffered a puncture and finished 23 seconds adrift. Peter Sagan, the in-form Slovakian chasing the green points jersey, lost seconds when he came close to crashing on a roundabout.

'I'm really happy,' said Wiggins. 'I did say to the team last night that there was one man who could beat me and that was Fabian. He is king of these prologues, the best in the world without a doubt.'

Going forward, Team Sky was right in the mix. Without the stress of defending the yellow jersey, the team could concentrate on protecting Wiggins in the torrid early days and also work for Mark Cavendish in the forthcoming stages with sprint opportunities.

'We are in a great position. When Bradley opened up it was plain to see his condition is good. It is just a question of staying out of trouble, starting tomorrow,' said Sean Yates.

> 'It's the perfect start. I was really calm, really relaxed. I felt fantastic out there. I didn't take any major risks. I concentrated and it was everything we have been training for.'
>
> Bradley Wiggins

PROLOGUE RESULT:

Winner: Fabian Cancellara (SWI); Radioshack Nissan Trek; 7'13"; 13.470 (53.2km/h)

2. Bradley Wiggins (GB); Team Sky; + 0.00.07

3. Sylvain Chavanel (FRA); Omega Pharma Quickstep; + 0.00.07

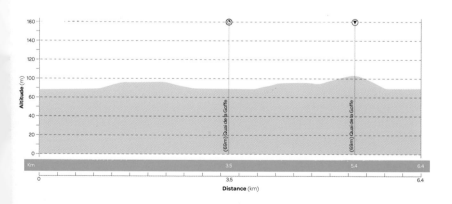

Prologue
0.00.00

Saturday 30 June / Liège to Liège, 6.4km / Individual Time Trial 151

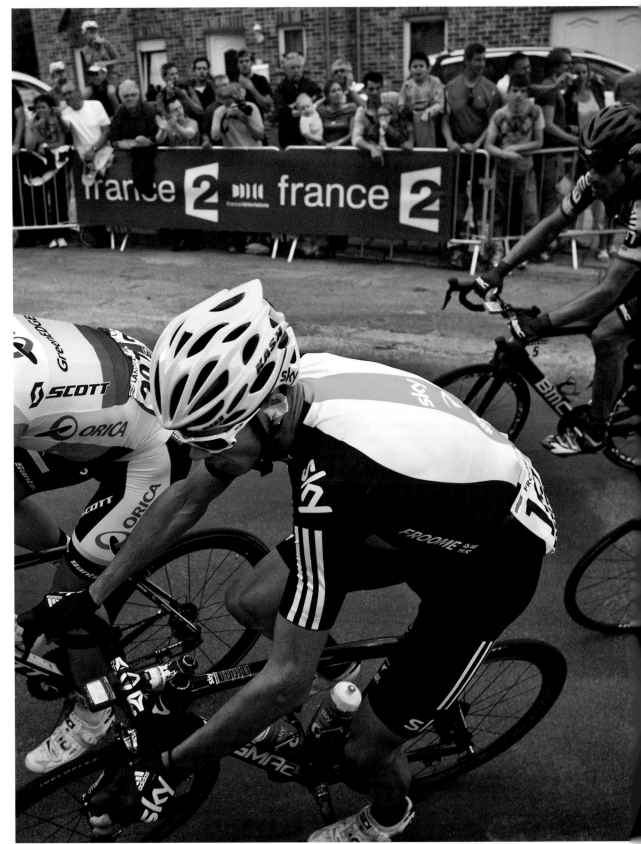

ROUTE/ The undulating forest-covered terrain of the Ardennes provided five Category-4 climbs for the first full day's racing. Dense woodland, punctuated by industrial scars left by Belgium's coal and steel industry, formed the backdrop to the day's pictures from the peloton. The finish was at the top of a long, steep drag – the Côte de Seraing – which rises for 2.4km at an average of 4.7 per cent.

THE CHALLENGE/ The stage suited punchy racers who climb well, not the sprinters. The priority for Bradley Wiggins in these early stages was to get through the day safely with minimum loss of time.

HOW IT UNFOLDED/ Six riders made a break early after the start in Liège, leading over the first four climbs of the day and staying clear for nearly 190km. The break was caught with approximately 10km remaining, when the steady progression of the peloton burst into a hectic bustle as it broke up, the riders jostling for position on the final climb to the finish at Seraing.

Peter Sagan of Slovakia, tracking Fabian Cancellara, coolly outwitted the race leader by ignoring his call to go past him with 500m remaining, then pouncing 50m from the line to sprint past the Swiss rider and Edvald Boasson Hagen to take victory. Sagan, making his Tour debut at the age of 22, became the youngest stage winner since Lance Armstrong in 1993.

Bradley Wiggins retained a 10-second lead over defending champion Cadel Evans. Stage 1 was notable for the way in which Wiggins successfully staved off a fierce uphill sprint attack from the Australian. Wiggins, having trained specifically at Team Sky's Tenerife training camp to negate such attacks, instinctively anticipated the move. At the start of the climb, Wiggins moved up through the field, tucked in behind Evans and shadowed him all the way to the line, finishing in the group behind Sagan.

Behind Wiggins, Team Sky had a fraught run-in. Michael Rogers was involved in a minor crash caused by a spectator 23km from home. Chris Froome suffered a puncture nine miles from the finish, prompting the call to Richie Porte and Christian Knees to turn back to help him.

Team Sky riders wore yellow helmets as part of an innovation created by the organisers for the 2012 race. They earned the right to do so thanks to their domination of the prologue. The team honoured their new distinction by winning the Stage 1 team classification too; Sky was one of only eight of the 22 teams that had riders in the same group as the stage winner in Seraing – which entitled the British squad to wear yellow helmets again for Stage 2.

Going forward, Cancellara retained the race lead seven seconds ahead of Wiggins, who was happy to have kept out of trouble and come through unscathed.

'It was pretty sketchy at times. I got really nervous once that first crash happened. Brad drifted back at one stage but he was with Bernie Eisel and it was easier to move up on the climb than on the flat. He just waited for that and moved up very comfortably on the outside. I don't think people can attack Brad on these punchy little climbs anymore. We've come through it. The first day's done. Still here to fight another day.'

Dave Brailsford

STAGE 1 RESULT:

Winner: Peter Sagan (Svk); Liquigas-Cannondale; 04h 58'19"
2. Fabian Cancellara (Swi); RadioShack-Nissan ; same time
3. Edvald Boasson Hagen (Nor); Team Sky; same time

HOW TEAM SKY FINISHED STAGE 1:

3. Edvald Boasson Hagen (Nor); 04h 58' 19" + 00' 00"
16. Bradley Wiggins (GB); 04h 58' 19" + 00' 00"
22. Michael Rogers (Aus); 04h 58' 19" + 00' 00"
26. Kanstantsin Siutsou (Blr); 04h 58' 19" + 00' 00"
95. Chris Froome (GB); 04h 59' 44" + 01' 25"
128. Mark Cavendish (GB); 05h 00' 26" + 02' 07"
162. Richie Porte (Aus); 05h 02' 00" + 03' 41"
184. Christian Knees (Ger); 05h 02' 00" + 03' 41"
191. Bernhard Eisel (Aut); 05h 03' 09" + 04' 50"

OVERALL CLASSIFICATION:

1. Fabian Cancellara (Swi); RadioShack-Nissan; 05h 05' 32"
2. Bradley Wiggins (GB); Team Sky; 05h 05' 39" + 00' 07"
3. Sylvain Chavanel (Fra); Omega Pharma-Quick Step; 05h 05' 39" + 00' 07"

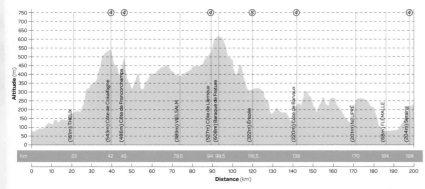

Stage 1
THEY'RE OFF
Sunday 1 July / Liège to Seraing, 198km

ROUTE/ Travelling west from French-speaking Walloon country to the Dutch-speaking Flanders territory, this stage was as flat as a local crêpe. Breakaways would be common, with the peloton keeping a wary eye on the gap. Typically, the bunch expect to catch a break on flat terrain at a rate of one minute per 10km. In expectation of a sprint finish, huge crowds gathered in Flanders where bike racing is followed fanatically.

THE CHALLENGE/ With only one Category-4 climb – at the halfway point, a 2.1km ascent to Côte de la Citadelle de Namur, a castle on a limestone crag that overlooks the city – the day promised the first duel between the sprinters. Wiggins again was looking to stay in the bunch and emerge unscathed.

HOW IT UNFOLDED/ Anthony Roux broke from the pack after 22km with fellow Frenchman Christophe Kern and Michael Morkov of Denmark in pursuit. The trio spent much of the race out ahead alone, taking the top three placings at the intermediate sprint. Roux launched another solo attack, but Kern and Morkov let him go and eased back into the peloton, which then collectively gave chase and reeled in Roux with 15km remaining.

All eyes were on the sprinters: Mark Cavendish, André Greipel, Matt Goss and co. Two kilometres from the finish, the bunch upped the tempo and Cavendish unleashed an awesome, well-timed burst of speed to snatch victory from Greipel by half a wheel. It was his 21st Tour stage victory, moving him into sixth place on the all-time list, behind Lance Armstrong.

Wiggins finished comfortably in the bunch, as did Cancellara and Evans, leaving the GC standings unchanged.

'With 5km to go, Bernie and Edvald were with me, but I told them I would take it from there,' said Cavendish. 'I saw the space and opportunities and did what I always do. Normally I win by a bike length, today I had to lunge. If it was just the sprinters involved at the finish it would be good to have two or three helpers, but all the GC riders were there as well, and when that happens it can be best to go on your own. Also, if you are asking Bernie and Edvald to move me up at that speed, 70km plus, that's incredibly hard. I would have killed them by the end of the week!

'People have got to understand that there is one objective in our team and that is for Brad to win the yellow jersey. If I can win some sprints along the way, that's fine, but we are here to win yellow.'

'I knew it would be difficult, dangerous and hectic here, but I came in without any pressure. It was just about being plucky about it. I knew the finish and knew there was a headwind, so I knew you could come from behind.'

Mark Cavendish

STAGE 2 RESULT:
Winner: Mark Cavendish (GB); Team Sky; 04h 56'59"
2. André Greipel (Ger); Lotto; same time
3. Matt Goss (Aus); Orica; same time

OVERALL STANDINGS
1 Fabian Cancellara (Swi); RadioShack; 10h 02' 31"
2 Bradley Wiggins (GB); Team Sky; @ 07"
3 Sylvain Chavanel (Fra); Omega Pharma; same time

Stage 2
MASTERCLASS IN SPRINTING
Monday 2 July / Visé to Tournai, 208km

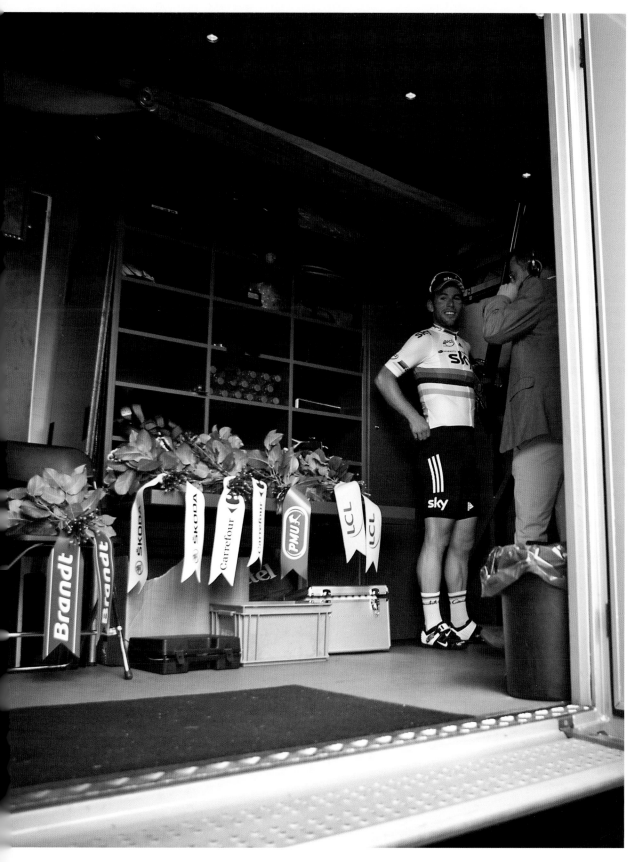

ROUTE/ A brutal test, starting on cobblestone back lanes and ending on a 700-metre lung-busting slog uphill after a trip around the wind-lashed tops of the Monts du Boulonnais above the port of Boulogne. The day included six climbs – two Category-3 and four Category-4 – with the first kicking in 35km from the finish.

THE CHALLENGE/ The third of three tough opening road stages will show form and intent.

HOW IT UNFOLDED/ Polka-dot jersey holder Michael Morkov led a breakaway for the third time in as many stages when he disappeared with Andriy Grivko, Giovanni Bernaudeau, Ruben Perez and Sébastien Minard. Thereafter the day's chase was marred by several pile-ups. Team Sky's Kanstantsin Siutsou crashed out, fracturing his left tibia, and became the first rider to pull out of the 2012 Tour – a fate which was played up by rivals as bad news for Wiggins, now a team mate down. A later crash saw José Joaquín Rojas, who was second in the points classification in 2011, also withdraw.

The Fast Five were swallowed up by the bunch, with Grivko holding out until 7km to the finish, where Chavanel launched an attack on the descent of the penultimate climb. Into the final kilometre the peloton hunted Chavanel down on tight narrow roads in a nerve-fraying finish. The Frenchman capitulated, caught by a dynamic peloton with Wiggins, Evans and Sagan all in contention.

More drama. A crash within sight of the line saw Wiggins trapped while a group of 20 riders went clear. Sagan pressed on for victory and claimed the stage ahead of Team Sky's Edvald Boasson Hagen to retain the green points jersey. It was tense for Wiggins. He finished 53rd, almost a minute down, but was awarded the same time as the winner because of a rule regarding crashes in the final 3km, thus remaining second overall, seven seconds behind Cancellara.

'You can't look backwards in this sport, you have to look forwards. It's like boxing. You take a punch, but as long as you have still got gloves on and are fighting you can still knock the other bloke out. That's the approach we have got to take,' said Brailsford.

'It's not ideal because Kosta is a strong rider, a classic mountain domestique and one of the key workers in the team. We are sad to see him go home. The first week of the Tour is inherently risky. You just have to take it on the chin. It's a question of staying upright on your bike. Bradley has done that today. He has got through. Another box ticked.'

'It's a setback, but not a devastating setback. Bradley's a very good climber so he can do that first part in the key mountain stages. But to be honest the climbing department, as it were, is probably where we're at our strongest.'

Dave Brailsford

STAGE 2 RESULT:
Winner: Mark Cavendish (GB); Team Sky; 04h 56' 59"
2. André Greipel (Ger); Lotto; same time
3. Matt Goss (Aus); Orica; same time

OVERALL STANDINGS
1 Fabian Cancellara (Swi); RadioShack; 10h 02' 31"
2 Bradley Wiggins (GB); Team Sky; @ 07"
3 Sylvain Chavanel (Fra); Omega Pharma; same time

Stage 3
A MAN DOWN
Tuesday 3 July / Orchies to Boulogne-sur-Mer, 197km

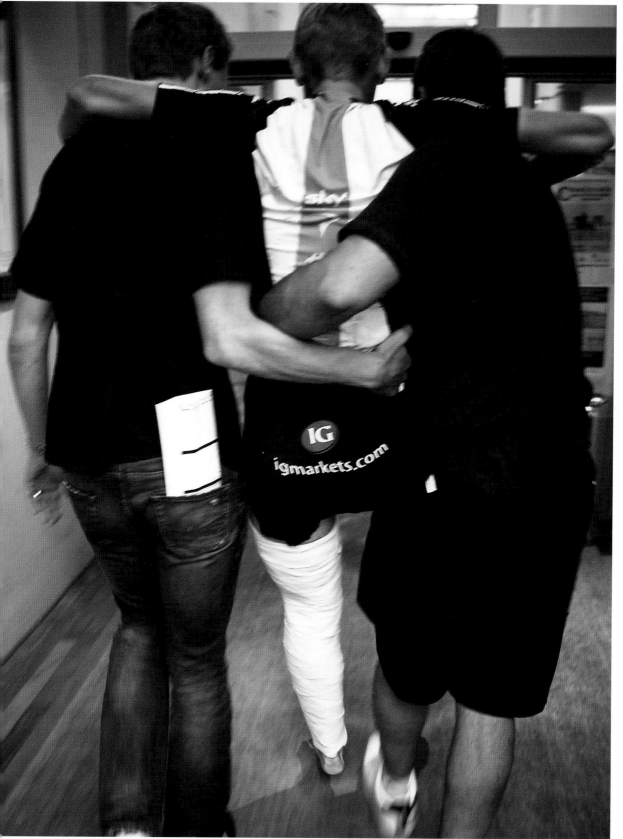

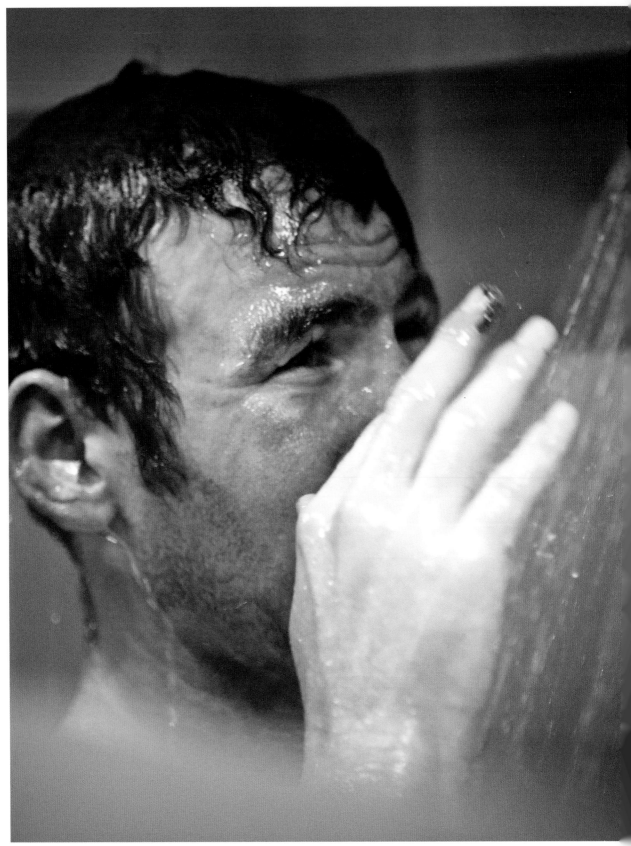

ROUTE/ One of the longest stages, and relatively flat, the route looked tantalising for sprinters. With 100km of the action rolling south-west down the Picardy coast, high crosswinds and uneven exposed roads heightened the possibility of crashes.

THE CHALLENGE/ Not necessarily a routine sprint. Troublesome crosswinds could split the field. If a breakaway included one of the top contenders, they could opt to emulate the tactics beloved of Tour legends Eddy Merckx and Lance Armstrong; i.e., putting the hammer down to stay unreachable.

HOW IT UNFOLDED/ Yukiya Arashiro, of Japan, and the French pair David Moncoutie and Anthony Delaplace, launched an audacious break within minutes of the start in the Normandy sunshine and at one point held a lead of nearly nine minutes. Initially the wind remained gentle. A topless couple in novelty wigs amused the peloton at the halfway point of the race.

Within a few kilometres of the finish, the trio were reeled in, and though a handful of riders – including Samuel Dumoulin, Sylvain Chavanel and Wouter Poels – broke out again, the peloton soon reeled them in to set up a bunch sprint finish.

At 4.39pm, with the peloton travelling at 44mph, and 2.6km from the end, a huge clattering crash saw Robbie Hunter suffer a horrible fall after clipping a wheel. Cavendish, well positioned to launch a bid for his 22nd Tour stage victory, went down hard. Eisel also hit the deck. Both Team Sky riders got back to cross the line, but the race was won by a bike-length by Greipel, a former team mate of Cavendish. Tom Veelers of the Netherlands took third with Peter Sagan in fifth retaining the green points jersey.

'It was certainly not what we wanted to see. Nobody wants to see crashes for anybody and we were among the victims again today. They are fine, nothing broken, although there are always a few bumps and bruises when you hit the deck at that speed,' said Sean Yates, Team Sky's sport director. 'They are not happy, though; there was a fair bit of bad language because it was a chance missed at a win. A bit of massage and physio should sort it, but obviously it's not ideal that the next stage is a sprint as well. When you do cut yourself, your body requires strength to heal itself; it can take the edge off your sprinting.'

Cancellara, who has led the GC since winning the opening prologue, retained the yellow jersey after narrowly avoiding the pile-up and managing to safely cross the line. The overall standings were unaffected, with Wiggins still seven seconds behind.

> 'Ouch. Crash at 2.5km to finish today. Taken some scuffs to my left side, but I've bounced pretty well again. Congrats to André Greipel.'
>
> Cavendish on Twitter

STAGE 4 RESULT:

Winner: André Greipel (Ger); Lotto; 05h 18' 32"
2. Alessandro Petacchi (Ita); Lampre; same time
3. Tom Veelers (Ned); Argos; same time

OVERALL STANDINGS:

1 Fabian Cancellara (Swi); RadioShack; 20h 04' 02"
2 Bradley Wiggins (GB); Team Sky; @ 07"
3 Sylvain Chavanel (Fra); Omega Pharma; same time

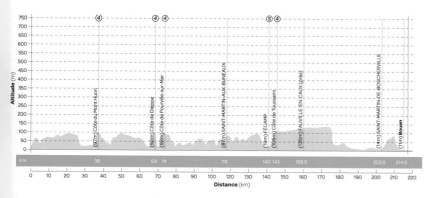

Stage 4
OUCH
Wednesday 4 July / Abbeville to Rouen, 215km

ROUTE/ Starting in Rouen – which, in pre-Roman days, was the capital of a tribe known as 'Velocasse', ancient franglais perhaps for 'broken bike' – the route wound north-east through pretty, undulating roads in Normandy then ventured across Picardy to finish in St Quentin. The stage presented sprinters with an appealing dead straight and flat last 25km.

THE CHALLENGE/ The second big day for sprinters. If a breakaway group didn't achieve a serious buffer of time advantage they would be overrun by the peloton as it blasted into St Quentin.

HOW IT UNFOLDED/ Team Sky bore the previous day's war wounds – Cavendish with a sore hand and Eisel with stitches above his eye – and they set off in yellow helmets determined to keep at the front as a tight unit.

Matthieu Ladagnous led a breakaway pursued by Jan Ghyselinck, Julien Simon and Pablo Urtasun. The peloton allowed the quartet to build up a lead of more than five minutes before reeling them back in. Team Sky rode in a train on the left-hand side of the peloton during the closing kilometres. It was all about keeping Wiggins near the front and out of bother while giving Cav – on Isle of Man Day – a chance to go for the

sprint finish. It looked as though the plan had worked until Tyler Farrar brought several riders down in the bunch with 3km remaining. Team Sky's riders were unaffected but Sagan was among those taken out.

While the bunch regrouped, Ghyselinck attacked his fellow escapees and was within sight of the finish when Greipel, Goss, Haedo and Cavendish surged past him. If 'trundling on' characterised much of this stage, the finish was a thriller. Ghyselinck's bid for glory nearly paid off, but the sight of the world's top sprinters giving it everything off the final bend was awesome.

Wiggins remained second overall, seven seconds behind Cancellara. 'Everyone realises where the safest place to ride is. It was a conscious effort. We've got the legs. We've got one of the best teams here and Dave B said in the morning to "stop dithering" and we did that,' Wiggins said. 'It was nice to hit the front and open up a little bit because you risk "de-training" in the first week. It's so easy in the peloton. You're literally doing nothing at times. We knew it was going to be a bunch sprint. Yesterday was a bit messy and mad so we wanted to stay out of that and avoid crashing at this late stage before we get to the hills and this race settles down.'

'I've been a bit caught up in all of the mess the last few days and obviously, thinking about last year and what happened when I crashed, it was a conscious effort [to stay out in front].'

Bradley Wiggins

STAGE 5 RESULT:
Winner. André Greipel (Ger); Lotto; 196.5km in 04h 41' 28"
2. Matt Goss (Aus); Orica GreenEdge; same time
3. Juan José Hædo (Arg); Saxo Bank; same time

OVERALL STANDINGS:
1. Fabian Cancellara (Swi); RadioShack; 24h, 45', 32"
2. Bradley Wiggins (GB); Sky; @ 7"
3. Sylvain Chavanel (Fra); Omega Pharma; same time

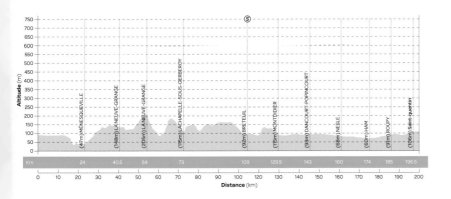

Stage 5

STOP DITHERING

Thursday 5 July / Rouen to St Quentin, 197km

ROUTE/ From the vineyards of Champagne to the wine-growing lands of Moselle, this stage was the last day of gently undulating terrain before the Tour hit the mountains. The route snaked in and out of landforms and settlements, with an ever-present danger that momentary loss of concentration would cause a touching of wheels.

THE CHALLENGE/ In the third-longest stage, accumulated fatigue was a potential factor that needed consideration.

HOW IT UNFOLDED/ Until the halfway point most of the riders were pootling along, unconcerned about reeling in a four-man break-away group which comprised Davide Malacarne, Romain Zingle, David Zabriskie and Karsten Kroon. The pattern of the day was dramatically interrupted by several big crashes that left 29 riders needing medical treatment and 10 taken to hospital.

The first accident occurred 35km in, and saw Greipel injured and unable to try to become the first rider since Lance Armstrong in 2004 to win three consecutive stages. There was a second low-paced tumble after the intermediate sprint, but the worst came in the peloton 25km from the finish on the run-in to Metz – caused, apparently, by a rider removing a cover from his shoe and swerving at speed. 'Never been to war and pray

that I never do but I think that might be the closest I get,' tweeted veteran Christian Vande Velde.

Mangled bike frames and wheels littered the road. Riders sat dazed on the verge, others sat bleeding and nursing smashed knees, thighs and ankles across the tarmac. Those that escaped injury scrambled to reach new bikes to get going again. Team Sky riders missed the 70km/h tidal wave of debris described by riders as 'the scariest' they'd ever experienced, though Cavendish and Boasson Hagen were held up and missed the sprint.

Sagan sprinted to a third stage win, powering past Greipel, who had been injured in the first crash of the day. The big pile-up affected Wiggins's GC rivals: Frank Schleck, who finished 3rd last year, and Ryder Hesjedal, were down to 37th and 108th places respectively in the overall standings.

Wiggins was happy to have survived the first week unscathed and to be going into the mountain stages on an equal footing with Evans, just seven seconds behind Cancellara who still held the yellow jersey.

'In a split second everything changed and all hell was let loose. The importance of spending that bit of energy to be at the front of the bunch is well worthwhile. Five minutes before that crash happened Brad came right up to the front and it was one of the best moves he's made so far,' said Brailsford.

'It's been a mad first week.'
Bradley Wiggins

STAGE 6 RESULT:
Winner. Peter Sagan (Svk); Liquigas; 04h 37'
2. André Greipel (Ger); Lotto; same time
3. Matt Goss (Aus); Orica GreenEdge; same time

OVERALL CLASSIFICATION:
1. Fabian Cancellara (Swi); RadioShack; 29h 22' 36"
2. Bradley Wiggins (GB); Sky; @ 7"
3. Sylvain Chavanel (Fra); Omega Pharma; same time

Stage 6
BRAKE AND PRAY
Friday 6 July / Épernay to Metz, 208km

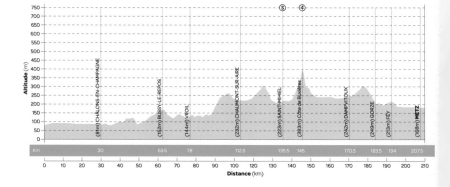

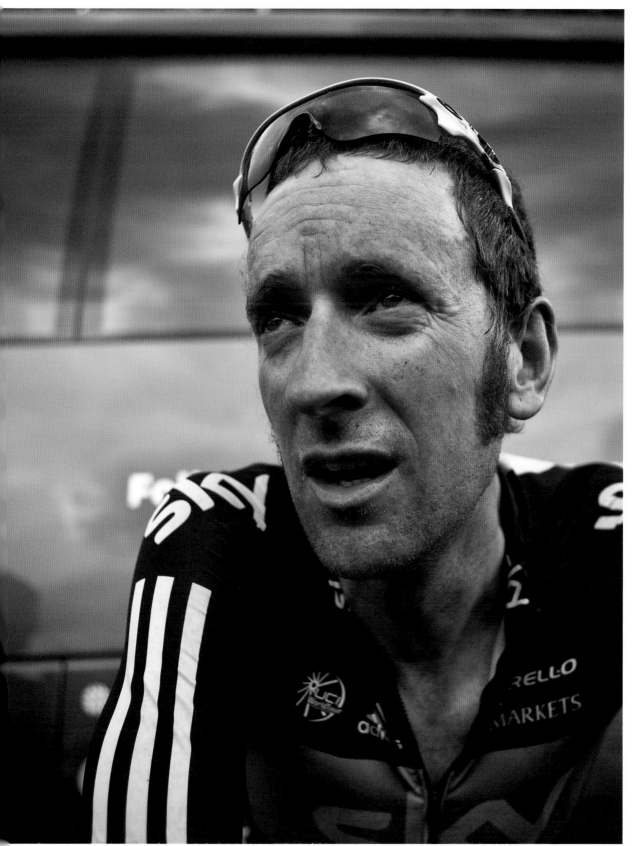

ROUTE/ The first serious climbing stage was set to finish on a 'new' mountain – La Planche des Belles Filles. The riders started in the Meurthe-et-Moselle department and headed into the Vosges hills for the slog along tough roads with two challenging warm-up climbs – the Col de Grosse Pierre and the Col du Mont de Fourche – before the final killer climb to the summit finish.

THE CHALLENGE/ The terrain favoured breakaway posses so the favourites needed their super-domestiques to help them hit the climb in the best position. With Cancellara, a time-trial specialist, leading by just seven seconds, the yellow jersey was up for grabs.

HOW IT UNFOLDED/ The peloton was now 11 riders down, with many riding sore. Rabobank, for example, claimed to have notched up 15 crashes, two broken ribs, one punctured lung and one square metre of missing skin. In what would be a milestone stage, seven riders broke clear after 15km but were eaten up as Team Sky's Boasson Hagen, Rogers and Porte set a blistering pace up the climbs to split the peloton wide open. Cancellara, not expected to keep pace, duly dropped away on the final climb.

Porte dropped back with 2km remaining, leaving Froome to take his turn at the front. Wiggins continued to be paced up the mountain with Evans, Vincenzo Nibali and Rein Taaramäe also in the hunt for the stage win. Evans attacked near the summit, but Wiggins followed and Froome launched a counter-attack on the 20 per cent gradient, 500m from the line, before riding away for an unexpected victory. Wiggins followed Evans over the line to take the race lead. On 8 July he would become the fifth Briton to wear the yellow jersey, following Tom Simpson (1962), Chris Boardman (1994, 1997, 1998), Sean Yates (1994) and David Millar (2000).

A psychological, as well as symbolic, blow had been dealt too, as the team supporting Evans was nowhere when it counted. 'It is an amazing feeling. It went perfectly for us. The boys put it on the line and did a fantastic job. Froomey was mind-blowing – he is just going from strength to strength – and we got the yellow jersey, so it is fantastic,' said Wiggins.

'To be in the yellow jersey was a childhood dream of mine. I'd sit on the home trainer watching my Tour de France hero, Miguel Indurain.'

At the end of the first week, Team Sky took the yellow jersey, the King of the Mountains jersey (Froome) and also boasted three men in the top 10. It was an emphatic all-round show of power.

> 'It's a great day for me and yes, of course, it had been a dream of mine. I know the history of this race and I feel very honoured. One year on from lying in hospital after crashing, here I am in the jersey.'
>
> Bradley Wiggins

STAGE 7 RESULT:

Winner. Chris Froome (GB); Team Sky; 04h 58' 35"
2. Cadel Evans (Aus); BMC; @ 2"
3. Bradley Wiggins (GB); Sky; @ 2"

OVERALL STANDINGS:

1. Bradley Wiggins (GB); Sky; 34h 21' 20"
2. Cadel Evans (Aus); BMC; @ 10"
3. Vincenzo Nibali (Ita); Liquigas; @ 16"

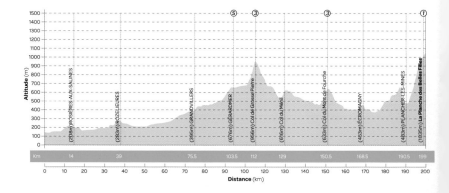

Stage 7
YELLOW
Saturday 7 July / Tomblaine to La Planche des Belle Filles, 199km

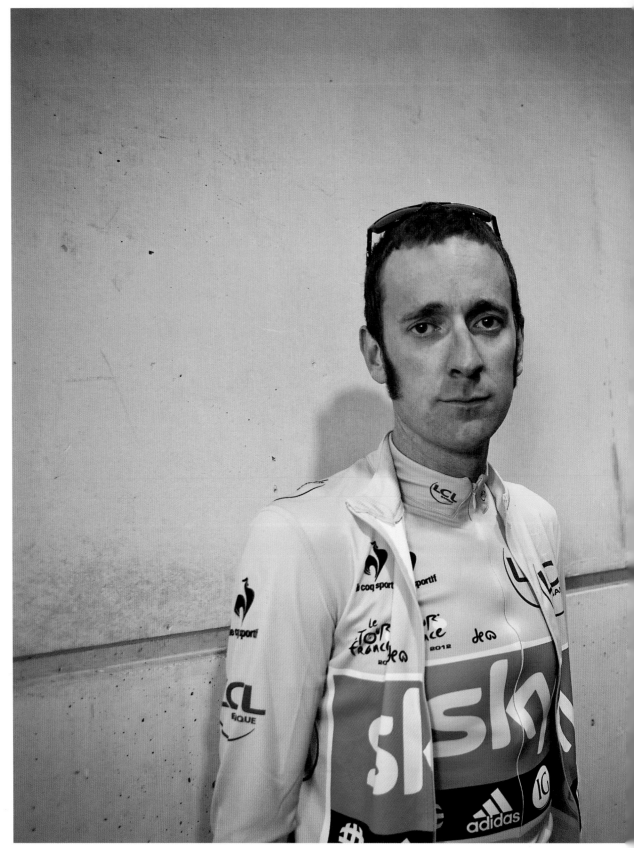

Seven hard climbs. The last three had very testing sections, including a Category-1 hill at Col de la Croix, a mere 16 km from the finish. This was billed as the stage with 'nowhere to hide, nowhere to rest'. The flat road was at the start and finish. The riders headed out from Belfort in the north-east of France and finished up in the picturesque Swiss municipality of Porrentruy.

THE CHALLENGE/ A very fast stage. The climbers would aim to squeeze as much as possible from this stage.

HOW IT UNFOLDED/ The scene was set for a scintillating day in a frenetic opening 60km with several attacks and counter attacks failing to make an impression as Team Sky strived to set the pace of the main bunch. Veteran Jens Voigt was among those trying to form a breakaway group and the German eventually made a solitary break but he was reeled in on the fourth climb, the Côte de Saignelégier.

Intense riding claimed another casualty as Olympic road race champion Samuel Sanchez briefly lost consciousness after hitting his head in a crash and was pictured in tears, his 2012 Tour and Olympics over.

The attacks continued. Jeremy Roy also enjoyed the lead before Fredrik Kessiakoff picked him off and made his own bid for victory. However, with the final summit almost in sight, Pinot stole the show. In a thrilling piece of solo riding, the youngest rider in the Tour was urged on over the final 10km by his FDJ-BigMat manager Marc Madiot shouting and banging the side of the team car. 'I lived through the longest 10km of my life,' said Pinot. 'When I saw the peloton had got to within 50 seconds with 10km to go, I began to panic. If I wanted a stage victory, it was now or never.'

For Team Sky, the real drama was happening behind Pinot, as Wiggins repelled late attacks from first Nibali, the expert descender, and then Evans, the defending champion, who made his move on the descent into Porrentruy. The trio finished together, in a bunch 26 seconds behind 22-year-old Pinot. Kessiakoff took the polka dot King of the Mountains jersey from Chris Froome, who came home in the same group as Wiggins to move up to sixth in the overall standings.

'Vincenzo is a superb descender and we knew he would try and put us under pressure coming off that climb, but we responded,' said Wiggins. 'It's a fantastic position to be in after the first week and two tough days down. Now we have the time trial and then a rest day so it's certainly some of the toughest stages ticked off, that's for sure.'

'It was a lot harder than I expected it to be. I was surprised at the size of the group over the last climb, but we were there and we were present so it was good day for the team. The boys were incredible, they really marshalled the race fantastically and set us up to be able to go with them on the last climb.'

Bradley Wiggins

STAGE 8 RESULT:

Winner. Thibaut Pinot (Fra); FDJ-Big Mat; 03h 56' 10"

2. Cadel Evans (Aus); BMC; @ 26"

3. Tony Gallopin (Fra); RadioShack; @ 26"

OVERALL STANDINGS:

1. Bradley Wiggins (GB); Sky; 38h 17' 56"

2. Cadel Evans (Aus); BMC; @ 10"

3. Vincenzo Nibali (Ita); Liquigas; @ 16"

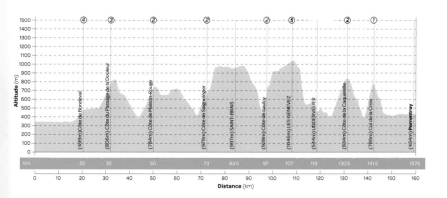

Stage 8

READY TO DEFEND

Sunday 8 July / Belfort to Porrentruy, 158km

ROUTE/ The clock starts to tick from the second the mobile start house sends each rider down the ramp and along an undulating, twisty route that hugs meandering rivers from the southern edge of the expansive Chaux forest to Besançon.

THE CHALLENGE/ The so-called Race of Truth, quite technical in places. The aim was for Wiggins to capitalise on his time-trialling talent to put a significant chunk of time between himself and Evans and Nibali.

HOW IT UNFOLDED/ Four-time world time-trial champion Cancellara, who won the opening Prologue, laid down the early marker, but Froome eclipsed his time. 'There are no tactics in something like today. This is by far the hardest event in cycling. You just have to go as fast as you can and turn yourself inside out to get the best time,' he said.

As race leader, Wiggins was the last to go and he immediately began to take time out of his rivals. At the first time check, he clocked the fastest time of 21:05, which was 1:02 quicker than Evans. He maintained his electric pace through the second time check, reaching it in 39:02 and stretching out his advantage on Evans to 1:19. He didn't relax in the

final 10km, and ended the day with a commanding overall lead, clocking 51 minutes, 24 seconds – 35 seconds faster than Froome.

Wiggins, the 32-year-old triple Olympic champion, had won his first stage on the Tour. What a way to strengthen his grip on the yellow jersey. It was another emphatic demonstration from Sky and a fantastic day for British cycling – a 1-2 on the podium.

'Time-trialling is what I do best. I know exactly the routine that I need to do,' said Wiggins. 'I felt great from the first pedal stroke and I knew I was in for a good one. This is what we have trained for. The graft during the winter, missing the kids' birthdays having been at training camps – this is what it is for. To get the stage win is fantastic.'

Evans remained second overall, but now one minute and 53 seconds behind Wiggins. The Australian had begun the day only 10 seconds adrift, but ended up fighting to stay ahead of Froome in the GC, after the Team Sky rider's performance rocketed him up to third, a further 14 seconds back. He said: 'I am really happy with today. I went hard at it. That is all I can do. I know I haven't won so there are no big celebrations, but there will be for Bradley.'

'It's never over until the fat lady sings and she's not even in the room yet. There is a long way to go and we could be faced with all sorts of situations yet. There is always the possibility of a bad day, injury or illness. It doesn't do to get ahead of yourself and you know for sure that Cadel will never give up until we get to Paris.'

Bradley Wiggins

STAGE 9 RESULT:

Winner. Bradley Wiggins (GB); Sky; 51' 24"

2. Chris Froome (GB); Sky; +35"

3. Fabian Cancellara (Swi); RadioShack; +57"

OVERALL STANDINGS:

1. Bradley Wiggins (GB); Sky; 39h 9' 20"

2. Cadel Evans (Aus); BMC Racing; +1:53"

3. Chris Froome (GB); Team Sky; +2:07"

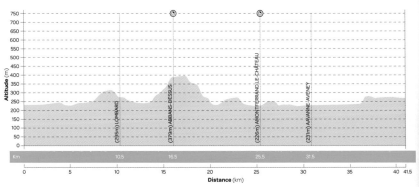

Stage 9
TIMED TO PERFECTION
Tuesday 10 July / Arc-et-Senans to Besançon, 41.5km Time Trial

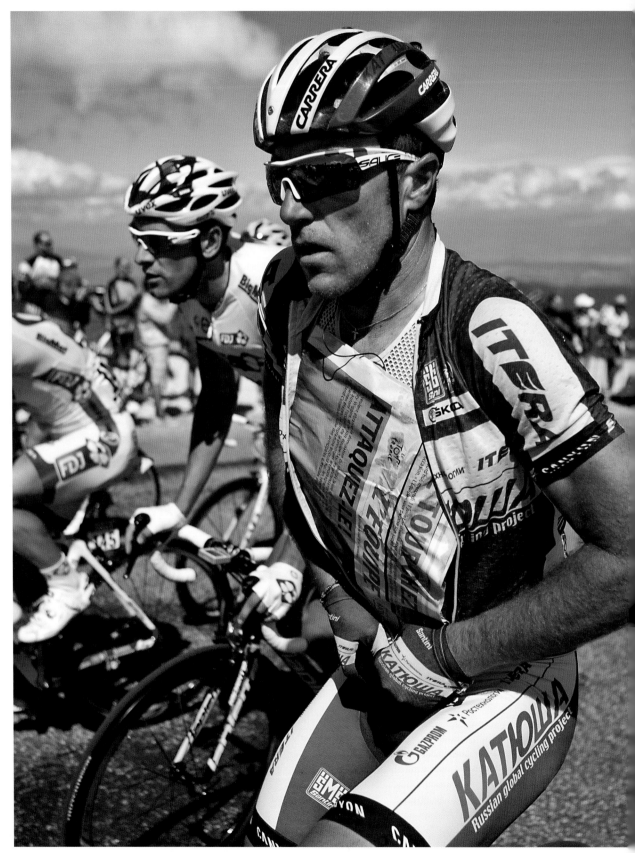

ROUTE/ After cobblestones, mini climbs, windy stages, sprinters' stages, serial short-but-steep climbs and a rest day came a stage with a knockout crazy-steep climb: the first 'beyond categorisation' challenge – the Col du Grand Colombier, aka the hardest climb in the Jura. The second of three climbs, it came shortly after the descent from the Côte de Corlier, unusual too in that it has 20km of undulating terrain at its highest point before the riders descend.

THE CHALLENGE/ Twofold. Overcoming the physical after-effects of a rest day and making best use of the Grand Colombier to attack. Team Sky were prepared: 'We have trained for the mountains and we have trained to back up one big effort after another. That's what we have to do now.'

HOW IT UNFOLDED/ By the 90km mark, a 25-strong leading group made their way up the Côte de Corlier with Team Sky at the fore of the peloton, 6 minutes 43 seconds behind the escape party. All eyes were on Nibali, the 'incredible descender', and currently fourth in the GC, just 2 minutes 23 seconds behind Wiggins. Would he put time into the yellow jersey holder?

True to expectation, Nibali attacked and gained momentum on the descent from Colombier.

Evans tried to keep pace with him but dropped back. With 2km left on the descent, Nibali, with Sagan shadowing him, continued his attack. Team Sky confidently reeled him in during the final climb, the 7.2km Category-3 Col de Richemond.

'We were prepared to lose the jersey if needs be to Michele Scarponi who was the best up there in the breakaway. It's about wearing it in Paris, not for three weeks,' commented Wiggins. 'I was waiting for Nibali to play his joker card. Fortunately he went solo and we knew that he wouldn't have the legs. It was a bit desperate really. You have to gamble a bit and let some people go, you can't chase everything that moves. But we rode hard on the next climb to get it back and it all worked out.'

Thomas Voeckler, who wore the yellow jersey for 10 days last year, was part of a 25-man breakaway which was whittled down to five riders – Scarponi, Jens Voigt, Luis Leon Sanchez and Dries Devenyns – by the end of the stage.

Team Sky did everything perfectly, with Boasson Hagen and Porte setting a fierce pace at the front of the peloton to negate any potential attacks without having to use Froome. Wiggins still leads Evans by one minute and 53 seconds, with compatriot Froome third and Nibali staying in fourth place overall.

> 'We talk over the phone when I am not with him and the team during the Tour but there is no need to say a lot. He is in control of all of his emotions and my belief is that he is untouchable at the moment.'
>
> *Team Sky's Shane Sutton on Wiggins*

STAGE 10 RESULT:

Winner. Thomas Vœckler (Fra); Europcar; 04h 46' 26"
2. Michele Scarponi (Ita); Lampre; +3"
3. Jens Voigt (Ger); RadioShack; +7"

OVERALL STANDINGS:

1. Bradley Wiggins (GB); Team Sky; 43h 59' 02"
2. Cadel Evans (Aus); BMC Racing; +1:53"
3. Chris Froome (GB) Team Sky; +2:07"

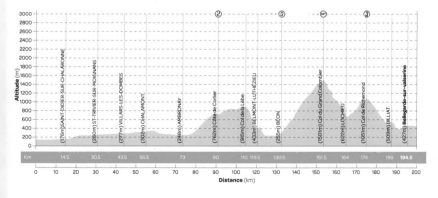

Stage 10
A KNOCKOUT CLIMB
Wednesday 11 July / Mâcon to Bellegarde-sur-Valserine, 195km

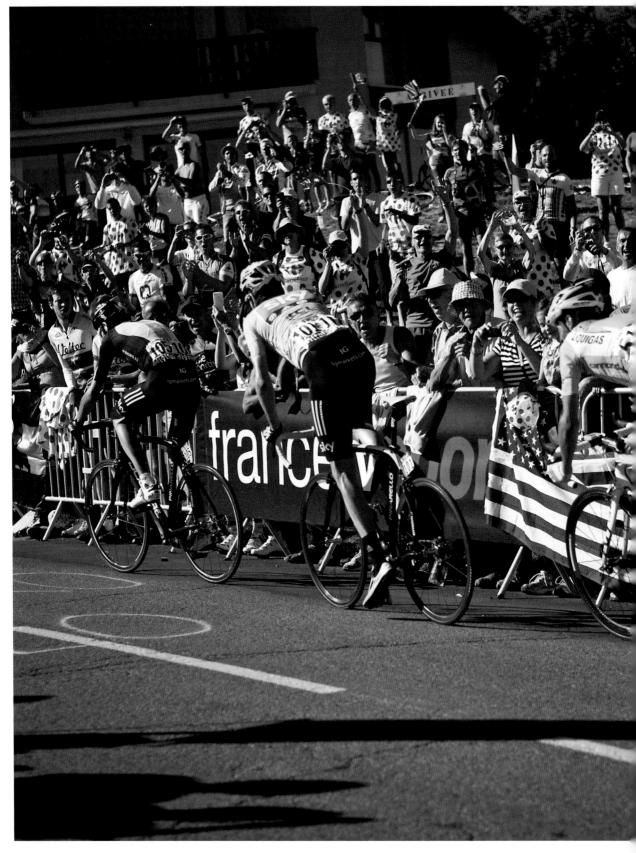

ROUTE/ The slog from Albertville, the host of the 1992 Winter Olympics, to the ski resort of La Toussuire was a brisk, brutal, Alpine odyssey boasting four mountain ascents, including two 'beyond categorisation' climbs – the Col de la Madeleine and Col de la Croix de Fer.

THE CHALLENGE/ Make or break day for climbers. Wiggins was wary of Nibali and Evans, and of teams on a quest for a big place who might blast from the start and force Sky to commit energy early in the stage.

HOW IT UNFOLDED/ More than 20 riders, including Pierre Rolland, charged clear but the breakaway did not contain any GC contenders. Behind the escapees, Evans was the first to try his luck in launching an attack on the Croix de Fer with just over 62km remaining. Michael Rogers put in a phenomenal stint at the front and the pair, never able to gain more than 20 seconds, were reeled in after a few kilometres.

Nibali posed the more significant threat. The Italian attacked early on the final climb, joining a breakaway that also included the highly-placed Van den Broeck. Rogers and Richie Porte dropped back having done their jobs. Froomey attacked, testing his

legs, but when he realised Bradley was isolated he was called back and the group reformed.

'I'd been riding [hard] for 1.5km, 2km before that. I wanted to clear the lactate and didn't want to make any more of an acceleration,' explained Wiggins. 'There was a lot going on over the radio and a bit of confusion as to what we were doing. In the morning we'd spoken about Chris attacking in the final and maybe making up those 20-odd seconds to move into second overall. The plan was for me to stay with Vincenzo and those guys, as long as Chris didn't drag them away.'

Rolland held on to win, with Froome edged out by Thibaut Pinot for second, 55 seconds back. Wiggins crossed the line with Nibali a further two seconds behind in sixth. Evans came in almost 90 seconds later to knock his chances of defending his title.

'When we got to the last climb, with about 5km to go, the relief started to come that we were almost at the finish,' said Wiggins. 'Once Cadel had got dropped and we were in that little group, the sense of relief was slightly overwhelming that we've got through the stage ... and taken more time off Cadel, which I don't think we expected this morning.'

'I'll follow orders at all costs. I'm part of a team and I have to do what the team asks me to do. Wiggins is just as strong as me, I think, and stronger than me in the time trial.'

Chris Froome

STAGE 11 RESULT:

Winner. Pierre Rolland (Fra); Europcar; 04h 43' 54"
2. Thibaut Pinot (Fra); FDJ; @ 55"
3. Chris Froome (GB); Team Sky; @ 55"

OVERALL STANDINGS:

1. Bradley Wiggins (GB); Team Sky; 48h 43' 53"
2. Chris Froome (GB); Team Sky; @ 2'07"
3. Vincenzo Nibali (Ita); Liquigas; @ 2'23"

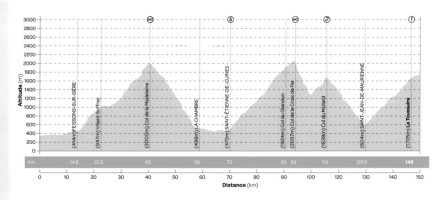

ROUTE/ Still in the Alps, with two good climbs before the route trends downhill all the way to Annonay Davézieux. Sounds a breeze, but a frustrating rollercoaster effect was inherent in five steep hills along the way, each with a long descent, allowing the sprinters to catch up.

THE CHALLENGE/ A difficult stage to control. Overall contenders would want to conserve after two tough days; sprinters would want to hurtle to the finish.

HOW IT UNFOLDED/ The 45th anniversary of Tom Simpson's death on Mont Ventoux prompted hopes of a British feel-good story – and it came in a tremendous victory for David Millar, of the Garmin-Sharp team, who became the fourth British rider to win a stage in 2012 (after Cavendish, Froome and Wiggins). Team Sky, meanwhile, had an untroubled day with Wiggins retaining the race lead.

Millar, who was in a five-man breakaway from the get-go, beat Jean-Christophe Péraud in a sprint after an exhilarating ride. He was involved in the first escape attempt in the opening kilometres and stayed away over the two Category 1 mountain climbs when others fell back into the peloton.

After descending the second mountain, Millar, Robert Kiserlovski,

Egoi Martinez, Peraud and Cyril Gautier opened up a lead of more than 12 minutes with the peloton happy to let them go – as none of the riders were in overall contention. The quintet rode well together until the final three kilometres when Peraud and Kiserlovski tried to attack but Millar covered them with ease. Peraud rallied another assault in the closing 200 metres but Millar kicked again to win by a few bike lengths.

'It was absolutely perfect for me. Guys who get over two climbs like that don't normally have a sprint and I soon realised I was the quickest there. I started planning my move 75 miles from the line. I was determined to just follow every move until the time was right,' said Millar.

'It's nice, very poignant, to have won clean having made the same mistakes that Tommy made. I hope there's a message there about how far the sport has come in the last 45 years, indeed five years. I'm an ex-doper who is now clean and there is never any point in hiding that. I have a duty to remind people where our sport has been. It is always important to show you can win races clean.'

Wiggins enjoyed a relaxed day in the peloton as Team Sky controlled the pace and chose not to chase down the escapees, though fans brandishing flares unnerved them towards the end.

> 'I'm covered in yellow stuff and got a bit of a burn on my arm. It was some nutter running up the hill with a flare and it shows you freak things like that can happen in the Tour. I'm fine though.'
>
> Bradley Wiggins

STAGE 12 RESULT:
Winner. David Millar (GB); Garmin; 05h 42' 46"
2. Jean-Christophe Péraud (Fra); AG2R
3. Egoi Martinez (Spa); Euskaltel; @ 6"

OVERALL STANDINGS:
1. Bradley Wiggins (GB); Team Sky; 54h 34' 33"
2. Chris Froome (GB); Team Sky; @ 2'05"
3. Vincenzo Nibali (Ita); Liquigas; @ 2'23"

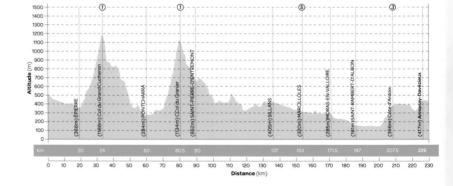

Stage 12
THE LONGEST DAY
Friday 13 July / St-Jean-de-Maurienne to Annonay Davézieux, 226km

ROUTE/ This postcard-picturesque stage is flat – except for Mont St-Clair, 23km from the finish – and relatively untaxing. The heat can be sapping and the Mediterranean crosswinds troublesome. Twice in recent years, splits forced by the wind have caused havoc with the field and general nerves.

THE CHALLENGE/ Bastille Day. The French riders would be out to put on a good show.

HOW IT UNFOLDED/ Michael Morkov went on the attack in the opening kilometres on a quest to win the stage in memory of his father who died five years ago to the day. He helped a group of eight riders – including five Frenchmen seeking glory on Bastille Day – build up an advantage of more than nine minutes. When the peloton closed them down, he charged off on his own with 65km remaining, battling crosswinds that split the bunch behind him.

Morkov was caught 25km from the finish on the solitary climb of the day, the deceptively tough 1.6km ride up Mont St-Clair, as Evans and Van den Broeck attacked Wiggins. The Team Sky leader was in a phalanx with Rogers and Froome though, and the trio maintained a consistent pace, catching Evans and Van den Broeck as they reached the summit.

It is not often you witness the yellow jersey undertake a red-hot lead-out for a colleague – the risk of accidents and injuries in bunch sprints is too great – but that is exactly what Wiggins did for Boasson Hagen into the finishing straight. As he tailed away, the Norwegian pulled ahead before Greipel and Sagan sprinted ahead to the line.

'Once we knew that Mark Cavendish wasn't going to come back, everybody said we'd try to do the job for Edvald,' said Wiggins. 'We had checked out the finish on video at breakfast and we knew it was a dangerous, fast, final bend, so to be honest, riding up the front was probably the safest place to be. But it was also a chance to help Edvald, a chance to repay a friend of mine for his help.'

Wiggins maintained his advantage and became the first Briton to wear the yellow jersey for a seventh time, breaking the record of Chris Boardman who had the distinction three times in 1994, twice in 1997 and once in 1998. Team Sky had their most relaxed day in more than a week. The Lotto and Orica GreenEdge teams set the pace on the peloton and Sky only needed to be vigilant in the final 25km.

'Bradley is strong. He feels good. We're going into the Pyrenees with confidence,' said Brailsford.

'Cross winds and small roads today; even the classics riders said it was a stressful day. Certainly had some dangerous moments.'

Defending champion Cadel Evans on Twitter

STAGE 13 RESULT:

Winner. André Greipel (Ger); Lotto; 04h 57' 59"
2. Peter Sagan (Svk); Liquigas; @ same time
3. Edvald Boasson Hagen (Nor); Team Sky; @ same time

OVERALL STANDINGS:

1. Bradley Wiggins (GB); Team Sky; 59h 32' 32"
2. Chris Froome (GB); Team Sky; @ 2'05"
3. Vincenzo Nibali (Ita); Liquigas; @ 2'23

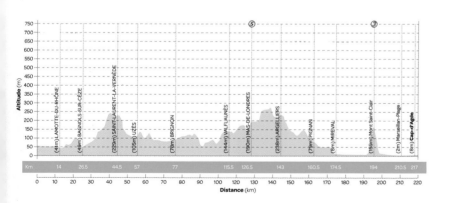

Stage 13
GO EDDY
Saturday 14 July / Saint-Paul-Trois-Châteaux to Le Cap d'Agde, 217km

ROUTE/ Into the Pyrenees. Three testing climbs and a thrilling descent would enthuse a breakaway but was unlikely to provide GC contenders with much scope to make up ground on Wiggins.

THE CHALLENGE/ Full alertness required. As Wiggins – who became the first Briton to wear the yellow jersey for a seventh time – said, 'You can win or lose the Tour by seconds.'

HOW IT UNFOLDED/ A breakaway initiated by Peter Sagan and two others at the 35km mark was boosted by an eight-man counter-breakaway soon afterwards. It would be one race for the Escaping Eleven – Sagan, Philippe Gilbert, Cyril Gautier, Gorka Izaguirre, Sébastien Minard, Eduard Vorganov, Sandy Casar, Luis Leon Sanchez, Steven Kruiswijk, Sergio Paulinho and Martin Velits – and another for the peloton. At 3.53pm, the chasing bunch was struck by saboteurs who scattered tacks leaving 30 riders with punctures.

The 50-strong yellow jersey group had continued its ascent of the final climb, led by Porte, Froome and Wiggins, and as observers marvelled at how Team Sky's dominance meant Wiggins could not be isolated, Cadel Evans punctured and stood holding his bike in the air and shouting. The narrowness of the road meant no car could reach him with a spare. Team mate Steve Cummings arrived, but he'd punctured too.

Aware that a bizarre number of riders behind him had punctured, Wiggins signalled to the peloton to 'slow down' and wait for Evans to catch up. The climb was over. It was a sporting gesture as it would be unfair to take advantage of a rival's misfortune. Only Pierre Rolland ignored the instruction and the shouts of protest from Porte. Then Wiggins punctured. Evans punctured again, got a new wheel and set off, passing Rui Costa who had punctured. And so on.

The yellow jersey group finished 18 minutes and 15 seconds behind winner Sanchez. Wiggins was praised by organisers for 'fair play'. Race official Jean-François Pescheux confirmed: 'The nails were mainly thrown on the ground around 200m from the summit. It was obviously done on purpose. We have the tacks but we don't know who spread them. They are imbeciles.'

'It's something we can't control,' said Wiggins, who had previously been hit by a flare. 'There's nothing stopping more of that stuff happening. It's sad. These are the type of things we have to put up with as cyclists. People take it for granted sometimes, just how close they can get to us … We're out there, quite vulnerable at times, very close to the public on climbs. We're just the riders and we're there to be shot at, literally.'

'We're out there, quite vulnerable at times, very close to the the public on climbs. We're just the riders and we're there to be shot at, literally.'

Bradley Wiggins

STAGE 14 RESULT:
Winner. Luis Leon Sanchez (Spa); Rabobank; 04h 50' 29"
2. Peter Sagan (Svk); Liquigas; @ 47"
3. Sandy Casar (Fra); FDJ BigMat

OVERALL STANDINGS:
1. Bradley Wiggins (GB); Team Sky; 64h 41' 16"
2. Chris Froome (GB); Team Sky; @ 2'05"
3. Vincenzo Nibali (Ita); Liquigas; @ 2'23

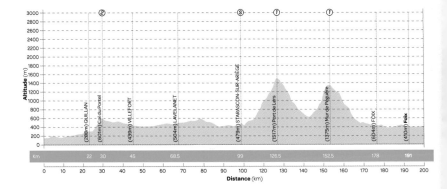

Stage 14
SABOTAGE
Sunday 15 July / Limoux to Foix, 191km

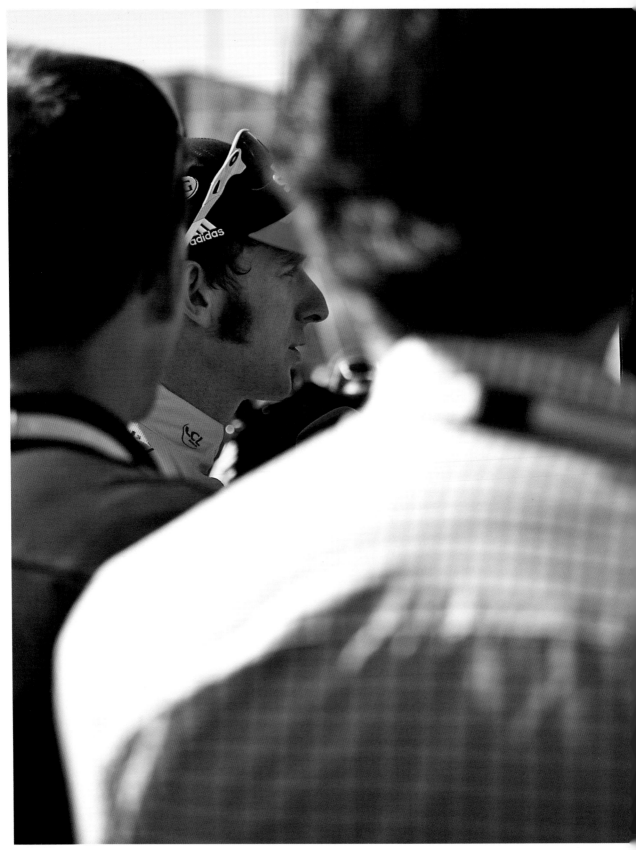

A largely flat and short ride to Pau, with a bunch sprint expected at the finish.

THE CHALLENGE/ To remain unscathed and race quietly before two massive stages in the Pyrenees.

HOW IT UNFOLDED/ After several failed early breakaways, Pierrick Fédrigo consolidated his role in a six-man party that escaped at the 70km mark by staying clear to take victory in Stage 15. Christian Vande Velde and Fédrigo charged clear of Thomas Voeckler, Dries Devenyns, Samuel Dumoulin and Nicki Sorensen with five kilometres remaining and the Frenchman – who won in Pau in 2010 – proved unbeatable in the sprint.

At one stage it appeared that Team Sky with Mark Cavendish or Lotto with André Greipel would chase them down, but instead the peloton was happy to let the gap grow and it was left to the escapees to tussle for the stage win.

Wiggins and the peloton finished almost 12 minutes behind, but the Team Sky leader kept his overall lead of two minutes and five seconds over team mate Chris Froome. Nicknamed 'Le Gentleman' by the French media for his part in neutralising the race after the previous day's sabotage, Wiggins enjoyed a welcome soporific ride after suffering an early puncture.

Off the road, Team Sky continued to be questioned about relations within the team, particularly between Froome and Cavendish. 'We are first and second on GC so it doesn't take a rocket scientist to work that out,' responded Wiggins, when asked if it would be more difficult to win if Froome were riding for another team. 'He's my team mate and we'll keep it like that.'

Froome, too, offered assurance: 'Relations within the team are fine. A lot of things have been taken out of context. There is no bad blood in the team. We are still here with the same goal. There's nothing wrong with that.'

Of Cavendish, Wiggins said: 'Mark has been fantastic these last two and a half weeks. He's been so committed to my cause – to the yellow jersey – and he's a great champion and a great friend ... We've seen him going back for bottles and yesterday he tried really hard to get over that first climb with us. He's been an absolute gentleman. There is still the stage to Paris for him and we are going to lay it down in Paris for him and try and get him the win there.'

The riders were ready for a well-earned rest day, but Wiggins acknowledges there's plenty to do in the remaining five days. 'I always think if you start looking too far ahead, you forget what's in front of you.'

'I don't think it is down to us to do all the work at the moment with the Pyrenees coming up. It makes sense for us to conserve our energy a little bit or share the workload. But the other teams don't want to share the work, so we conserved our energy.'

Dave Brailsford

STAGE 15 RESULT:
Winner. Pierrick Fedrigo (Fra); FDJ; 03h 40' 15"
2. Christian Vande Velde (US); Garmin
3. Thomas Voeckler (Fra); Europcar; @ 12"

OVERALL STANDINGS:
1. Bradley Wiggins (GB); Team Sky; 68h 33' 21"
2. Chris Froome (GB); Team Sky; @ 2'05"
3. Vincenzo Nibali (Ita); Liquigas; @ 2'23

Stage 15
ANOTHER DAY
Monday 16 July / Samatan to Pau, 159km

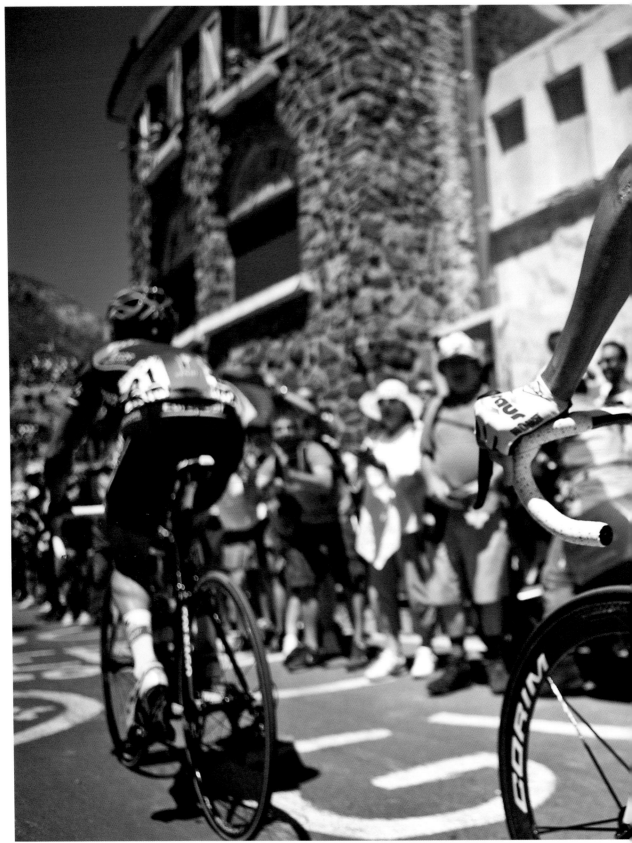

ROUTE/ A daunting stage with 4,687m of climbing. Four big mountains in the High Pyrenees stood to play a potentially decisive role in deciding the overall winner. The day posed tests in the form of two 'beyond classification' climbs in the Col d'Aubisque and the mighty Col du Tourmalet (one of the most famous climbs in Tour history, it has been included more than any other pass), followed by the Col d'Aspin and the Col du Peyresourde.

THE CHALLENGE/ Temperatures expected to be very hot. Strong teamwork required to muzzle Evans and Nibali.

HOW IT UNFOLDED/ A remarkable day, first in observing Thomas Voeckler as the first to reach the top of every major climb and move into the lead in the King of the Mountains category after winning the stage, and second in admiring Team Sky's watertight teamwork. The yellow jersey group finished more than seven minutes behind the charismatic Frenchman.

Wiggins's day involved repelling a series of persistent attacks. Eisel and Boasson Hagen shared the work on the first two climbs, handing the baton to Rogers and Porte on Aspin and the early part of Peyresourde. Evans recovered after being left behind on the third climb, but was dropped for good on Peyresourde. Falling from fourth to seventh overall, his challenge was all but over. He had begun the day 3 minutes 19 seconds behind Wiggins and ended it 8 minutes 6 seconds down on the leader, resigned to losing his crown. 'That's pretty much the Tour de France over for me,' he admitted.

Third-placed Nibali showed persistence on Peyresourde, the final climb of a brutal day, but the Italian was frustrated in every attempt to escape the race leader as Wiggins and Froome rode as a unit to relentlessly reel him in as soon as he got 50m on them. Wiggins finished with Nibali and Froome to retain his overall lead. The Italian said: 'Sky were too strong today. I'm aiming for the podium now. I'd still like to win the stage tomorrow, but it's getting too hard to open the door.'

'It was probably the hottest day on tour and, on the day after a rest day, everybody responds differently,' said Wiggins. 'As a team, we passed the test. The guys were fantastic again and it ended up being the ideal scenario. We put even more time into Cadel even if we didn't get rid of Nibali, who was strong. I don't think Nibali is just racing for a podium place. He is a class bike rider and he gave us a good go out there. I would never underestimate him.'

'It was hard today but a lot of guys might have been holding back a little bit, an extra five per cent, maybe for tomorrow. We were very comfortable there, though. I don't think Nibali was really going anywhere. I mean it's great that he was able to put in those moves, but he was only getting 50 metres or so, and we were bringing him back. It's one more day down and one day closer to Paris.'
Chris Froome

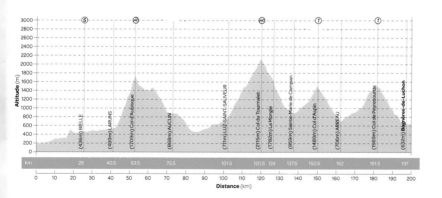

Stage 16
TORRID TIMES
Wednesday 18 July / Pau to Bagnères-de-Luchon, 197km

ROUTE/ Short, brutal and four big vertical zig-zags to cope with: the Col de Menté, the Col des Ares, the Port de Bales and the 1,603m Col de Peyresourde. A key day – the final punishing mountain stage – and a climb of more than nine miles to the summit finish.

THE CHALLENGE/ Wiggins must survive only one more day in the Pyrenees where Vincenzo Nibali would try to make the most of his last chance to reduce his lead before the 21 July time trial. 'Froome service' very much required.

HOW IT UNFOLDED/ Nibali's Liquigas team tried to set him up for a last-gasp stage win on the climb towards the finish line at the top of Peyragudes, but the Italian could not maintain pace. Froome and Wiggins, a familiar tight unit now, were left to try to chase down Alejandro Valverde. The Spaniard eventually crossed the line first, 19 seconds ahead of the Team Sky duo, with Wiggins extending his lead over his main rivals.

'We were talking about Nibali. We knew he was on his limit,' said Wiggins. 'The moment we crossed the Peyresourde, I allowed myself to drift and that was the first time I thought maybe I've won the Tour.

All the way up that last climb my concentration had gone, everything about performance had gone. Chris was egging me on to take more time and I was in another world.'

Wiggins now retains a lead of 2:05 over Froome and 2:41 over Nibali, with no other rider within five minutes of the *maillot jeune*. With three stages to go – including the time trail and the final stage where, by tradition, the yellow jersey is never attacked – Wiggins and Team Sky had all but closed out the 2102 race. Sportingly he maintained Froome would one day win the Tour. 'Maybe he is stronger than me in the mountains, but I'm not a true climber. I'm still a rider against the clock who can climb.'

'Credit to the guys, they did it again,' said Dave Brailsford. 'All the work they did to set it up for the two guys at the end was brilliant. Now that the mountains are over we can let out a sigh of relief and look forward. We set out to consolidate the lead and we showed again we are the best team in the race. Unity was really important to us, I'm very proud of that. The closer you are the more you have to lose. It is my job to ensure that tomorrow we'll be as vigilant as at the start of the Tour.'

'Everyone in the team makes sacrifices for the yellow jersey, that's cycling. It's our work. I'm 27 and I hope to win the Tour one day. If you had said to me a month before the Tour that with three days to go I would be second. I wouldn't have believed you. I'm very happy.'

Chris Froome

STAGE 17 RESULT:

Winner. Alejandro Valverde (Spa); Movistar; 04h 12' 11"
2. Chris Froome (GB); Team Sky; +19"
3. Bradley Wiggins (GB); Team Sky; +19"

OVERALL STANDINGS:

1. Bradley Wiggins (GB); Team Sky; 78h 28' 2"
2. Chris Froome (GB); Team Sky; +2:05"
3. Vincenzo Nibali (Ita); Liquigas; +2:41"

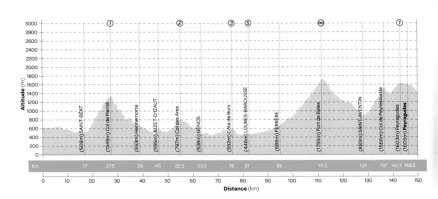

Stage 17
GOODBYE MOUNTAINS
Thursday 19 July / Bagnères-de-Luchon to Peyragudes, 144km

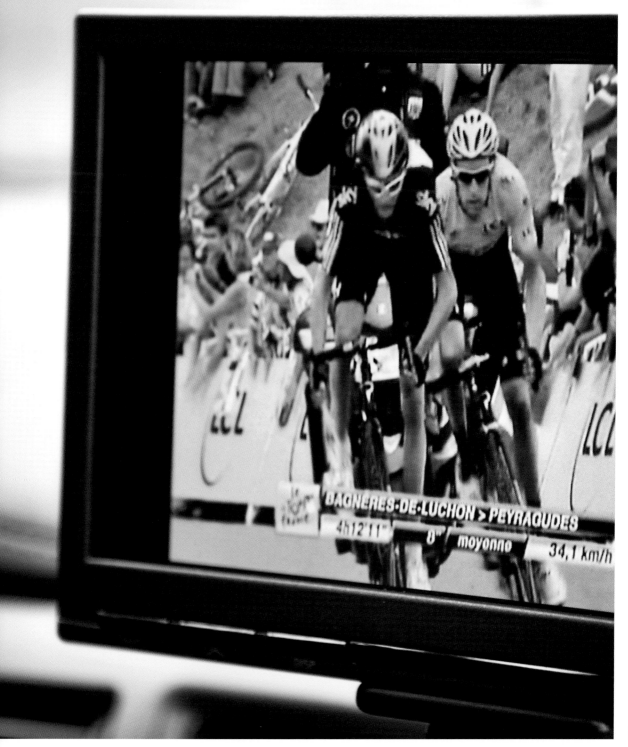

BAGNÈRES-DE-LUCHON > PEYRAGUDES

4h12'11" 0" moyenne 34,1 km/h

185

ROUTE/ The second-longest day of the Tour covered relatively flat terrain, but the roads would be damp and slippery for the bunch sprint expected at the end.

THE CHALLENGE/ Wiggins must not risk anything to protect his lead, but he had other ideas ...

HOW IT UNFOLDED/ Wiggins stayed safely near the front of the peloton for most of the day as the main bunch chased down a 16-man breakaway that included David Millar and Team Sky's Edvald Boasson Hagen. Three riders – Alexandre Vinokourov, Adam Hansen and Luca Paolini – remained in front as the riders reached the outskirts of Brive, and were joined by three others – Andreas Klöden, Luis Leon Sanchez and Nicolas Roche – entering the final 5km.

The gap was down to eight seconds with 3km to go when – what was this? – Wiggins hit the front of the peloton with 1km to go and Cavendish on his back wheel. Wiggins was not adhering to the convention that the yellow jersey ensconces himself safely in the peloton at this stage. Instead, he sought to 'ride for Cav'.

'We knew it was a hard stage and it would have been easy for the guys to concentrate on Paris,' said Cavendish, after outsprinting Matt Goss and Peter Sagan to storm to his 22nd Tour de France stage win in Brive-la-Gaillarde. 'Sean [Yates] said "take it easy, let the break go", but Brad jumped in immediately and said that we should go for the sprint and he would lead out.'

'They are a really good group of guys and were there for me at the end,' conceded Cavendish, who drew level with Lance Armstrong and André Darrigade in all-time wins. 'They moved me up nice and smoothly. We didn't want to catch the break too soon and with 600 metres to go I put all my chips on the table. It wasn't an easy day and I was suffering at times, but I recovered quickly and sprinted with real acceleration. Spirits in the team are really high. It's not often you can come here to win the yellow jersey at the Tour de France.'

Wiggins said: 'Mark has waited a long time and been patient and he has got his reward. He has had to put away his goals and make sacrifices on the Tour so far, and that is hard for a world champion. He has always been the first to say that the General Classification is the most important thing and we all wanted to repay him somehow.'

STAGE 18 RESULT:

Winner. Mark Cavendish (GB); Team Sky; 04h 54' 12"
2. Matt Goss (Aus); Orica GreenEdge; same time
3. Peter Sagan (Svk); Liquigas; same time

OVERALL STANDINGS:

1. Bradley Wiggins (GB); Team Sky; 83h 22' 18"
2. Chris Froome (GB); Team Sky; +2:05"
3. Vincenzo Nibali (Ita); Liquigas; +2:41"

'I just knew I was going to go for it. I have done nothing all Tour so I have saved so much energy. I knew I would be able to go from a long way out, and no one would get past me today. I felt really good. It would have been easy for the guys to cruise into Paris and Sean [Yates, Team Sky's sporting director] was saying "just take it easy" but I was pleading for a chance in the team meeting. But then Brad said "we are going to ride today" and Froomey committed to my cause and I'll always be grateful for that. We have got a great group of guys. It has been an emotional three weeks but I have enjoyed it.'

Mark Cavendish

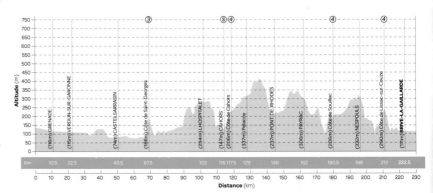

Stage 18
THE RIDE FOR CAV
Friday 20 July / Blagnac to Brive-la-Gaillarde, 223km

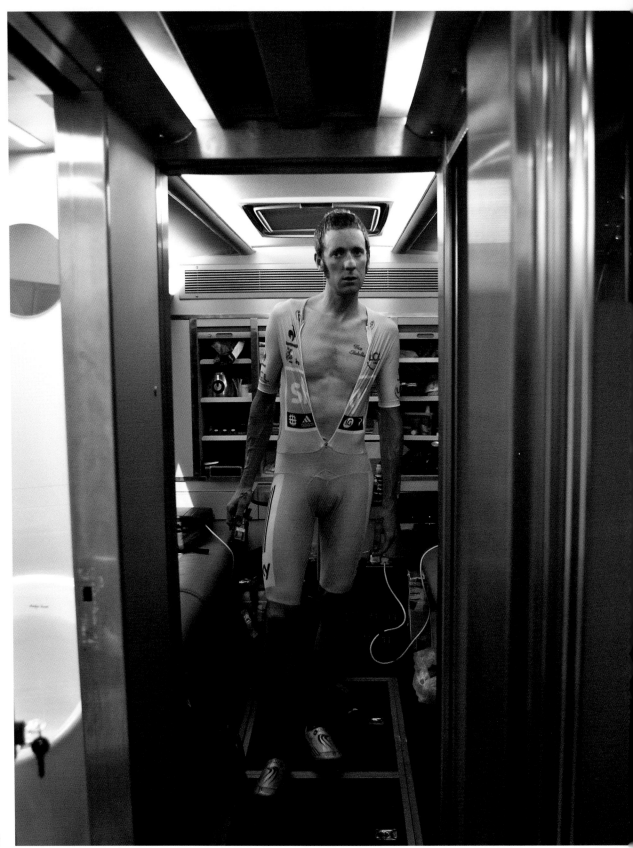

ROUTE/ From Bonneval to the cathedral city of Chartres, the penultimate stage of the Tour de France 2012 was the second long time trial of the race.

THE CHALLENGE/ To avoid any *force majeure*.

HOW IT UNFOLDED/ Wiggins simply did what he does best – dominated a time trial – and finished the day with an increased lead in the General Classification, poised to become the first Briton ever to win the Tour de France. Wiggins showed blistering speed to win the stage in 01:04:13, finishing one minute and 16 seconds ahead of Chris Froome, who he now leads in the GC by three minutes and 21 seconds. Team Sky had three men in the top five.

'It was a beautiful way to finish the Tour with the course lined with cheering fans, many of them waving Union flags. Today was a superb performance. I really wanted to get out there and finish with a bang. Fortunately I managed to do that,' said Wiggins.

'It's the stuff of dreams to win the final time trial and seal the Tour. I was thinking of my wife, children, grandfather, nan with about 20 kilometres to go. It sounds cheesy, but your whole life is for this and the reason I got into cycling as a kid was today.'

Froome was also on the verge of history – no Briton has finished on the Tour podium in 98 previous events. Now there were set to be two. 'As we saw he's stronger than me,' said Froome. 'I'm very happy. The goal this year was to win the Tour with Bradley. To be second is an added plus.'

Vincenzo Nibali was set to complete the top three despite finishing three minutes and 38 seconds behind Wiggins. The Italian was six minutes and 19 seconds adrift of Wiggins in the overall standings, and almost four minutes clear of fourth-placed Belgian Jurgen Van den Broeck.

Dave Brailsford described the very proud moment: 'Bar anything silly we can start thinking about winning this race now. I would never have said we could do it if I didn't believe that. We had done our homework. We knew what Bradley was capable of and what the British team is capable of. Today is all about Bradley – and what a fantastic champion! We are lucky to have Chris and Bradley in the same team. But this was a tour that suited Bradley, he's climbing well and his time trials are off the scale. That shows why we stuck with Bradley. It's a lot easier to manage two good riders than two bad ones.'

'Congratulations @bradwiggins. That's been an inspirational display of athleticism and ambition. You are one of the greats of cycling.'

David Millar on Twitter

STAGE 19 RESULT:

Winner. Bradley Wiggins (GB); Team Sky; 1h 4' 13"
2. Christopher Froome (GB); Team Sky; @ 1'16"
3. Luis Leon Sanchez (Spa); Rabobank; @ 1'50"

OVERALL STANDINGS:

1. Bradley Wiggins (GB); Team Sky; 84h 26' 31"
2. Christopher Froome (GB); Team Sky; @ 3'21"
3. Vincenzo Nibali (Ita); Liquigas; @ 6'19"

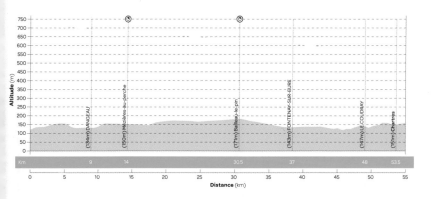

Stage 19
STUFF OF DREAMS
Saturday 21 July / Bonneval to Chartres, 53.5km Time Trial

ROUTE/ A processional finish into Paris for the man in yellow until the Champs-Elysées, where the sprinters would contest the stage win.

THE CHALLENGE/ To set up Mark Cavendish for a fourth successive win on the Champs-Elysées. Team Sky's sprinter aimed to remain unbeaten on the famous boulevard, having won there in the three Tours he has completed in 2009, 2010 and 2011.

HOW IT UNFOLDED/ Cavendish began his sprint early and held off Peter Sagan's challenge with Matt Goss chasing hard in third. The victory lifted the Manxman's tally of stage wins to 23, to surpass seven-time Tour winner Lance Armstrong and Frenchman André Darrigade and move into fourth in the overall stage-win standings, 11 short of Belgian Eddy Merckx's record of 34.

The day, however, belonged to Wiggins, who safely negotiated the streets of Paris to complete formalities after the previous day's emphatic time-trial performance had put him in a league of his own. The three-time Olympic track champion crossed the line arms raised, having helped set up Cavendish's sprint victory in front of a sea of British fans who had flocked to the Champs-Elysées.

The race ended with a Team Sky one-two on several levels. Wiggins became the first British rider to win the Tour de France while Cavendish claimed his goal of a fourth consecutive final-stage victory with some ease. Wiggins finished in the chasing peloton around the streets of Paris with a winning margin of three minutes and 21 seconds. Fellow Brit and Team Sky team mate Chris Froome consolidated second place with Italy's Vincenzo Nibali third.

Team Sky achieved the rare feat of a 1-2 on the podium, the first since 1996, when Bjarne Riis of Denmark finished ahead of his German team mate at Telekom, Jan Ullrich. It was also the first time compatriots have celebrated a 1-2 since France hailed Laurent Fignon's win ahead of five-time victor Bernard Hinault in 1984.

Thomas Voeckler of France won the polka dot jersey for the 2012 race's best climber, with Peter Sagan of Slovakia securing the green jersey in the points competition.

With a well-deserved taste of champagne, Wiggins could reflect on three testing weeks, in which he had worn the yellow jersey for 13 consecutive stages as he toiled over the Alps and the Pyrenees to beat the world's best by more than three minutes in the intense 20-stage, 3,500km race.

'I've got to get used to that [being a legend in the spotlight], it's going to take a while. I'm just trying to soak it all in. You never imagine it will happen to you but it's amazing.'

'I don't know what to say, I've had 24 hours for it to soak in. I'm still buzzing from the Champs-Elysées, the laps go so quick. We had a mission with Cav and we did it. What a way to finish it off.'
Bradley Wiggins

STAGE 20 RESULT:

Winner. Mark Cavendish (GB); Team Sky; 03h 8' 7"

2. Peter Sagan (Svk);Liquigas; @ same time

3. Matthew Goss (Aus); Orica GreenEdge; @ same time

OVERALL STANDINGS:

1. Bradley Wiggins (GB); Team Sky; 87h 34' 47"

2. Christopher Froome (GB); Team Sky; @ 3'21"

3. Vincenzo Nibali (Ita); Liquigas; @ 6'19"

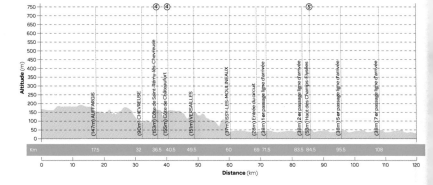

Stage 20
CELEBRATION

Sunday 22 July / Rambouillet to Paris, 120km

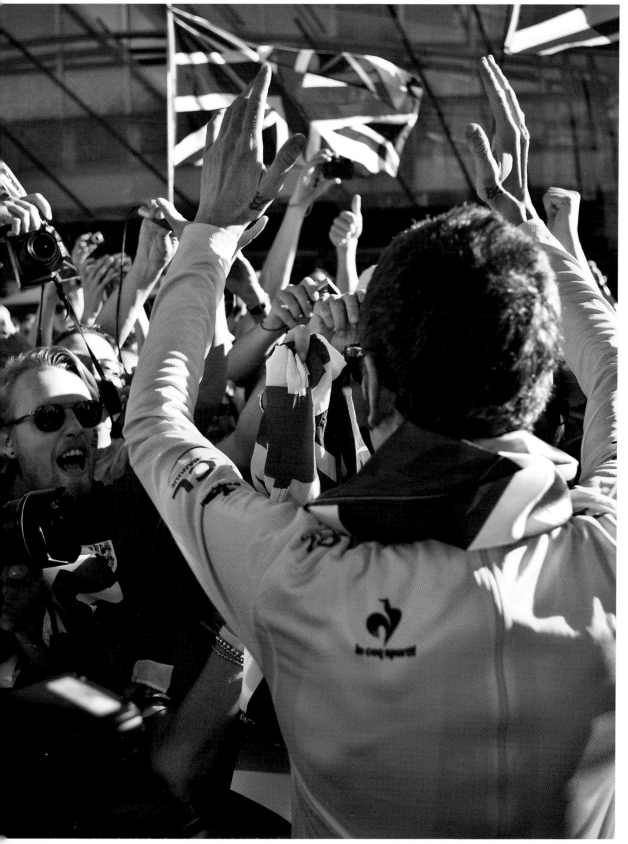

First published in 2012 by
HarperSport
an imprint of HarperCollinsPublishers
77–85 Fulham Palace Road,
Hammersmith, London W6 8JB
www.harpercollins.co.uk

10 9 8 7 6 5 4 3 2 1

Photographs by Scott Mitchell
Words by Sarah Edworthy
Art Direction by Martin Topping

Team Sky asserts the moral right to be identified as
the author of this work

A catalogue record of this book is available from the
British Library

ISBN 978-0-00-750661-3

Printed and bound in Italy by L.E.G.O. S.p.A.

MIX
Paper from
responsible sources
FSC™ C007454

FSC™ is a non-profit international organisation established to promote the
responsible management of the world's forests. Products carrying the FSC
label are independently certified to assure consumers that they come from
forests that are managed to meet the social, economic and ecological needs
of present and future generations, and other controlled sources.

Find out more about HarperCollins and the environment at
www.harpercollins.co.uk/green